ACRYLIC WATERCOLOR PAINTING

Wendon Blake

DOVER PUBLICATIONS, INC.
Mineola, New York

Published in Canada by General Publishing Company, Ltd., 30 Lesmill Road, Don Mills, Toronto, Ontario.
Published in the United Kingdom by Constable and Company, Ltd., 3 The Lanchesters, 162–164 Fulham Palace Road, London W6 9ER.

Bibliographical Note

This Dover edition, first published in 1998, is a revised edition of the work first published by Watson-Guptill Publications, New York, in 1970.

Library of Congress Cataloging-in-Publication Data

Blake, Wendon.
 Acrylic watercolor painting / Wendon Blake.
 p. cm.
 Originally published: New York : Watson-Guptill, 1970.
 ISBN 0-486-29912-0 (pbk.)
 1. Watercolor painting–Technique. 2. Acrylic resins. 3. Artists'
materials. I. Title.
ND2422.B49 1998
751.42'2–dc21 98-10546
 CIP

Manufactured in the United States of America
Dover Publications, Inc., 31 East 2nd Street, Mineola, N.Y. 11501

Contents

1.
Why Paint Watercolors in Acrylic?

Acrylic paints have won the hearts of thousands of artists who've been raised on traditional oil paints. But most watercolorists have yet to discover that acrylics can do just about everything that traditional watercolor paints can do, plus a great deal more.

The purpose of this book is to introduce the watercolorist to the extraordinary new possibilities of acrylic. In the pages that follow, you'll discover how acrylic lends itself to all the basic watercolor techniques; but even more important, you'll learn how acrylic can extend the range of traditional watercolor techniques to encompass new technical possibilities which are beyond the range of traditional watercolor. You'll also find it refreshing to learn how acrylic, when used as a watercolor medium, eliminates many of the headaches which can make traditional watercolor so exasperating for the beginning painter.

Before I go any further, let me emphasize one important point: I'm not proposing that the watercolorist chuck out all his materials and begin again with acrylics. Although this book is called *Acrylic Watercolor Painting*, watercolor and acrylic *are* different media. Each has its unique character. I see no reason for acrylic to replace traditional watercolor. By experimenting with the techniques described in this book, you'll learn which medium—watercolor or acrylic—is the right one for you. Like many distinguished watercolorists, you might very well discover that you like the two media equally, and will switch from one to the other, depending upon your mood and the effects you hope to achieve in a particular painting.

To demonstrate the extraordinary variety of watercolor techniques that are possible when you work with acrylic paints, this book is illustrated with a diverse selection of paintings by leading American watercolorists. You'll find that paintings done in watercolor are hard to tell from those done in acrylic. Only an experienced eye can tell the difference. And this is just the point! An acrylic watercolor often *looks* like a watercolor. But acrylic does have its own special handling qualities, which are sometimes like traditional watercolor and sometimes surprisingly different. Be patient. It will take time, trial and error to learn to exploit the full potential of this versatile new medium.

To help you during the getting-acquainted stage, I'm going to suggest a variety of projects; I'll give you step-by-step instructions which you can follow for a while until repeated practice makes these

procedures something you do subconsciously, without thought or hesitation. The key word, of course, is *practice*: like every watercolorist who's ever lived, be prepared to spoil and toss out a lot of paper before acrylic becomes "second nature." No, I take it back: don't throw out all those spoiled sheets of expensive paper! One of the miracles of acrylic is that you *can* use those sheets again. I'll tell you how in Chapter 3.

What is Acrylic?

But just what is this new medium with the odd name that carries the connotation of the scientific laboratory, rather than the artist's studio?

To make paint, you (or the manufacturer) need three things: coloring matter, a liquid adhesive of some sort, and a solvent. The coloring matter is usually a pigment in the form of dry powder, though sometimes it's a dye in liquid form. The pigment or dye is mixed with the adhesive, which is necessary to stick the coloring matter to the painting surface. The solvent (which is obviously a liquid) is added to the mixture in order to thin the paint to whatever consistency the artist requires.

In oil paint, for example, the adhesive is a vegetable oil called linseed oil, and the solvent is usually turpentine or some petroleum derivative. In tempera, the adhesive is egg and the solvent is water; if you have any doubts about the adhesive qualities of an ordinary egg, just leave the debris of a fried egg on your breakfast plate for a few days, and then try washing it off without some sort of scraper. In casein paint, the adhesive is a kind of glue derived from milk, while the solvent is water. And in watercolor, the adhesive is a water-soluble glue, called gum arabic, and the solvent is obviously water.

In all these painting media, the coloring matter is essentially the same: mostly minerals dug out of the ground and crushed to powder, and the products of chemical companies.

The big difference between acrylic and the other media is in the adhesive. Linseed oil, egg, casein, and gum arabic are all products that come from the world of nature. But the adhesive (or binder) used to manufacture acrylic paint is a product of the scientific laboratory. It's a man-made glue devised by twentieth-century plastics technology. Tiny particles of plastic—visible only to the microscope—are suspended in water, producing a milky fluid which

actually has the consistency of thick cream. If you pour this fluid onto a flat surface, then let it dry, it becomes a tough sheet of plastic, clear as glass. This plastic sheet is the same sort of stuff used to make illuminated signs or the bubble-shaped skylight on the roof of my studio. A sheet of Plexiglas is another form of acrylic.

To make acrylic paint for artists, this liquid plastic emulsion is mixed with most of the pigments and dyes used to make the older forms of paint, although science has also developed a number of new pigments and dyes which are particularly suitable for acrylic painting materials. The solvent for acrylic paints and for the acrylic emulsion is water, as you've already guessed. While the emulsion (or the paint) is still wet or even slightly moist, it remains soluble in water. But once the liquid acrylic is dry, water will no longer dissolve it. Neither will soap or turpentine or any ordinary household cleaner. Only a really powerful industrial solvent like acetone will budge the amazingly durable film of dried acrylic paint or emulsion.

Permanence

To judge the durability of oil paint, all you need is one visit to a museum and one look at all the cracks and muddy colors in the battered masterpieces that line the walls. Looking at the masterpieces executed in tempera, you'll see that the colors have retained far more luminosity than the colors in the oil paintings; but tempera is brittle and so are the gesso panels on which they're painted, which accounts for the scratches, chips, and hairline cracks which mar these delicate surfaces.

The watercolors of the masters have held up better than one might expect. If the artist was clever enough (or lucky enough) to choose nonfading colors and rag papers free from chemical impurities, a seemingly fragile painting has often survived in better shape than bigger, more rugged productions on canvas and wood panels. But too many watercolors of the masters have been ruined by just a touch of moisture, by chemically unsound paints or papers, and by exposure to polluted air.

In acrylic paint, science hopes that we have the solution to all these problems. It's true, of course, that acrylics haven't withstood the test of centuries. But acrylics *have* been subjected to so-called artificial aging tests and we have strong reasons to

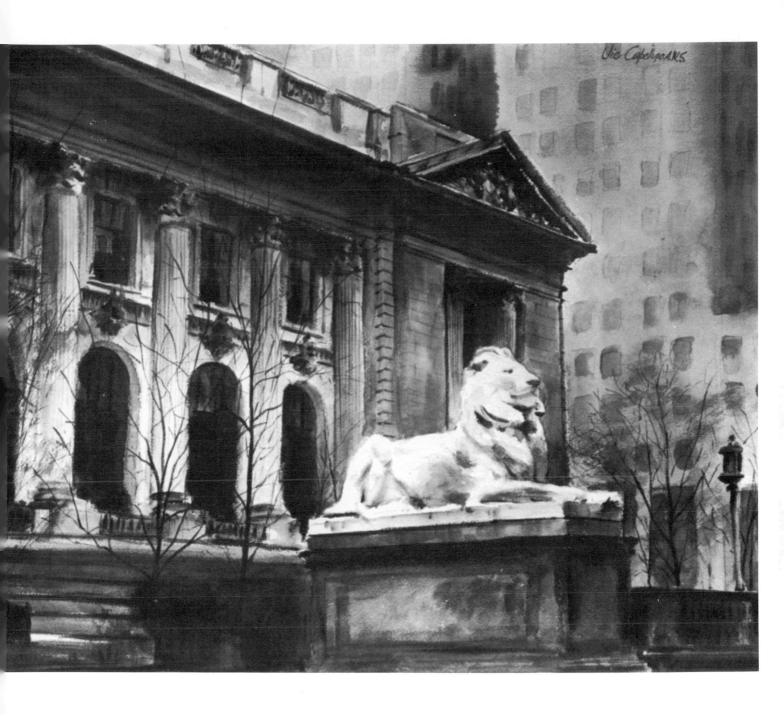

New York Public Library *by Victor Capellupo, A.W.S., acrylic on paper. Working in a completely transparent technique, the artist has built his values from light to dark. In comparing acrylic with traditional transparent watercolor, Capellupo comments: "Especially interesting . . . was the retention of brilliance from application to drying." Observe the treatment of edges. The forms in the foreground and middle distance are crisply defined, while the distant buildings in the upper right are out of focus. The light and shadow planes of the distant buildings merge wet-into-wet. Strokes of drybrush are used to model the forms of the stone lion. (Photo courtesy M. Grumbacher, Inc.)*

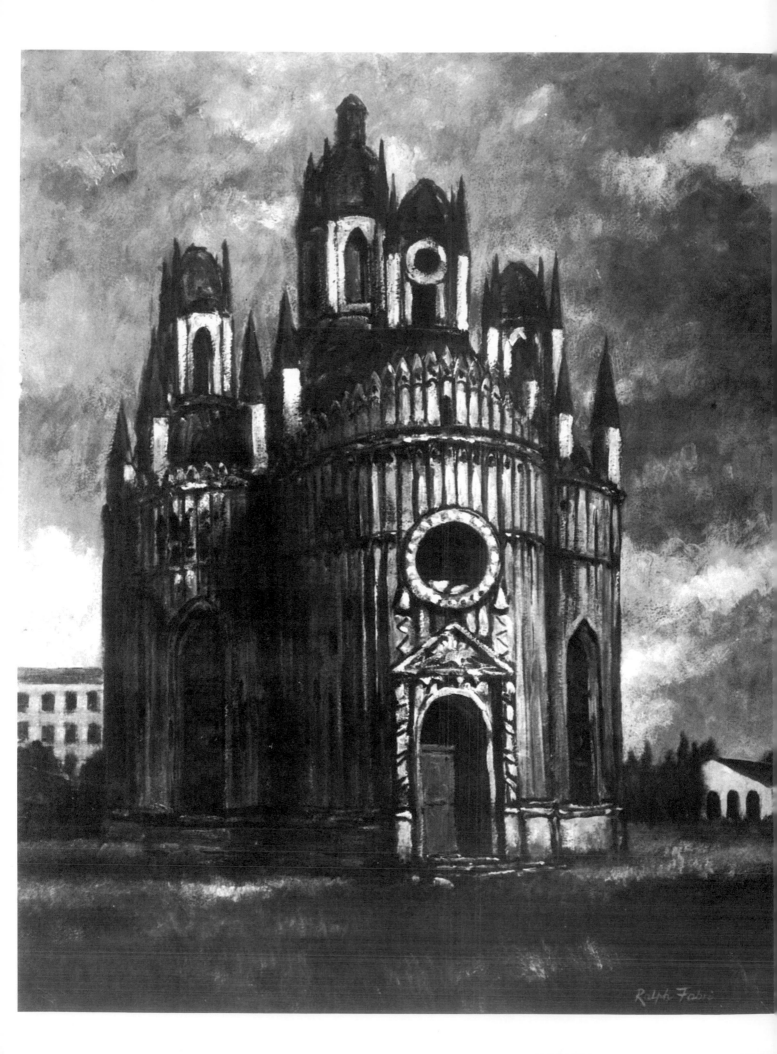

believe that paintings in acrylic will outlast paintings in any other medium.

To begin with, acrylic dries to a tougher surface than any other paint used by artists. The surface of a dry acrylic painting will resist abrasion and chemical attack more stubbornly than any other dried paint surface. Nor will this surface deteriorate because of internal chemical change—the chemical instability which is the bane of oil paint.

Second, the acrylic emulsion seems to be capable of sticking to a painting surface with more tenacity than any other adhesive used to manufacture paint. Not only does acrylic cling fiercely to paper, canvas, or a panel, but the paint also retains a certain flexibility; in contrast with the brittleness of tempera, for example, this flexibility means increased resistance to damage because acrylic can "roll with the punches."

Finally, the manufacturers of acrylic paint have eliminated all doubtful pigments and dyes from the palette. This means that acrylic paints won't fade or change color on exposure to light or air. Equally important, it means that two or three acrylic colors, mixed with one another, won't produce a chemical reaction that results in an impermanent color. I might add that each granule of coloring matter is sealed within a glassy film of dry plastic that protects the color—like a fossil sealed into a layer of ancient rock.

Versatility and Simplicity

Permanence aside, acrylic's real claim to fame is its remarkable combination of versatility and simplicity. A dozen tubes of paint—plus half a dozen tubes, bottles, and cans of mediums and varnishes—can give you a more diverse range of effects than any other single medium. Depending upon how you apply the paint (and what you add to it) you can have the pasty thickness of oil color, the lean precision of egg tempera, or the spontaneous fluidity of watercolor. Whatever technique you choose, the entire studio can be cleaned up with just plain water in a matter of minutes.

Your choice of a painting surface is simplified too. Acrylic will stick comfortably to any non-oily painting surface. With the aid of acrylic gesso, you can adapt any reasonable surface—and some pretty unreasonable ones—for immediate use.

For the impatient painter, acrylic dries swiftly when used straight from the tube or thinned with water. On the other hand, not everyone *likes* his paint to dry quickly. Drying time can be controlled and extended by adding a touch of retarder. So the old complaint—that acrylic dries too fast—is now eliminated. You now have your choice of quick drying or slow drying paint.

Finally, acrylic simplifies corrections. Because it dries so rapidly, you can simply paint out and paint back in a faulty passage as soon as it's dry. Of course, it's true that you can't scrape down to bare canvas, or wash down to bare paper, because dry acrylic paint is so terribly tough. But a few quick strokes of gesso or white paint, and you're ready to start again on a fresh painting surface.

As the title of this book suggests, the emphasis in these pages will be on acrylic techniques for the watercolorist. These techniques are only a small fraction of the total range of possibilities which this new medium offers. But they're more than enough to fill a book all by themselves.

Abandoned Church, Leningrad *by Ralph Fabri, N.A., A.W.S., acrylic on gesso board, 28"x22", collection Dr. Harry Soletsky. When applied thickly—only slightly diluted with water or with liquid medium—acrylic can produce a richly textured painting like this architectural study. The artist has applied his paint in a combination of scumbling and drybrush, developing a slightly rough, crumbly texture throughout, which unifies and enlivens the entire painting surface. Notice the slightly crusty texture of the sky, in* *which the light tops of the clouds are very soft, semi-liquid drybrush. The stonework of the towers is thickly painted with strokes that allow the texture of the panel to come through and suggest the roughness of the masonry. The dark areas of the grass are painted with more fluid color than the lighter tones, which are touches of drybrush. In general, the darker passages tend to be more fluid than the lighter passages, which show more impasto—a "rule" which dates back to the old masters.*

2. Painting Equipment

Every artist loves good painting tools, and it's tempting to walk into a good art material store and buy everything in sight, especially when you're beginning to work in a new medium. Naturally, the art supply dealer would be delighted to have you buy out the store, and the manufacturers are constantly producing new gimmicks and gadgets to stimulate trade. But the experienced painter knows how little gear he really needs to do his job. In fact, one of the ways that you can tell a beginner from a pro is by comparing how much equipment they carry into the field: the beginner often needs a knapsack, while the pro can carry everything in an old fishing tackle box—with room to spare.

So don't yield to the temptation to collect painting tools and equipment for the sheer joy of it. Begin by buying just a few things and get to know them well; then you can add more weapons to your arsenal very gradually, mastering each one before you buy another.

Fortunately, acrylic lends itself to this kind of simplicity and is a blessing to the painter on a budget. In this chapter, I'm going to list a fair variety of tools and equipment; but I hope to make very clear that you don't need them all! I'll tell you which ones are essential and which ones are optional. I'll also suggest some ways in which you can improvise with humble pieces of equipment that you can find in the kitchen and in the toolbox. These improvised tools aren't necessarily crude substitutes for the real thing; on the contrary, they're often better than the so-called professional gear that you pay good money for in the art supply store. Peek into the paintbox of most professionals and you'll discover quite a number of improvised tools.

Sable Brushes

When you think of watercolor, you automatically think of sable brushes. They're the most expensive brushes you can buy, but most professionals agree that sables—or a reasonable facsimile—are essential for watercolor painting or for acrylic watercolor painting. The one consolation is that a good sable brush can be a lifetime investment. Although sable hairs seem delicate, they're amazingly durable if you take proper care of them. They can survive the most rugged brushwork and, if they get bashed out of shape, they're so resilient that you can restore their shape very easily. I'll tell you how later in this chapter.

Sable brushes come in two shapes: round and flat (or chisel shaped). Most painters buy some of each. Luckily for your pocketbook, you won't need too many.

In the long run, it's best to buy the largest brush you can afford. The biggest round sable—and obviously the most costly—is the number 12. A really good number 12 round sable will be worth more to you than a flock of smaller sables, which may cost less individually, but which add up to more money when you total up what you've paid for them. The big number 12 tapers down to a sharp little point, which can render much finer detail than you might suppose.

Once you've made the investment in a number 12 round sable, all you'll need will be one or two smaller round sables. A number 7 or a number 8 is a good medium sized brush; its fine point can get into the tightest corners of a picture. For sharp linear accents, you might want to add a number 4 rigger, which is a long, slender sign painter's sable.

When you shop for flat sables, follow the same strategy: one big flat sable and a medium sized one will do. Just as the number 12 is the standard big brush in the round sable category, the flat sable to save your money for is 1" wide. (Flat sables don't carry numbers; they're measured in inches.) A 5/8" flat sable is a good medium sized brush. Don't waste your money on a smaller flat sable; the medium sized number 7 or number 8 round sable can do everything that a small flat sable will do, and a good deal more.

Like the number 12 round sable, the big flat can work with more precision than you might expect: it not only produces big color areas with a few sweeps of the brush, but the hairs come down to a crisp edge which can make clean, decisive lines when you use the tip.

These five sables—three round and two flat—are *all* the sables you're likely to need. Five brushes are not a lot, but five sables (two of them really big) can still make a sizable dent in your paycheck. Do you really need all five? Frankly, I think you can get along quite comfortably with just two or three. The one really indispensable tool is the big round number 12 or the 1" flat; you do need one large, reliable brush for the large color areas. Second in order of importance is the medium sized round number 7 or number 8. Third in order of importance—and you can get along without it if you must—is the medium sized 5/8" flat.

I've watched lots of watercolorists at work, and

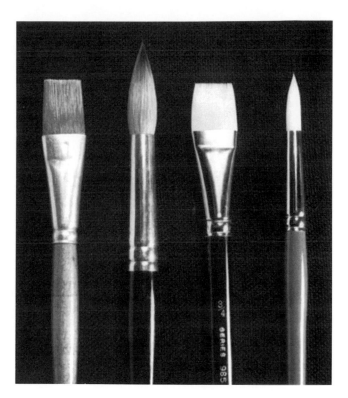

Here are four typical brushes for acrylic watercolor painting. At the left is a flat brush that can be sable or a less costly synthetic fiber. The big round brush—second from left—is the favorite shape of most watercolorists, and can also be sable or synthetic. The flat white brush can be the traditional hog bristle used for oil painting or the slightly softer synthetic version. And the round white brush is nylon, a popular synthetic fiber.

I think it's safe to say that most pictures can be painted with one big brush (round or flat) and one medium sized round brush. The other three are great to have, but you can get along without them for quite a while.

Bristle Brushes

Because acrylic can be thinned with water to very thin washes, or thickened to washes that have considerable body, there are times when you'll want to try bristle brushes like those used in oil painting. Since bristle brushes were made for pushing around thick paint, they're obviously right for thicker passages of acrylic paint too.

If you already have some bristle brushes which you've used for oil painting, there's no reason why you can't use them for acrylics. But be sure to wash them thoroughly in soap and water to eliminate any trace of oil or turpentine; as you know, oil and water don't mix, and even a slightly oily brush will have trouble holding water based paint.

Bristle brushes come in four shapes. Long flat bristle brushes—which are generally called flats—have long, resilient bristles, which will hold plenty of fluid acrylic paint and which feel reasonably comfortable on watercolor paper. However, the short bristle brushes—called brights—are just too stiff and stumpy; they'll hold plenty of oil paint, but not nearly enough fluid acrylic. They also have the wrong feel on watercolor paper: they force you to paint with a clumsy, scrubbing motion, which seems awkward and insensitive.

A particularly good bristle brush for acrylic watercolor painting is the little known shape called a filbert. Whereas the long flats come to a squarish chisel point, the filbert is a fascinating compromise between a round and a flat brush. The body of bristles is rather thick and tapers to a rounded point, something like a worn watercolor brush. You can get extra long filberts with exceptionally resilient bristles that have a lot of bounce and hold lots of paint. Of all oil painting brushes, the filbert is the one that handles most like a watercolor brush, but produces big, rough strokes quite unlike sable or oxhair—adding great strength and lively texture if you go for a rugged style of painting.

Although two or three sables are essential for acrylic watercolor painting, bristle brushes are really optional. They *can* produce strokes and textures that are distinctive, creating an interesting counterpoint when played against the softer passages of

sables. But it might be wise to hold off buying bristle brushes until you've mastered sables.

If you've painted in traditional watercolor, you know that professionals often carry a medium sized bristle brush for scrubbing out corrections and spots of white. This won't work on acrylic watercolors. Acrylics dry to a tough, waterproof surface, which no brush can scrub out.

Synthetic Brushes

Having urged you to invest in sable brushes, I must add that the price of sables has risen to the point where many artists just can't afford them—or at least can't afford the larger sizes. Fortunately, many manufacturers have developed synthetic brushes—brushes made of plastic fibers—that behave so much like natural fibers that it's hard to tell the difference. I have a set of reddish brown synthetic watercolor brushes that look and act so much like my old (and far more costly) sables that I'm not sure which is which.

There are also long-handled white synthetic brushes that look a lot like the traditional hog bristles used for oil painting—but have a unique feel that's also worth a try. They're stiffer than sables, but softer than bristles. And this makes them particularly good for acrylic painting.

It's also worth mentioning that acrylic paint tends to wear out the natural fibers—sable and hog bristle brushes—more rapidly than synthetic fibers, which can take more punishment. But buying synthetic brushes is still no excuse for carelessness. You still have to work with wet brushes—*never* dip a dry brush into acrylic paint—and you must always clean *every* brush thoroughly, whether the hairs are natural or synthetic.

Knives, Wooden and Plastic Tools

Painters in traditional watercolor use knives and other sharp instruments for three purposes: to scratch dark lines into wet paint; to scrape away wet paint and reveal light lines; and to scratch light lines into dry paint. Because acrylics dry to a much tougher film than traditional watercolors, the third technique isn't always easy. But sharp (and not so sharp) tools still have their uses in acrylic watercolor painting.

When you put down your first wash of color on a sheet of untouched watercolor paper, you can scratch in a dark line with the point of a knife. The

liquid color will soak into the scratch and make a line darker than the surrounding wash. But once you've allowed one or two washes to dry, the surface of the paper has grown tougher. The paper gets harder and harder to scratch. By all means, keep a sharp knife handy for this technique, but remember that this trick is easier on bare paper than on two or three dried washes.

Scraping away *wet* paint is actually easier in acrylic watercolor than in traditional watercolor. Because a wash of acrylic tends to have more body than traditional watercolor, it's easier to move the paint around; this means that a knife or even a fingernail can take out a light line with one quick movement. When a fresh wash is applied over one or two dried washes, it's even easier to scrape away the wet paint; because the underlying surface has been toughened by earlier washes, you can scrape away a new, fresh wash without worrying too much about digging into the paper and damaging earlier washes.

But the third technique, scratching away dried paint to indicate a fleck of white or a lost detail, may not be easy in acrylic. You may be able to scratch into a part of the painting surface which is covered *thinly* with color, but a heavily painted area will probably have a tough coat of paint which resists attack by even a razor blade or rough sandpaper. So save this technique for thinly painted areas.

The best knives and other tools for scratching and scraping acrylic watercolor paintings are ordinary kitchen knives. There's no need to go to an art supply store. An ordinary paring knife, with a reasonably sharp (but not razor sharp) point, will make crisp, dark lines in a wet wash. The blunt end of a butter knife is just right for scraping away wet color for light lines.

Ice cream sticks, wooden and plastic chopsticks, and cheap plastic sculpture tools—like the kind you buy for children—will also do an efficient job of scraping away wet color. The noted watercolorist Edgar Whitney used a plastic credit card with great abandon. You can also scrape away big gobs and stripes of wet color with the side of a soup spoon or the long blade of an unsharpened carving knife.

For scratching away dried color, the usual tool is a razor blade or a small, sharp pocket knife. However, you won't get rid of much color with the flat edge of the blade; acrylic is just too tough. A strong hand can scratch away a thin line for a blade of grass or a twig.

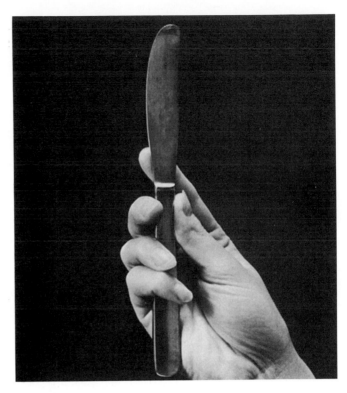

For scraping away wet paint without marring the surface of your watercolor paper, nothing is better than a blunt butter knife found in the kitchen. The tip will scrape away a thin line, while the side of the knife can scrape away an area an inch wide. Be sure the knife isn't too sharp; it should **squeeze** *the paint out of the paper rather than scratch away the surface.*

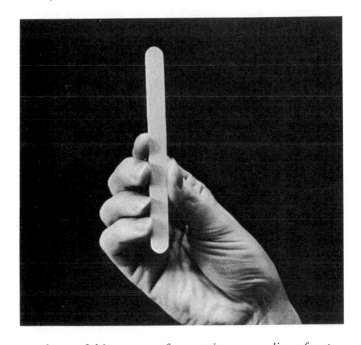

Another useful instrument for scraping away a line of wet paint is the ordinary wooden ice cream stick. You may want to lacquer the stick so that wet paint won't soak into it as you scrape.

9

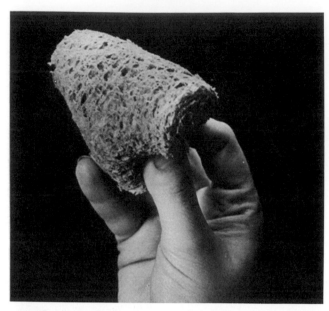

An ordinary household sponge can be used to wet down your painting surface, to wipe away wet paint, or even to apply paint. This well-worn kitchen sponge is bent double to produce a curved surface which resembles the irregular shape of the more expensive natural sponge. Rectangular man-made sponges can be bent or even cut to any shape you please.

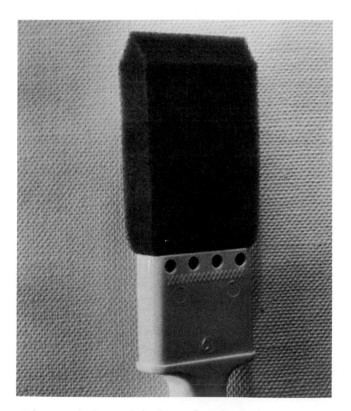

A housepainting tool that's worth trying is the sponge-brush sold at many paint stores. This is a plastic sponge with a chisel end, set in a handle that's shaped nicely to fit your hand. The sponge makes a soft, smooth stroke.

Sponges and Paper Towels

Painters in traditional watercolor have long since discovered that the ordinary household sponge is an excellent painting tool. They use it not only for sponging out dried or semi-dried color, but for wetting down paper preparatory to laying down a wash, and even for painting. Although you can't sponge away dried acrylic color, you should certainly have some sponges handy for moistening paper and for a variety of painting techniques which I'll describe in Chapters 5 and 6.

You can buy a small, irregularly shaped natural sponge at your local drugstore. This is best for moistening small areas and for dabbing on irregular patches of paint.

A man made sponge, rectangular and about the size of your hand, is good for wetting down or wiping out big areas if they're still wet. Moistened with color and pulled or pushed flat across the paper, this big, flat sponge will produce an interesting, streaky wash for a sunrise or a calm lake. Carefully folded to make a kind of dabber, the man made sponge assumes the shape of a natural sponge, and can be pressed lightly against the painting surface to lift away wet paint and suggest a fleecy cloud, or to apply color that suggests the ragged outlines of trees. A natural sponge is equally suitable for these two jobs.

Manufacturers of housepainters' supplies have introduced two new products which you won't find in art supply stores, but which are useful to the watercolorist. One is a brush that has a wedge shaped, fine grained sponge (made of plastic foam) instead of bristles. Dipped in fairly thin color—it's not good for thick, gummy color—this sponge-brush will make a very smooth, clean, sharp edged, rectilinear stroke, splendid for painting architecture. A similar product is a big rectangular sponge on a plastic handle, designed to compete with the fleecy rollers used to paint walls. This tool comes in several sizes—including a foot wide—and will lay a huge wash of very delicate color.

Watercolorists often carry paper towels for cleaning up, but rarely think of them as painting tools. Actually, a wadded paper towel will pick up wet paint with a quick, decisive dab as efficiently as a sponge. Traditional watercolor is too fluid to be applied with a paper towel dabber, but acrylic can be made thick and gummy enough to be applied with a wadded paper towel. The effect is some-

thing like the mark left by a rounded natural sponge.

Needless to say, some paper towels are worth keeping nearby to blot up spills, to wipe brushes, and to blot your brow on a hot day.

Palettes

You'll find a variety of metal and plastic palettes for watercolor painting in your local art supply store. Choosing the right palette is a matter of personal taste. Given a variety of palettes to choose among, pick the largest, the one that gives you the most elbow room for mixing and sloshing around.

For painting in the studio, a big enamel butcher tray gives you the maximum amount of space for mixing colors and for trying out a variety of washes. It's a good idea to use this tray side by side with a smaller palette with wells or compartments into which you can squeeze tube color and mix smaller washes. The wells or divisions in the smaller palette will keep one color from running into another, while the tray becomes the surface on which you do your mixing when you *want* colors to run into one another. For really big washes, it's convenient to have several little saucers in which you can mix enough liquid color to cover a whole sheet of watercolor paper if necessary. Covered porcelain dishes are practical because the covers will keep the wash from drying out for a while.

As usual, the kitchen is a wonderful source of improvised equipment. A metal muffin tin, for example, will give you a dozen really deep wells for mixing big washes of color. The silvery color of the metal may make it difficult for you to judge the color of a mixture, however, so spray the tin with a couple of coats of smooth, quick-drying white enamel. A white plastic ice tray will give you a lot of smaller wells in which you can mix modest washes. Soft margarine and other foods often come in throw-away plastic containers, which are smooth and white; these also make excellent saucers for mixing large washes.

Cleaning dried acrylic off a metal or plastic palette is usually easy. Simply soak the palette—or saucer or muffin tin or ice tray or what have you—in a sink full of water for five or ten minutes. A thick layer of dried paint will peel away in a soggy, flexible sheet; a thinner layer of dried paint can be rubbed away with your fingers or with a wet sponge.

A housepainter's tool that will lay really huge washes very quickly is a man-made sponge with a soft, fibrous surface. This is sold in paint stores as a competitor to the rollers which are so widely used. The sponge comes in many sizes and can be snapped out of the handle and thrown away when the time comes to buy a replacement.

Paper towels are useful not only for cleaning up, but for lifting away wet color, and even for applying color. Wadded up into a dabber, as you see here, a paper towel will function very much as you use a sponge. The dabber can be used wet or dry.

This white plastic palette has circular wells into which you can squeeze your paint, and slanted, rectangular wells for mixing small washes.

For mixing big washes, a porcelain saucer like this one is especially useful. The saucer has a top which can be put on to keep the paint wet a bit longer.

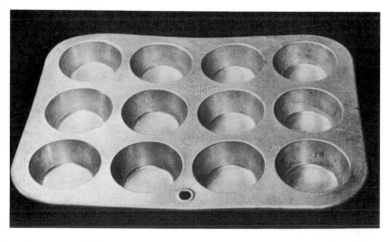

For mixing up a whole lot of large washes, an ordinary muffin tin from the kitchen can be ideal. The silvery color may be confusing, so spray the muffin tin with a hard sur-faced white enamel.

Water Containers

It may seem unnecessary to discuss water containers since it's so obvious that you'll need them, but I should make one important suggestion. It's more convenient to work with *two* water containers than just one. Get into the habit of using one container of water for cleaning your brushes—and for nothing else. Use the other container for picking up fresh water to mix with the paint. If you work with just one water container, you'll foul that water when you clean your brush in it; this means that you won't have clean water for thinning paint. If you work with two containers, you'll always have clean water when you need it.

A clear glass quart jar rescued from the kitchen makes a better water container than a porcelain mixing bowl. The clear glass lets you see whether your water is clear or dirty, so you know when to change it.

Easels and Drawing Boards

Easels are probably the most expensive items in your local art materials store. A drawing table is a piece of furniture and can also run into a good deal of money. Both are useful, but you can easily get along without them.

A watercolor easel is essentially some legs attached to a clamping device that grips your drawing board; you can adjust it quickly to whatever angle you choose. At times, you'll want a fairly shallow angle to keep big washes from running. At other times, you'll want a steeper angle, perhaps when you're putting in final touches of thicker paint that won't run, or when you want to step back to examine your picture from a distance. When you pick your watercolor easel, look for the one that adjusts most quickly; remember that watercolorists have to work fast.

A watercolor easel is lighter and more portable than a drawing table, and therefore more suitable for work outdoors. But if you do most of your work in the studio, you may prefer a drawing table. Like the watercolor easel, the drawing table has a top that adjusts to various angles, and should also adjust to different work heights so you can paint standing or sitting. The top of the table should be at least 23" x 31", which is ½" larger all around than a standard sheet of watercolor paper (22" x 30").

Many professional watercolorists—particularly those who work outdoors—have never owned a

painted walls can *really* distort the colors
painting. For this reason, most professional
aint their walls white or a very pale gray.
ing outdoors, you have very little control
hting conditions, but you have more con-
n you think. On a sunny day, try to keep
inting surface in the shade; direct sunlight
g off a sheet of white paper will blind you
ort your color relationships. If you can do
else, sit or stand so that your own shadow
oss the paper.

avoid working in the shadow of a brightly
wall. Remember that the reflected color of
will be picked up by your painting surface,
you pretend not to see it while you're

it's always important to wear old clothes
u paint, it's even more important to wear
hes when you paint with acrylics. Tradi-
atercolors remain water soluble forever and
sh out easily. If you get oil paint on your
the stains will come out at the dry cleaner.
ing, literally nothing, will remove acrylic
t's soaked into a good dress or a new pair
. The washing machine won't work and
ill all the magic detergents advertised on
; the dry cleaner will fling up his hands in
despair.

and brush will be less likely to fall across the painting as you work.

Of course, a window may not give you enough light. You may need a lamp or two to boost your natural light with some artificial light. Art supply stores frequently sell so-called daylight bulbs; the advantage of these is that they don't throw the yellowish light of incandescent bulbs on your painting surface, thus distorting the natural color. If you buy a fluorescent light fixture, get one that holds two tubes: a cool white tube and a warm white tube. This will give you a balance of warm and cool light that's a reasonable substitute for natural light.

The walls of your studio or workroom will have a strong influence on the color of the light you work in. White walls will boost the amount of light available since they magnify the light like a photographic reflector. Dark walls will soak up the light and make the room darker. Colored walls or wallpaper—whatever the color—will be reflected in your painting surface even if you can't see it.

So reserve a special part of your closet for clothes that are doomed to destruction: frayed shirts; trousers falling apart at the seams and beyond hope of repair; dresses mangled by the cat; woolens perforated by moths. Wear these, and only these, when you paint with acrylics. I wouldn't even waste money on a good artists' smock; it will soon be indistinguishable from a paint spattered floor.

Don't forget to wear old shoes, too. Acrylic may be a bit easier to get off leather than off fabric, but your good shoes will still show signs of the struggle. Wear old shoes or your dirtiest old sneakers. If you insist on wearing sandals, don't worry if paint gets on your feet. Nor is acrylic any threat to your hands or face. It's non-toxic and won't adhere to any oily surface; since everybody's skin contains some oil, dried acrylic will wash away easily with soap and water.

If you get it in your hair—well, that's another problem. Some people have oily hair and dried

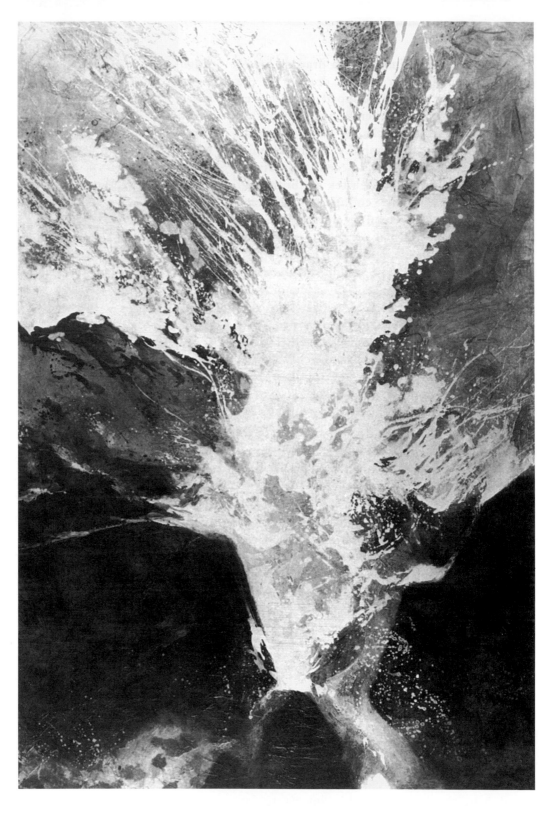

Tide Passage *by Edward Betts, N.A., A.W.S., acrylic on Masonite, 60"x40". Almost invisible at first glance, lightly wrinkled collage papers underlie the textures of the stones washed by the breaking waves. The splash of semi-opaque foam that dominates the composition literally spatters over the rocks in one of those "planned" accidents, which the artist can arrange so easily with acrylic. This spatter effect is most obvious on the dark rock in the lower right hand corner. But the entire plume of foam is surrounded by splattered drips and blobs. Even on so large a scale—the picture is 5' high—acrylic retains its liquid freshness. (Courtesy Midtown Galleries, New York.)*

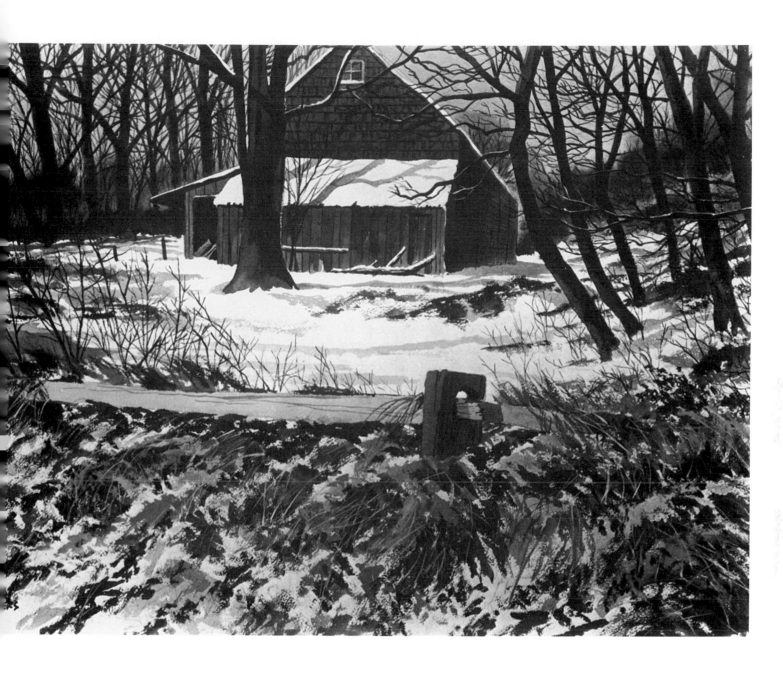

Underhill Farm *by John Rogers, A.W.S., acrylic on water-color paper, 20"x28". The ragged profusion of dried foliage in the foreground combines light-over-dark drybrush with delicate wispy lines made by the tip of the brush. Beyond this area, drybrush is used sparingly; this technique appears just in the twigs and in patches of dark on the snow. The dark, distant trees along the horizon are thrown out of focus to create a sensation of atmospheric perspective: they're painted wet-in-wet.*

acrylic will wash out easily. But if you have dry hair (like me), you may have to wait for your next haircut before the dried paint is eliminated completely.

Accessories

A moment ago I mentioned paint spattered floors. If acrylic will stick tenaciously to a sheet of paper or wood, it stands to reason that dried paint will stick just as tenaciously to your floor. If you work indoors, keep plenty of newspapers on the floor around your work surface. Or put a big, dirty old mat under your drawing table and under your feet. Or simply choose a room—as most professionals do—with a floor that's already messy, and which won't be hurt by paint stains. Of course, if you sell your house, you may have to invest in a floor scraping for the benefit of the next owner.

Here are some other accessories—aside from old newspapers—that are worth having. You'll find a lot of them around the house already.

Hair dryer and tea kettle: Hereward Lester Cooke, a first rate watercolorist and Curator of Painting at the National Gallery, always kept two household gadgets on hand when he worked in the studio. A gun-shaped hot air hair dryer will quickly solidify a wet passage that needs to dry quickly before it loses its shape or texture. On the other hand, a blast of steam from a bubbling tea kettle will retard the drying of a wet passage that needs further work.

Syringe: A rubber syringe is helpful when you want to pick up a quantity of clean water and squirt it into a saucer or a tray to mix a large wash.

Eye dropper: An eye dropper—which you can probably find in the bathroom—will pick up a few drops of acrylic medium to modify a gob of paint.

Jars: In addition to your water jars, keep some dry jars around for storing brushes. Drop the brushes into the jars handle end down, bristle end up, so that wet brushes can dry freely in the air. Storing brushes this way will prevent them from banging into one another and crushing one another's bristles. During the summer, when the moths are out in force, it's probably better to keep your brushes in a tightly closed box or drawer with a handful of mothballs or moth killer.

Tape: A roll of tape, at least 1" wide, is useful to tape down the edges of a sheet of watercolor paper. The best pressure sensitive tape is called masking tape or architect's tape. Don't use Scotch tape, which is likely to tear the paper when you peel it off. Masking tape comes off more easily. You can also hold your paper down with brown wrapping tape, which carries a water soluble adhesive; but you won't be able to remove the dried tape, and this means cutting away the portion of the paper covered by the tape.

Tacks: Thumbtacks or pushpins are better than tape for holding down a thick sheet of paper.

Blades: A single edge razor blade or a mat knife will be needed to cut paper to size.

Ruler: A metal ruler, or a wooden ruler with a metal edge, is best for cutting and also for ruling straight lines with brush or pencil on your painting surface. A metal T-square is even better—though more expensive—because it insures that each cut or line will be parallel to the next or at right angles to the next, whichever you wish.

Pencils, charcoal, sketchpad: Naturally, you'll want some pencils or sticks of charcoal to sketch in your composition on the painting surface. You'll also want a small sketchpad or some scrap paper to experiment with your composition *before* it's transferred to the painting surface.

Eraser: A kneaded rubber eraser will do the least damage if you must remove a pencil line from your painting surface. A chamois or some other soft cloth will flick away the lines of a charcoal drawing.

Projector: Some of the bigger art supply stores sell a flashlight sized opaque projector which might be used to enlarge a thumbnail sketch onto a big sheet of watercolor paper. You simply darken the room, set the projector on top of your sketch, turn on the light inside the projector, and flash the image onto your paper like a color slide projected on a screen. You can then draw in the lines projected on the paper. However, the original drawing must *really* be a thumbnail sketch—really small—to fit beneath the projector.

Care and Cleaning of Painting Tools

If dried acrylic paint is impossible to remove from your clothes, it takes very little imagination to guess what it will do to your brushes. *Never allow*

acrylic paint to dry on a brush! Here are some ironclad rules to bear in mind when you paint in acrylics.

(1) Never dip a *dry* brush into wet paint. Always begin a painting session by dipping each brush in water. If this gives you too much water in the brush, squeeze the bristles out between your fingers or flick out the water, but make sure that they remain moist.

(2) Dip your brushes into water regularly throughout the painting session. Keep them moist even when you're not using them.

(3) As soon as you've finished painting with a particular brush, wash it out immediately; don't just put it aside with paint on it.

(4) When you've finished painting for the day, wash all your brushes thoroughly. Even if you think they're all clean, wash them once again before you put them away.

In theory, all your brush needs after a day of painting in acrylics is a thorough sloshing in water, but this really isn't true. Nearly invisible traces of acrylic paint do stick to bristles washed in plain water. In time these traces of dried paint build up imperceptibly and begin to stiffen the brush. To prevent this buildup, it's wise to give each brush a light washing in soap and water at the end of the painting session.

The gentlest way to wash a brush is to rub some household soap on the palm of your hand, then gently rub the wet brush against the palm with a slow, circular motion. Don't jam the brush against your palm; let the bristles trail softly behind, picking up the soap and forming a delicate lather. When the brush is thoroughly lathered, you'll see that the lather contains a trace of color. Wash out the soap and lather again until the lather is pure white. At that point the brush is clean. Wash it out and put it away.

But before you put the brush away, be sure to shape the bristles into a perfect heart or wedge (in the case of flat brushes) so that the bristles dry out in the right form for painting.

If a sable or oxhair brush loses its shape—because of improper drying or pressure by a nearby brush—it's simple to restore it. Soap up the brush or dip it in liquid starch, shape the brush with your fingers, and let it dry. After a few days, wash out the brush and the hairs will be retrained to take the

To preserve your brushes, wash them gently in mild soap and water after each painting session. Make a little "cup" of lather with one hand and move the brush with a gentle, circular motion, pressing the bristles down into your palm and working the soap up into the neck of the brush.

proper form. The stiffer bristle brushes may have to be retrained by dipping them into a water soluble glue like library paste.

Use only the mildest soap to wash your brushes. No yellow laundry soap! I've developed the habit of collecting stray bits of bath soap (pieces too small to wash my hands with) and tossing them into a big jar in my studio. Periodically, I add water to the jar, and the collected soap dissolves into a mush which I use for cleaning brushes.

Cleaning knives and plastic tools is a lot easier. Simply soak the tool in water for five minutes, and the dried paint will peel off or brush off. There's no harm in allowing acrylic paint to dry on a metal or plastic blade. It's really the brushes you have to worry about.

Outdoor Painting Equipment

When you set out for a day's painting on location, you obviously can't take the entire contents of your studio along. You're restricted to what you can carry in your hands. So then, what's the irreducible list of gear you need to work outdoors? For painters on a budget, I might add that this same outdoor list is really all you need to paint *indoors*. So the following list seems like a reasonable minimum setup for painting watercolors in acrylic wherever you are.

Brushes: As I said earlier, all you really need are a couple of brushes—a big number 12 round or a 1" flat, and a number 7 or 8 round.

Colors: You won't need more than a dozen tubes of color and eight or ten will probably do. See Chapter 4 for recommended palettes. Before you go out to paint, be sure that all the caps come off the tubes easily; if they don't, soak the tubes in hot water, remove the caps, clean away any dried paint that may be clogging the inside of the cap or the neck of the tube, and then put the caps back on. It's a nightmare to find yourself in the field with tubes of paint that you can't open! Traditional watercolors often come in tubes with metal caps that can be loosened after heating with a match. But acrylic paints come in tubes that have plastic caps which may be ruined by a match.

Drawing board: Cut a piece of wallboard to a size slightly larger than the sheet size of the paper you expect to take along. If you work on full sheets (22" x 30"), take along a board that's 24" x 32".

If you work on half sheets (15" x 22"), a board 18" x 24" is a good standard size. A quarter sheet is 11" x 15" and the board can be as small as 12" x 16".

Paper: Take along as many sheets of paper as you think you'll need. Be sure to pre-cut the paper to the correct size before you start on your trip. It's no fun cutting paper in a high wind. Speaking of wind, choose a paper that's heavy enough not to flap in the breeze while you're painting. Light and medium weight papers (72 lb. and 140 lb.) aren't easy to handle even in the studio; they can drive you mad outdoors. For work on location, stick to 200 lb. and 300 lb. (More about papers in Chapter 3.)

Tacks: If you work with reasonably heavy paper, you won't need to tape down the edges of the sheet. All you'll need will be a thumbtack or a pushpin for each corner. But don't just take along four tacks or pushpins; carry a few extras. Dropping a handful of tacks into high grass or off a pier is like a bad dream; so be sure to carry an extra set.

Water: The best container for water is an old plastic detergent bottle. Be sure to wash the bottle out thoroughly so that no trace of detergent remains to get mixed with your paints. For your two water containers, chop off the bottom halves of two more detergent bottles of the same size; plastic bottles cut easily with a razor blade. The two containers will "nest" inside one another, and the bottle will "nest" in the containers. Take a half gallon bottle; you'll need more water than you think.

Acrylic medium: For reasons which I'll explain in Chapter 4, take along a small plastic bottle of matt acrylic medium. Don't take along the big bottle you buy in the store; you won't need that much medium. Find yourself a small, discarded plastic bottle, like the ones used by drug and cosmetic manufacturers for packaging things like suntan lotion. The best kind are flexible bottles which release a few drops of liquid at a squeeze. The neck of a squeeze bottle is usually filled with some sort of a plug with a tiny hole in it; pry loose the plug, clean out the bottle, fill it with acrylic medium, push the plug back in place, and you've got an excellent traveling squeeze bottle.

Pencil or charcoal: Unless you're skilled enough to start painting without a preliminary outline, you'll

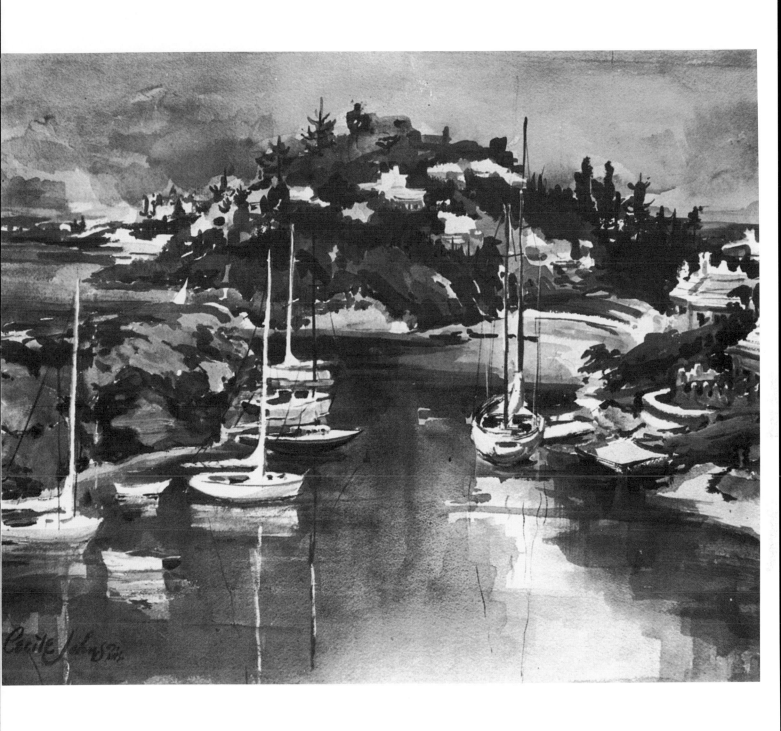

Blue Harbor *by Cecile Johnson, A.W.S., acrylic on watercolor board, 22" x 30". The artist began with a light pencil sketch, marking out small areas with masking fluid to protect such elements as masts and the far cottages. The light, warm sky color was washed under the distant hill to prevent the green from becoming too isolated. Clouds were painted in while the sky area was still damp. "The direction of the brushstrokes," explains the artist, "emphasized the growth pattern of the foliage, also the layered rock formation and the limpid water." (Photo courtesy M. Grumbacher, Inc.)*

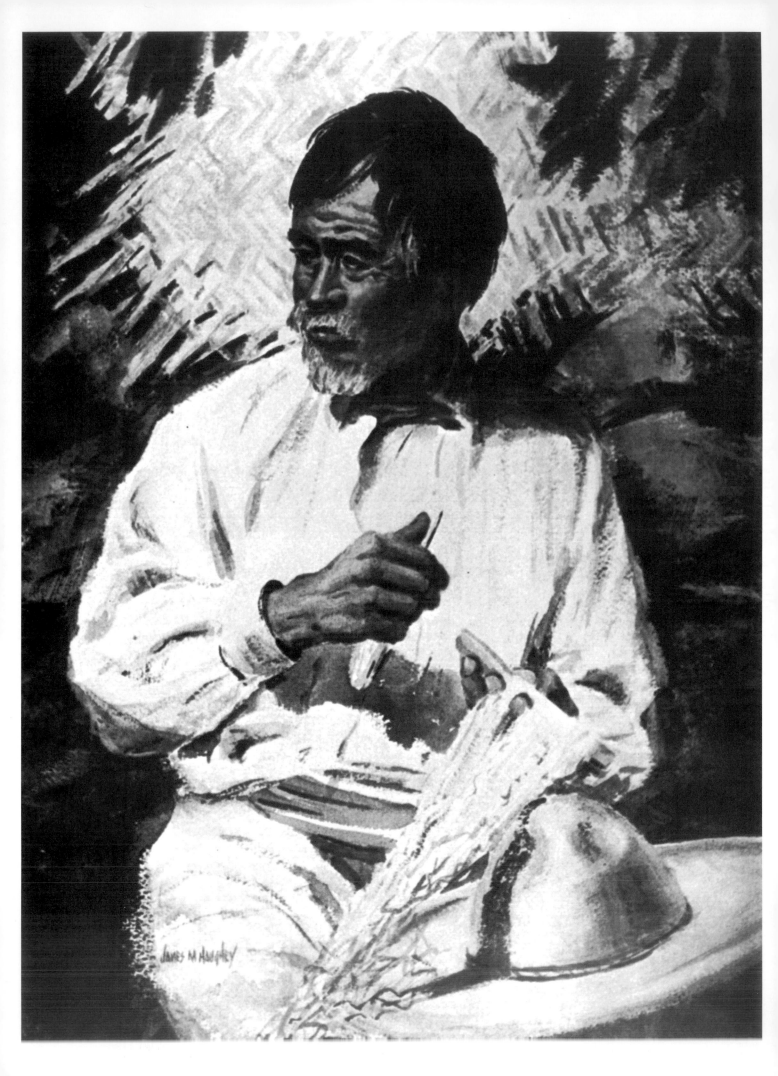

want to take along a pencil or a few sticks of charcoal. A mechanical lead holder with a stick of lead inside is better than a wooden pencil. If the point of a wooden pencil breaks, you've got to waste time sharpening it. The mechanical holder has a long lead, so there's plenty more available at the click of a button if you break the point. If you prefer charcoal, use sticks of natural charcoal, not a charcoal pencil. The charcoal in a pencil is processed with a faintly oily substance that makes the lines harder to erase. Be sure to take along two or three sticks of natural charcoal; they break easily.

Eraser: Take a kneaded rubber eraser to erase pencil lines. A chamois or a soft cloth will eliminate charcoal lines.

Sponge: When you're working in the field, a large man-made sponge is more useful than the smaller natural sponge. You can use the whole face of the sponge if you wish, or you can fold it into small shapes. You can supplement the sponge with some paper towels, but set a rock on them or they'll blow away.

Paintbox: An old metal toolbox or a fishing tackle box is the best carrying case for all this gear. There should be compartments of different sizes and shapes to hold the various items on this list. Every-thing will fit in except the water bottle, paper, and drawing board.

Envelope: Don't spend your money on one of those big portfolios that tie together with shoe-strings at the top and two sides. The strings always get knotted and the contents of the portfolio may get soaked if it rains. A big, transparent envelope (the plastic is called polyethylene) is cheaper, lighter, more durable, and really waterproof. Stationery stores also carry plastic envelopes in various colors with a clasp or a zipper; these aren't big enough to hold a full sheet, but you can easily get one to hold quarter sheets, and I've seen some big enough to hold half sheets.

This is really all you need. If you wish, you can add a sketching stool and a portable watercolor easel to the list, but many professional watercolorists just work on the ground.

One important tip about brushes. When you've finished a day of painting outdoors, be sure to rinse your brushes thoroughly before you toss the water away. Then, when you get home, give them the soap and water treatment.

Come to think of it, you may want to add three more items to the list: insect repellant, your lunch, and suntan lotion. The sign of a veteran outdoor painter—who's spent months bending over a drawing board on location—is a sunburnt neck.

Net Mender *by James M. Haughey, A.W.S., acrylic on 300 lb. rough Arches watercolor paper, 14"x21". Acrylic is particularly useful in watercolor portraiture because the subtle, three dimensional forms of the human face and figure can be built up gradually in a series of washes—without any fear that each new wash will destroy the vitality of the dried color underneath. The head and hands can first be modeled in monochrome to develop form and likeness, then washed over with color. Notice how touches of drybrush enliven the texture of the shirt and trousers.*

3. Painting Surfaces

One of the striking advantages of acrylic as a watercolor medium is the variety of painting surfaces to which this new medium will stick. You not only have your choice of papers, but you can paint on fine grained fabrics (like the Chinese masters), on panels, and even on special surfaces which you can prepare to suit your own style.

Watercolor Paper

Nearly all watercolor papers come in the standard size of 22" x 30". As I mentioned in the preceding chapter, this is called a full sheet. It takes a great deal of boldness and control to paint a full sheet. A beginner will find it easier to work on half sheets (15" x 22"), or on quarter sheets (11" x 15"). You can't buy half sheets and quarter sheets, but it's easy enough to cut them from full sheets.

Don't feel that half sheets and quarter sheets are just for beginners, however. The two greatest American watercolorists, Homer and Sargent, painted most of their pictures on half sheets. Turner, the greatest English watercolorist, normally painted on a scale slightly smaller than a quarter sheet. And Bonington, another British master of watercolor, painted scores of masterpieces on sheets half the size of the page you're now reading! Big pictures may *look* more important than small ones, but size has nothing to do with quality.

The most popular watercolor papers are European imports. Arches, a French paper, is widely used by American painters. Two other French papers are worth trying: Canson and Lana. The old Italian mill, Fabriano, makes several good watercolor papers in different price ranges. And three British papers are also attractive: Winsor & Newton, Saunders Waterford, and Bockingford.

Testing Watercolor Papers

No two brands of paper behave in exactly the same way. As your style of painting evolves, you'll find some papers more congenial than others. It's a practical idea to buy one sheet of each paper available in your local art supply store. Ask for some *rough* sheets and some *cold pressed* sheets so you'll have two different kinds of surface to work on (more about this later). If you cut each sheet into eight equal rectangles, 7½" x 11", this will give you enough paper to try out sixteen small paintings if you work on both sides. By painting lots of small pictures on all these different little

sheets, you'll begin to learn the following things about watercolor papers.

Texture: Watercolor papers generally come in three surface textures. The most dramatic surface is simply called *rough,* which means an extremely irregular surface that demands very bold brushwork. A more popular paper for general use is called *cold pressed,* which is still irregular enough to be interesting, but allows more delicate work. (In Great Britain, *cold pressed* paper is called *not.*) You can also buy *smooth* watercolor paper in which the peaks and valleys are almost invisible, but not quite. Handling liquid color on smooth paper is something for professionals only; better try the rough and cold pressed first.

Weight: Watercolor papers come in a variety of weights and thicknesses, which are measured in pounds. The thinnest paper you're likely to buy is 72 lb., which is so thin that it curls up as soon as water hits it. Most watercolorists consider 140 lb.—roughly twice the weight of 72 lb.—the thinnest paper worth buying. But even this is inclined to get wavy when wet. The most practical weights are 200 lb. and 300 lb., which is the heaviest weight you're likely to use. Sometimes you can find 400 lb., but this is stiff as a board and useful only if you plan to give your picture a great deal of punishment.

When you buy your sample sheets, you may find it interesting to buy one sheet of 72 lb. and one sheet of 140 lb., so you can try them out and see how they behave. You'll soon discover why most professionals prefer 200 lb. or 300 lb. The heavier weights remain flat and stiff, no matter how much water you flood onto them. The lighter weights hold their shape only if you stretch and mount them, as I'll describe later in this chapter.

Absorbency: As you try out your different sample papers, you'll find that some sheets drink up the liquid color, while others are inclined to fight back, leaving the liquid color lying on the surface. In other words, some papers are more absorbent than others. An absorbent paper is best if you work quickly and decisively, rarely changing your mind; if liquid color soaks in quickly, this means that you must guess right the first time, since you won't have time to change your mind and push the color around until you get it where you want it. A less absorbent paper will leave the color on the surface

Here's a scrap of cold pressed watercolor paper, covered with three strokes of color to show how acrylic behaves on this traditional painting surface. The top stroke is acrylic thinned with water; the effect is just like traditional watercolor, with the color settling into the irregularities of the surface and creating a slightly mottled effect, which happens just as frequently with the older medium. The middle stroke is drybrush; water and a drop of acrylic medium were added to the paint to produce a slightly thicker consistency and make the stroke easier to control. The bottom stroke is tube color thinned with acrylic medium, which produces a thicker (but still transparent) wash that retains the streaks left by the bristles of the brush.

Liquid paint behaves quite differently on the softer, more absorbent Japanese paper. The top stroke is tube color, thinned with water; the wash soaks instantly into the paper and leaves a smooth, soft tone. The middle strip combines several drybrush strokes, some wetter than others; the paper soaks up the stroke instantly and retains the exact character of the brushmark. The bottom stroke is tube color diluted with acrylic medium; this fairly dark wash soaked in immediately and formed a solid, dark tone. Study the ragged upper edge of the dark stroke, which makes clear that paint thickened with acrylic medium is ideal for drybrush on Japanese paper.

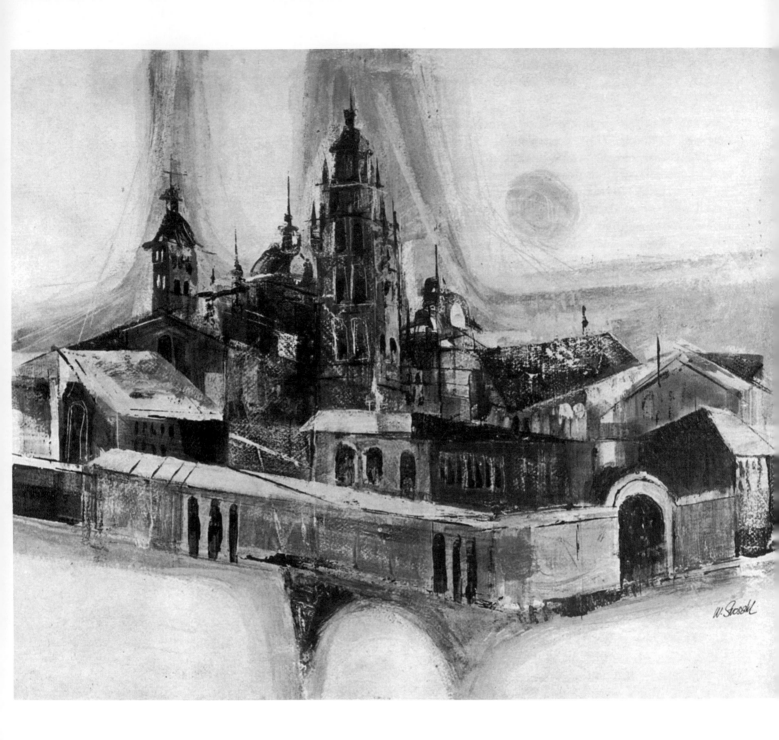

Walled Town by William Strosahl, A.W.S., acrylic on gesso board, 20"x24". Working in a combination of transparent and semi-opaque color, the artist has exploited the texture of the gesso board to suggest the stonework of the old buildings. Notice where he scrapes away wet paint to accentuate the texture and reveal the tone beneath. He also scrapes away lines for such architectural details as the windows on the central tower. The broad, rough brushstrokes are sharpened here and there by crisp lines, drawn with a small brush, or incised with a sharp point.

longer, giving you more time to push the paint around.

This makes a less absorbent paper easier for a beginner, but it doesn't mean that such paper is better than the absorbent kind. How absorbent or nonabsorbent you want your paper to be is a matter of taste. If your approach is to build up your picture rapidly and spontaneously, an absorbent paper may retain the freshness of your attack far better than a nonabsorbent paper. But if your approach is to build up a painting slowly, with a great many washes and strokes and textures laid over one another, then a less absorbent paper allows you to work more gradually and deliberately.

Hardness: Related to absorbency is the hardness or softness of the paper's surface. Some watercolor paper is almost as soft as blotting paper or filter paper. Others are tough, almost leathery. In general, the absorbent papers are the softer ones, while the more nonabsorbent the paper is, the harder the surface.

Obviously, a hard surfaced paper will take rougher brushwork and much more in the way of corrections. You can attack a hard surfaced paper again and again without wrecking the surface and ruining your painting. A softer surface won't take as much sponging out and repainting; you may even mar the surface by erasing a *pencil line*! Despite their fragile quality, the softer, more absorbent papers are especially good for beginners. Because such papers won't allow you to hesitate, change your mind, or brush and rebrush your colors to death, such surfaces force you to work decisively and spontaneously. And spontaneity, after all, is the essence of watercolor.

In the process of sorting out which paper or papers you prefer, bear in mind that only 100% rag stock is suitable for serious painting. A good watercolor paper contains no wood pulp in any form. Cheaper, student grade papers are generally made of wood pulp—which is why they're so cheap! Even if such papers seem to respond well to the brush, they eventually turn yellow or even brown—and that's the end of your painting.

It's tempting to practice on cheap paper; you figure that it's only a practice picture, so why waste your money on good paper? There are two holes in this argument. No two papers behave alike. You may get used to the behavior of an attractive cheap paper, then discover that you have to re-

Cold pressed watercolor paper can be covered with acrylic gesso—one coat applied from top to bottom, another coat applied from side to side—to suggest a texture like smooth canvas. The top stroke here is color thinned with water; it rides on the surface, rather than soaking in, suggesting the texture of a thin oil glaze on canvas. The middle stroke is drybrush; tube paint was thinned with water and a touch of acrylic medium. The bottom stroke is tube paint thinned only with acrylic medium and really looks like oil paint, although it's just as transparent as traditional watercolor.

Here are three strokes of color on smooth canvas. The top stroke is tube color thinned with water; the wash settles into the painting surface and the canvas texture dominates. The texture of the painting surface dominates the middle stroke too, which is drybrush—color thinned with water and a bit of acrylic medium. The bottom stroke is darker color thinned only with acrylic medium and has the same texture as the top stroke. As you can see, the texture of canvas does tend to be stronger than the texture of paper.

25

adjust yourself to the very different habits of a more expensive professional paper. You'll be angry at yourself for wasting a lot of time and effort learning how to handle a cheap paper, when you have to go through the whole process again when you switch to better paper.

The other problem is simply that practice pictures often turn out a lot better than you think. You'll wish you'd painted them on better paper. I have lots of drawings from my student days, drawn on cheap paper, which have turned dark brown and are starting to crumble. I wish I'd drawn them on good paper in the first place.

Starting out with cheap paper is particularly tempting because rag paper is so painfully expensive. When you walk into the art supply store and look at the prices, you really have to *force* yourself to buy those costly papers when there are so many attractive cheap ones. But don't deceive yourself. Sooner or later, when you get serious about painting, you'll be working on the expensive sheets. It's better to *begin* with them and learn how to use them, rather than delay your progress by getting used to the cheap ones.

One way to force yourself to buy the better papers is to remember that your paintings will look better on them. Remember what I said earlier—a fine rag paper will vitalize your brushstrokes and boost your ego.

Stretching

Traditionally, watercolorists have saved money by buying thinner weights of watercolor paper and stretching them so that they'll function like the heavier sheets. Frankly, I think the process is so much trouble that you lose in time what you *think* you save in money. But I'll explain the process briefly, just in case you'd like to try it. Perhaps you already have some sheets of 72 lb. or 140 lb. paper in the studio.

There are two widely used ways of stretching watercolor paper, both fairly simple. One way is to take a drawing board—an old, battered wooden drawing board, or a thick sheet of fiberboard—which is about 2" bigger all around than your sheet of watercolor paper. You simply soak the paper in your bathtub until the water penetrates and the sheet is limp; naturally, the paper will swell as it absorbs the water. Lay the wet paper flat on the board and smooth it down with a wet sponge or with your hand, taking care not to scratch or

scrape the painting surface, which is more vulnerable when it's wet than when it's dry. To complete the job, all you have to do is tape down the edges of the sheet with brown wrapping tape, the stuff you use to wrap packages with. The tape should be 2" wide and the glue on the tape should be the water soluble kind, not the pressure sensitive kind that's used on Scotch tape or in masking tape. If the tape is 2" wide, then 1" of its width will overlap the edge of the paper and the other inch will be on the drawing board.

Depending upon the absorbency of the paper, the absorbency of the drawing board, and atmospheric conditions, the wet paper will dry out in a few hours and shrink back to its original size, tight as a drum. When you paint on it, the paper may swell up again, but this is only temporary; it will shrink back, more or less, when the painting is dry. When the painting is finished and dry, simply trim off the taped edges with a razor blade or with a sharp mat knife. Then peel the tape off the board, toss the tape out, and you're ready to stretch a new sheet of paper. You've lost a 1" border of paper in the process, but that's something you can't avoid if you're going to stretch your paper.

Some watercolorists prefer a row of thumbtacks or pushpins to a strip of tape along the four edges of the paper. But the tacks or pins take longer to shove into the board and I'm not really sure you get as smooth a "stretch" this way. But you can try if you like.

The other method of stretching watercolor paper is something like stretching canvas for oil painting. Instead of a drawing board, you can use the wooden stretcher strips on which oil painters mount canvas. When the wooden strips are assembled, the outer dimensions of the rectangle should be about 1" smaller all the way around than your sheet of watercolor paper. Once again, you soak your paper in the tub. Then place the wet sheet on a clean, nonabsorbent surface—like a sheet of glass or a kitchen counter—and carefully place the wooden stretcher frame on the wet paper. Now fold up the edges of the wet paper and tack or staple them to the rim of the wooden stretcher.

When the paper dries, it stretches as tight as a drum. As I said when I described the previous stretching method, the paper may swell a bit as you paint, but it should stretch fairly smooth when it dries. Naturally, when you paint on paper that's been attached to a wooden stretcher frame, you must be a bit more careful than usual; remember

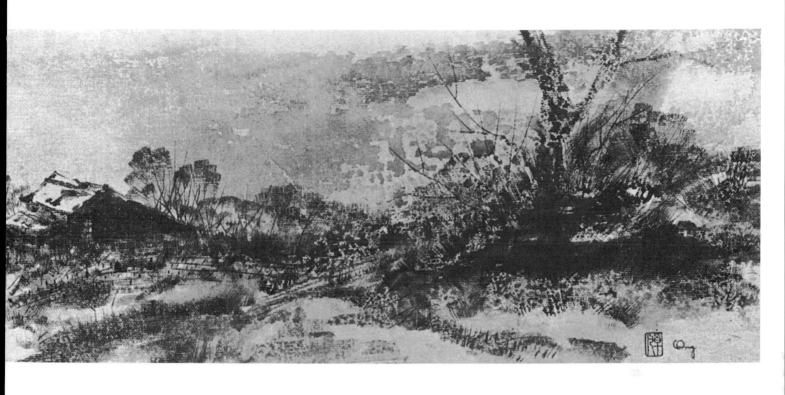

Winter *by Victor Ing, A.W.S., acrylic on canvas,
8½"x19¼". If the grain of the fabric is fine enough, canvas
can be a particularly effective painting surface for drybrush
effects. Only a very fine grained canvas is suitable because a
coarse fabric will overwhelm the strokes and impose its own
texture on the paint. Ing demonstrates the full range of
drybrush strokes, from hairline strokes placed side by side
in the foreground and in the distant trees, to much broader,
coarser strokes in the tree trunk and cluster of foliage in the
upper right. His washes tend to melt away into the weave of
the canvas and are enlivened by the many flecks of light
created by the fibers. Examine how the shadow side of the
house vibrates with these tiny points of light.*

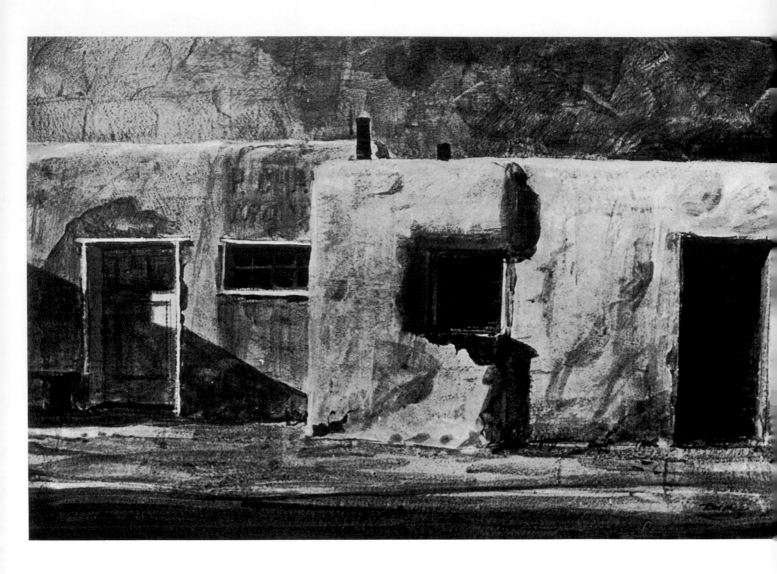

FLUID COLOR AND "DRY" COLOR

Adobe at Las Truchas, New Mexico *by Tom Hill, A.W.S., acrylic on gesso board, 14"x21". Thin, transparent strokes of color—well diluted with water—rest on the surface of the relatively nonabsorbent gesso board, settling into the texture of the gesso, but not really soaking in. Thus, the color takes on a granular, bubbly quality which is perfectly in keeping with the texture of the subject. The artist has also brushed on his liquid color in short, irregular strokes (rather than in continuous washes) which add to the rich textural effect. The only exception is the immediate foreground, where long, streaky strokes express the texture of the street. Even when applied very thinly, a stroke of acrylic watercolor retains its shape on a rigid gesso surface.*

Roslyn *by Seymour Pearlstein, acrylic on watercolor paper, 19"x19½". Here is a particularly free and interesting use of acrylic watercolor, ranging from very fluid passages at one moment to fairly dry, gummy passages nearby. The model's torso is rendered in very thin, transparent washes. Directly behind her is a wet-in-wet effect. To the viewer's right is a thick, scrubby passage of color that behaves almost like oil paint, retaining the impression of the bristles. To the viewer's left is a veil of color which has been made slightly smoky by a touch of opaque white. The whiteness of the bed is bare paper, in the tradition of transparent watercolor. The warm, bright color at her hip is thick color, hardly diluted, quickly blended with the brush. This apparently casual painting fully exploits the wide range of brushwork and paint consistency unique to acrylic.*

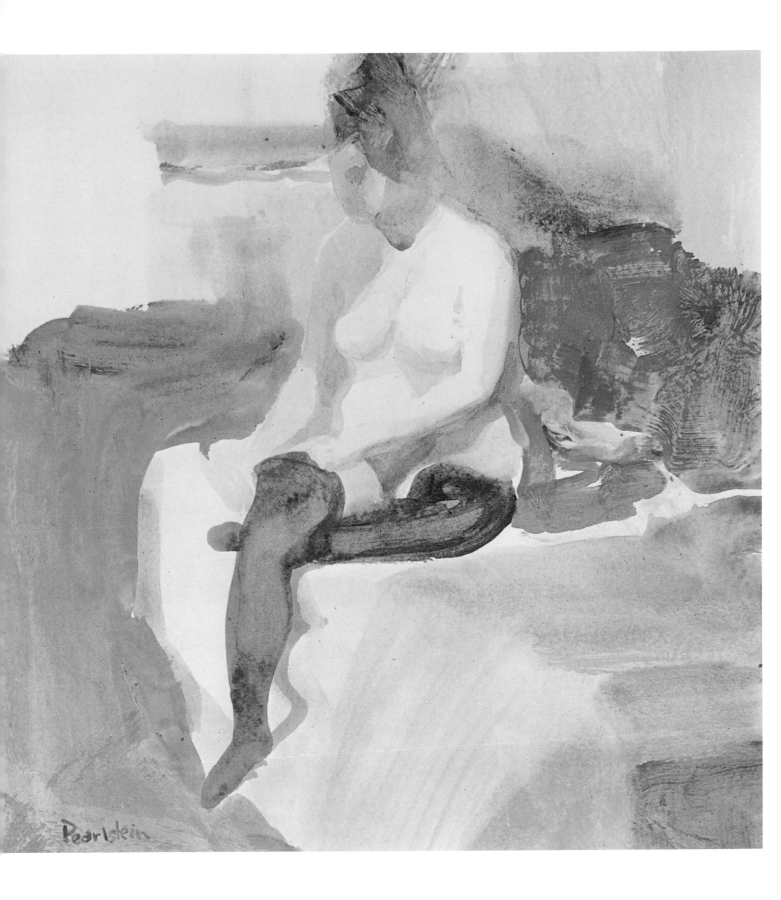

Pearlstein

29

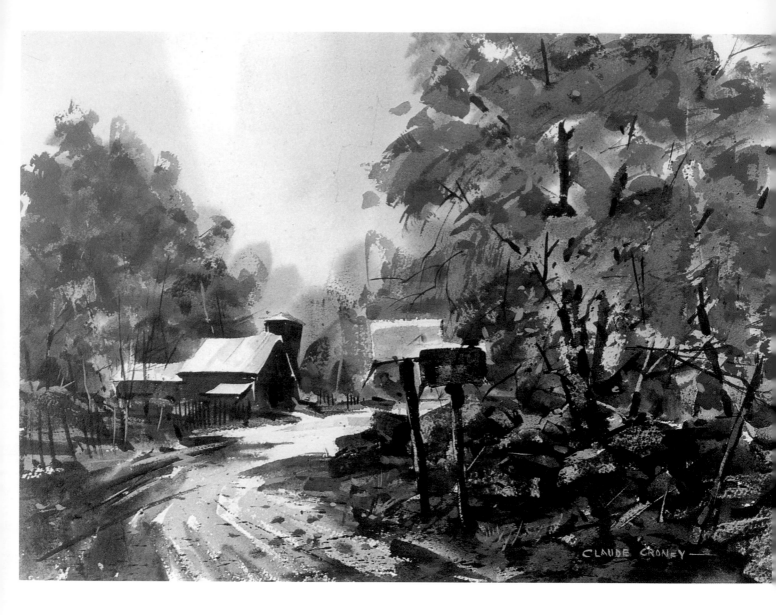

PAINTING WASH OVER WASH

New England R.F.D. *by Claude Croney, acrylic on 300 lb. watercolor paper, 15"x22". This vividly colored landscape seems indistinguishable, at first glance, from a traditional transparent watercolor. Yet acrylic lends itself particularly well to such effects as the complex, broken color of the autumn trees or the foreground stone wall. The trees are built up in a series of rough strokes piled over one another, and the rocks are handled in a similar way. These multiple overwashes are more likely to keep their luminosity and their purity of color in acrylic than in traditional water-color. As each stroke or wash dries, it becomes insoluble; thus, each color application retains its freshness no matter how much more paint is applied. Study the ragged, dry-brush strokes in the foreground trees and stones; applied thickly, straight from the tube, or thickened with acrylic medium, acrylic lends itself to especially rough drybrush textures. The wet-in-wet reflection of the barn at the end of the road is particularly effective, as is the warm reflection of the trees in the lower left.*

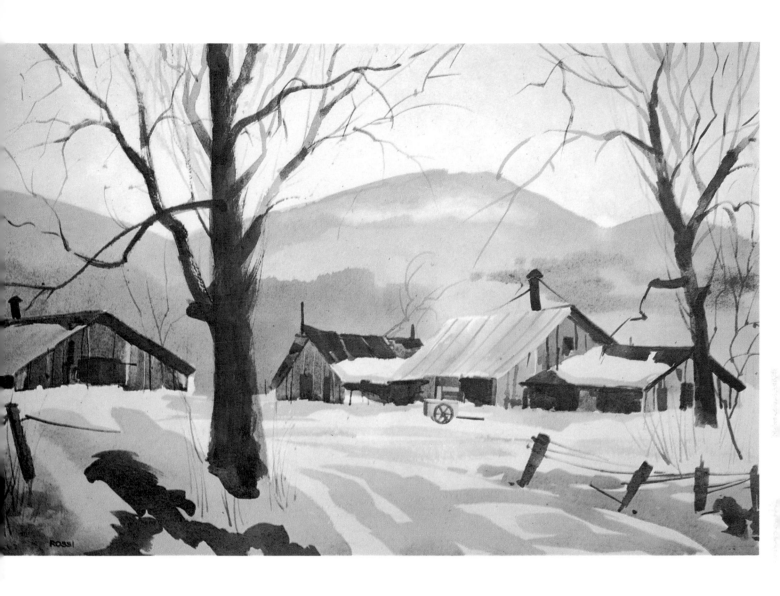

EXPLOITING BARE PAPER

Newburgh Winter *by Michael Rossi, A.W.S., acrylic on Arches watercolor paper, 15"x22". Painted with great economy of means, this acrylic watercolor is entirely transparent. The foreground snow is bare white paper and a few bold, deftly placed strokes of cool color indicate the shape of the snow. The distant mountains are an irregular wash of blue into which soft patches of warm color have been painted wet-in-wet at right and left. The only really heavy build-up of dark tone is the big tree left of center, which carries a hint of drybrush. The linear accents on the buildings were drawn with the tip of the brush or scratched away with some sharp instrument like the end of the brush handle.*

31

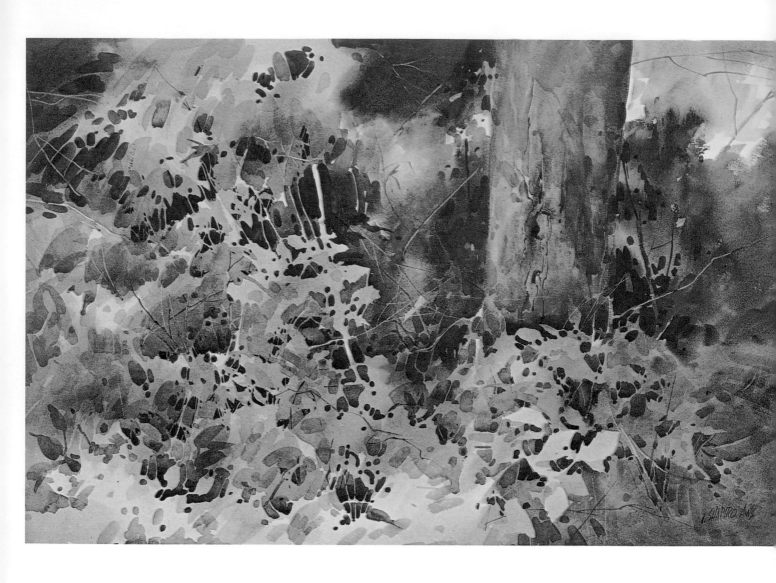

EMPHASIZING TRANSPARENCY

The Glade by Irving Shapiro, A.W.S., acrylic on watercolor paper, 19"x29". Despite the unique ability of acrylic to retain its translucency even when painted light over dark, the artist has chosen to paint this complex subject entirely in transparent color. The flickering tones and shapes of the forest growth are rendered almost completely in flat spots and dabs, one placed over another to achieve the full build-up of detail. Because each successive touch of the brush doesn't dissolve the underlying tone, every stroke retains its precise shape and color. The artist is able to add layer upon layer of strokes without any fear of his liquid color merging into a lifeless blur of muddy tones, which is always the risk with traditional watercolor. As the viewer's eye moves beyond the immediate foreground, the focus of the picture blurs, and the artist shifts to a wet-in-wet technique for the dark, distant forest beyond the single treetrunk. Dark, warm and cool tones fuse with unusual drama. Acrylic lends itself particularly well to vibrant darks, as we see in the background of the forest. And if the first application of dark color isn't dark enough, it's simple to let the passage dry, and then add another dark wash without fear of dissolving the first.

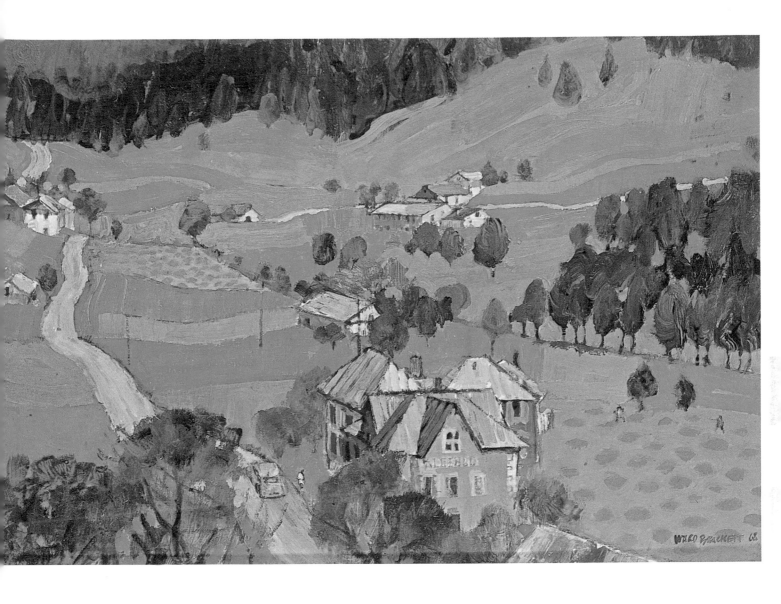

WORKING WITH VARIED BRUSHSTROKES

Val di Rizzo by Ward Brackett, acrylic on gesso board, 12-1/8" x 17-1/4". Opaque and semi-opaque acrylic color are usually most effective when applied flatly. Thus, this artist has handled his landscape as a fairly flat pattern of colored shapes, rendered with crisp, distinct brushstrokes. The flatness of the shapes is enlivened throughout by the casual, spontaneous quality of the strokes, which follow the direction of the landscape. Thus, the rolling hills in the distance are rendered in long, flowing, rhythmic strokes; the more geometric fields in the left foreground are rendered with short, straight strokes; even the slanting rooftops of the houses in the foreground are rendered with straight, diagonal strokes that follow the pitch of the planes. Although the color is thick, it's never entirely opaque, but the viewer always has a sense of inner light.

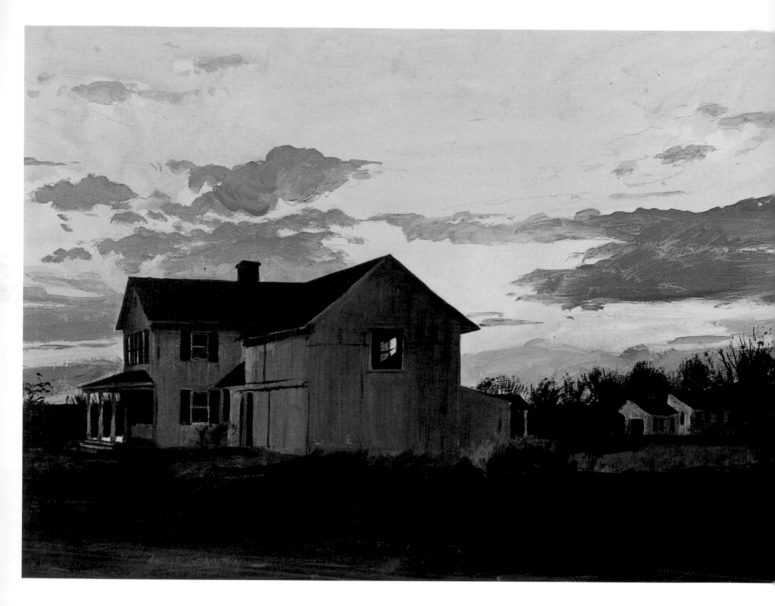

SCUMBLING SEMI-LIQUID COLOR

Evening Quiet *by Hardie Gramatky, N.A., A.W.S., acrylic on gesso, 16" x 22", collection Miss Helen Heinrich. One of the most effective ways to handle acrylic, particularly in a deep toned picture like this one, is with the rough, scrubbing stroke sometimes called scumbling. The clouds appear to be scrubbed in with semi-liquid color, rather than washed in with more fluid color. Thus, their shapes have a special vitality. The foreground darks are handled in the same way. And the scrubby texture of the paint really communicates the feeling of wood in the house itself. The distant trees are dry-brush, and the ruddy patch of ground is enlivened with dry-brush, too. Like so many successful acrylic watercolors, this painting combines transparent, semi-transparent, and semi-opaque color: the sky is a veil of transparent color; the clouds are heavier, but still allow the sky tone to come through; and the darker tones are heavier still, but are still translucent enough to allow the luminous gesso ground to come through. Nothing in the picture gives the feeling of complete opacity. Even the darkest tones are enlivened by an underlying glow of light.*

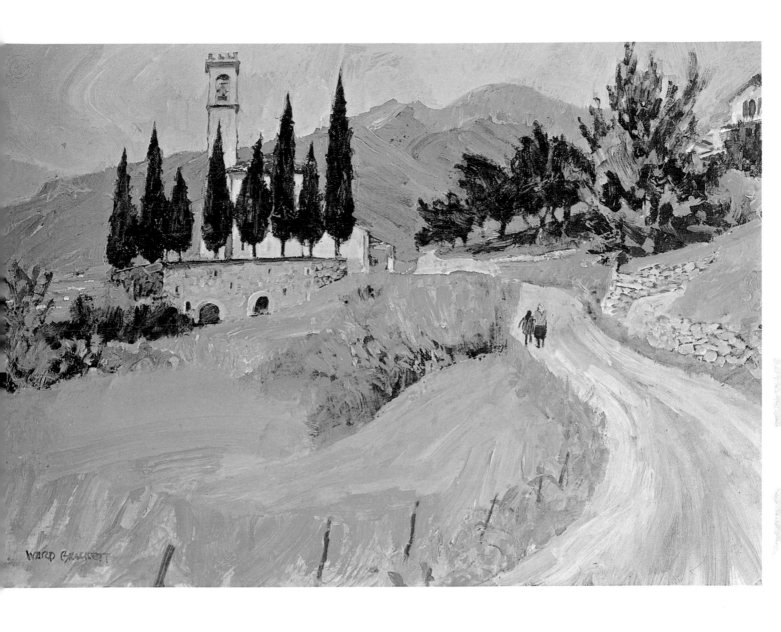

BROKEN COLOR

Tremosine *by Ward Brackett, acrylic on gesso board,
12⅛" x 17¼". Painted with the scrubby, scumbling stroke
which is so characteristic of opaque passages of acrylic, this
colorful Italian landscape reveals a great deal of luminosity
despite the thickness of the paint. The whiteness of the
gesso still shines through. Knowing that acrylic holds the
shape of the brushstroke with unusual precision, the artist
has planned the directions of his strokes to express the
shapes of the landscape. Notice how the strokes roll up the
side of the slope, swing around in the direction of the road
receding into the distance, become jagged to express the
shapes of the trees, and even suggest the direction of the
windblown, cloudy sky. The greens are a striking example
of broken color, in which a yellow underpainting constant-
ly breaks through the overlying greens and the two mix in
the eye of the viewer.*

35

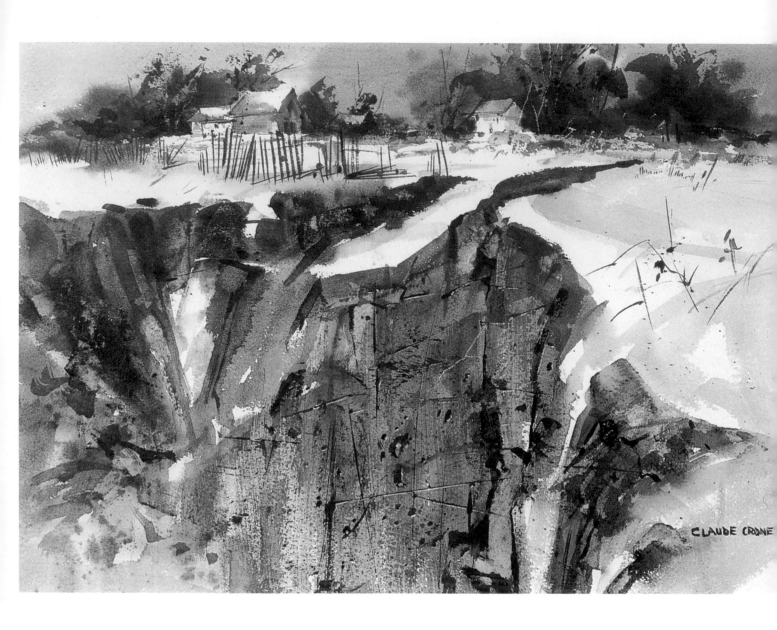

DRYBRUSH TECHNIQUE

The Quarry by Claude Croney, acrylic on 300 lb. watercolor paper, 15"x22". The wide range of textural possibilities in acrylic watercolor painting is evident here. The rocky foreground is an impressive combination of wet-in-wet, alternating warm and cool washes, drybrush, and scratching out. The rock formation began as multiple washes of delicate browns, grays, and blues. On this foundation, the artist has built a rich pattern of drybrush strokes, irregular flecks of color, and scratches with a sharp metal instrument. The trees and houses along the horizon combine wet-in-wet effects—where the trees merge with the sky—with touches of drybrush and occasional scratches to indicate light tree trunks.

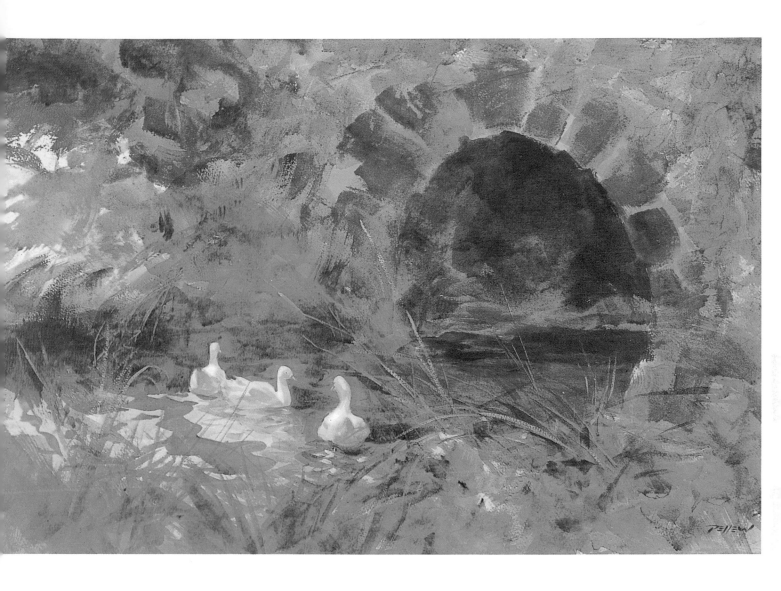

RENDERING COMPLEX TEXTURES

Mabel, Minnie, and Maud *by John C. Pellew, N.A., A.W.S., acrylic on 300 lb. cold pressed watercolor paper, 15"x20". This amazingly rich, lively color effect is particularly suited to acrylic. Study how large, rough strokes of warm and cool color are laid over one another to develop the complex texture of the stone bridge in the upper half of the painting. The color is handled in the same way in the foliage in the lower half of the painting. The artist has painted stroke upon stroke without any fear that the underlying color will dissolve and turn the fresh color to mud. On the contrary, the final effect is a ragged weave of glowing color which would be virtually impossible in traditional watercolor. Although there are some touches of semi-opaque color, these are lost in the overall feeling of transparency. Some of the foreground weeds are picked out with opaque color.*

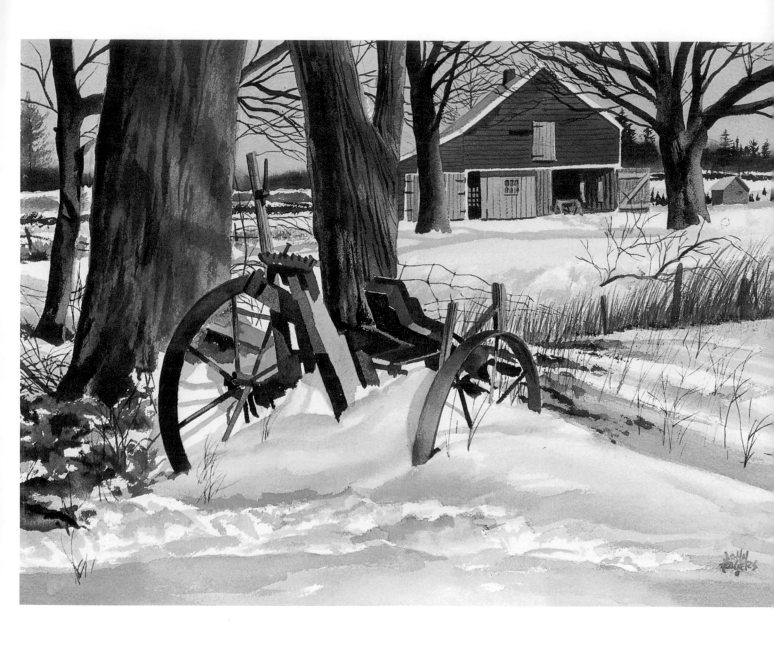

MODELING FORM WITH MULTIPLE WASHES

Early Winter *by John Rogers, A.W.S., acrylic on watercolor paper, 22"x28", collection Mr. and Mrs. G. R. Schreiber. Painted entirely in transparent color, an acrylic watercolor is indistinguishable from traditional transparent watercolor. The various treetrunks are interesting combinations of multiple washes, one laid over the other, to build up subtle warm and cool tones. Notice where the artist has used touches of drybrush for the rough texture of the bark. The blurred trees along the horizon are wet-in-wet. The snow in the foreground is carefully modeled in graded washes to give a three dimensional feeling, so that the drifting snow seems round and solid.*

WORKING WITH THICK COLOR

Fish and Copper Skillet *by Sergei Bongart, A.W.S., acrylic on gesso panel, 36"x48". Working with thick, opaque acrylic tube color, applied on a Masonite panel coated with acrylic gesso, the artist has created an effect similar to an oil painting. The paint is scrubbed on roughly, leaving behind the texture of the brush. The highlights are applied with impasto, while the background tones of the wall are semi-opaque, broken color effects. One color has been scrubbed over another, with each stroke allowing the underlying color to shine through. Even here, where acrylic is applied quite thickly, its inherent translucency is exploited so that the colors break through one another to produce a very elaborate range of tones.*

WORKING WITH A LIMITED PALETTE

Damian *by Seymour Pearlstein, acrylic on watercolor paper, 19"x24". Painted entirely in tones of blue and brown, this very subtle acrylic watercolor gives the impression of containing far more color than is really there. By blending various proportions of warm and cool color, the artist achieves an amazing range of tones. Note how the head is painted in overlying washes of warm and cool color, with just a touch of warmth for the hair. Although the color is applied in a very fluid manner, the stroke of the brush is retained throughout and enlivens every inch of the painting with the gesture of the artist's hand. Each swing of the brush retains its individuality.*

WORKING ON CANVAS-TEXTURED BOARD

Porto *by William Strosahl, A.W.S., acrylic on gesso board, 22"x28". The canvas-like texture of this picture comes from the painting surface, a type of wallboard that has a fabric texture stamped into it. The board was then coated with acrylic gesso which made the surface even more like canvas. The brush glides over such a surface very swiftly and leaves behind the exact texture of the stroke. Notice that the paint is scrubbed on very much like oil paint, but remains transparent or semi-transparent throughout. Optical color mixing is used frequently: that is, warm and cool tones are washed over one another, blending in the eye of the viewer, but never dissolving one another.*

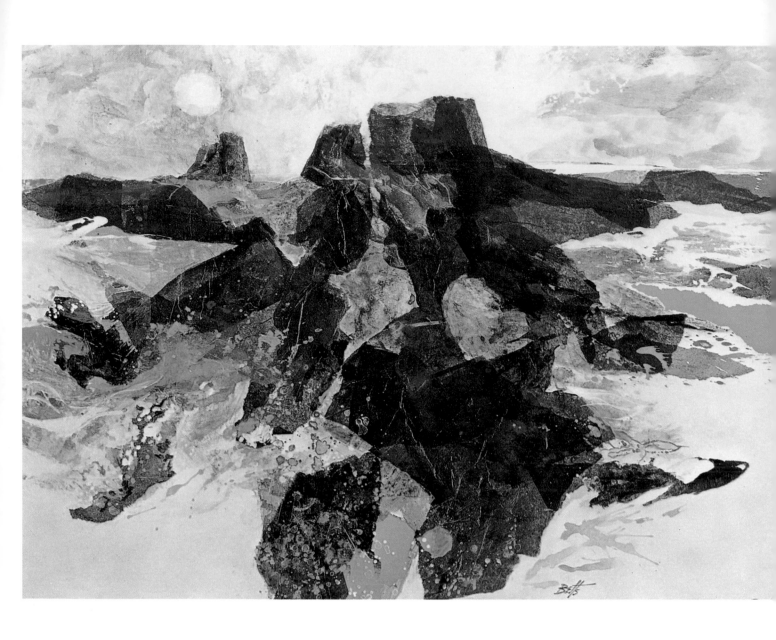

ACRYLIC MEDIUM FOR COLLAGE

Oarweed Cove *by Edward Betts, N.A., A.W.S., acrylic on illustration board, 20"x27", collection Mrs. Edward Betts. Acrylic color combines beautifully with collage elements, because acrylic medium—and the paint itself—have powerful adhesive qualities. This artist builds his pictorial textures with wrinkled layers of thin paper cemented to the painting surface. Fluid acrylic color is washed over and into the rough, wrinkled collage ground. Color isn't only brushed on, but spattered and dribbled on, as you can see in the left foreground. In the dark areas, there's a dense buildup of warm and cool tones, applied one over the other. This contrasts nicely with areas of bare painting surface in the foreground and the delicate, transparent sky. (Courtesy Midtown Galleries.)*

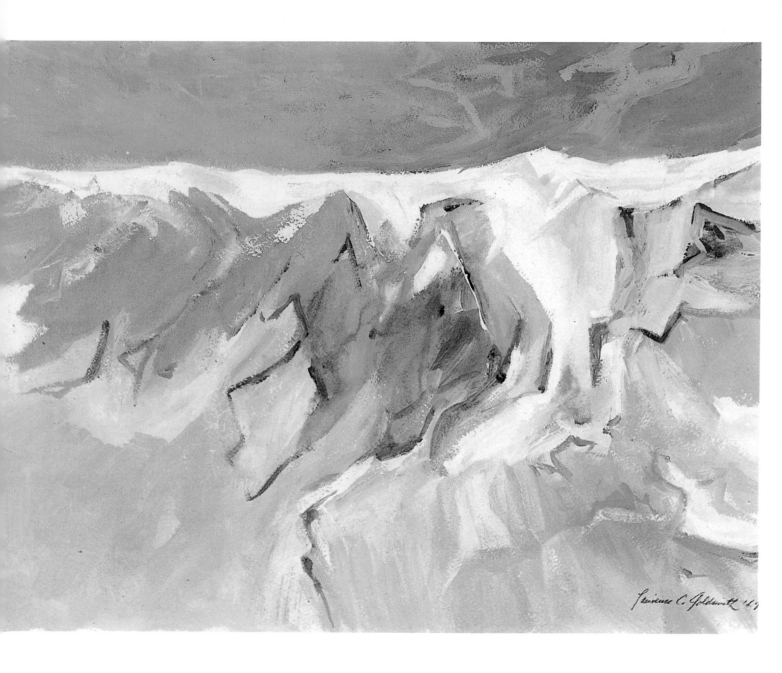

PAINTING WITH OPAQUE COLOR

Cascade by Lawrence C. Goldsmith, A.W.S., acrylic on watercolor paper, 18"x22". *Painted entirely in opaque and semi-opaque color, this acrylic watercolor retains far more luminosity than traditional opaque watercolor, which is often called* gouache *or* designers' colors. *Opaque acrylic never seems as chalky as opaque watercolor. The acrylic always seems to reflect a kind of inner light. The newer medium also permits a far richer buildup of color upon color, as in the glowing, cool tones of the sky, in which* strokes of many colors are painted into and over one another. The same passage in traditional opaque watercolor would be far less rich—and perhaps dangerous to try— because each new color application would run the risk of dissolving the underlying color, resulting in a muddy blend of both. Particularly interesting in the foreground is the range of warm and cool grays that can be produced by mixing blues and browns. These grays are far more lively than anything you can produce with black and white.

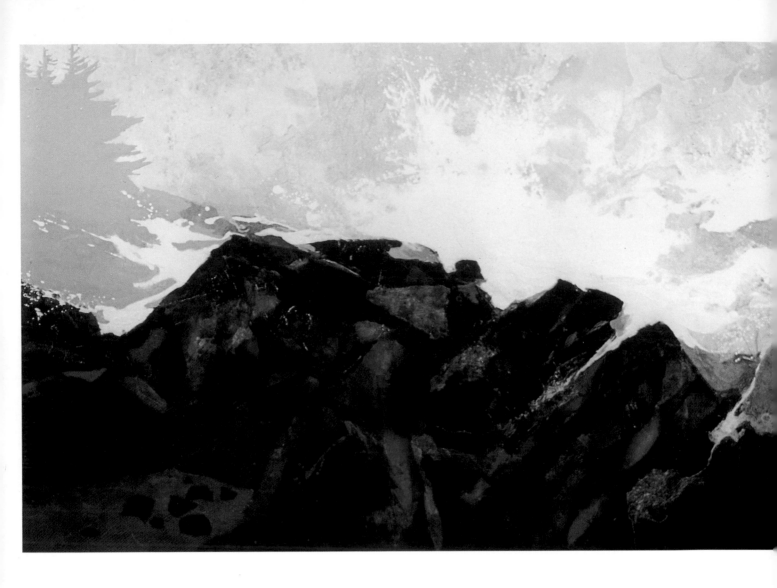

ACRYLIC WITH PAPER COLLAGE AND SAND

Coastal Storm *by Edward Betts, N.A., A.W.S., acrylic on Masonite panel, 30¼"x43¾". This powerful composition combines liquid acrylic color with heavily textured collage elements, as well as sand cemented to the painting surface. Despite the density of the foreground color, the paint retains its transparency. Warm and cool tones are washed over one another to build an effect surprisingly like stained glass. The rock formation, washed by the breaking waves, is glistening and transparent. (Courtesy Midtown Galleries.)*

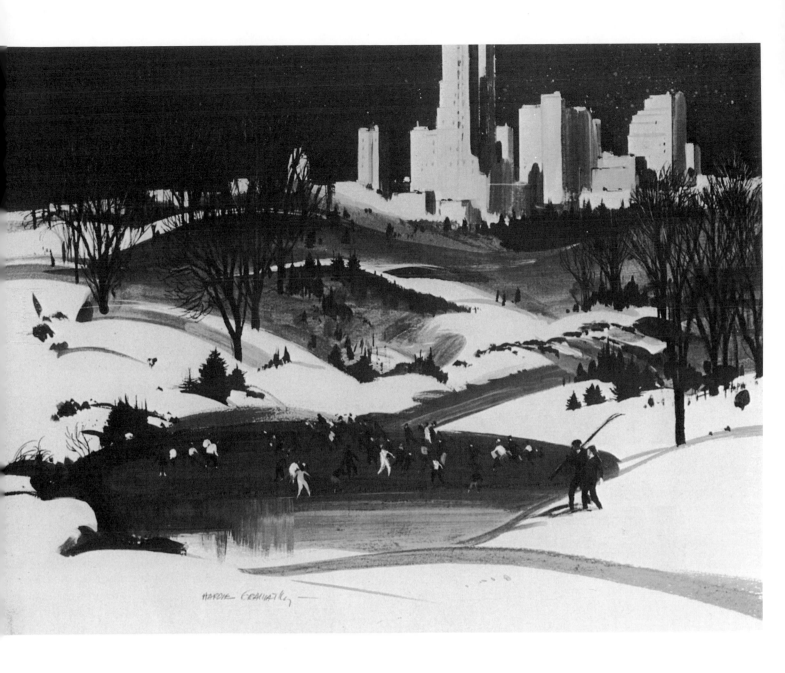

Skating, Central Park. *by Hardie Gramatky, N.A., A.W.S., acrylic on gesso board, 11" x 14", collection Mr. and Mrs. Cecil West. Retaining the white of the gesso board for the luminous color of the snow, the artist has applied broad, decisive strokes of transparent and semi-transparent color. Although the acrylic tube color has been diluted to a fluid consistency, it remains just a bit thicker than a wash of traditional watercolor and therefore retains the texture of the brushstroke in this painting. Gramatky uses this streaky texture to render the shiny reflections on the ice in the foreground and also to give texture to the shadows on the snow beyond. Liquid paint was spattered in the upper right hand corner to suggest the falling snow.*

that the paper isn't supported by a drawing board, so be sure not to poke the sheet with your finger, your elbow, or the brush handle, which might just puncture your painting surface. When the painting is dry, trim it away from the wooden stretcher strips with a razor blade or with a mat knife. As usual, you'll lose 1" of paper all around; yank out the staples or tacks along the edges and throw away the 1" strips of waste paper.

Having described stretching in such detail—for those who want to try it—I still think you should buy the heaviest sheet of watercolor paper you can afford and forget about stretching, unless you really *like* the character of the stretched sheet. For example, some painters like the "bounce" of watercolor paper on a wooden stretcher frame. But don't imagine that stretching will save you a great deal of money. If you invest in a 300 lb. sheet, remember that you have two sides to paint on, and that a coat of acrylic gesso quickly gives you a fresh painting surface on a sheet you may have spoiled. When you consider how many times you can use and reuse a heavy sheet, you may find that the heavier paper saves you money in the long run.

Japanese Papers

The larger art supply stores now stock a great many Japanese papers which are worth trying. They're often a good deal cheaper than European and American papers, but they're every bit as good in their own special way.

The Japanese papers were developed for a method of painting that relies on rapid brushstrokes, extreme spontaneity, sudden changes from a sopping wet brush to an almost dry brush, and liquid color that may be thick and gummy, or thinned with water to such an extent that there's only the faintest hint of color.

Japanese artists over the centuries have found that the ideal paper for such a technique is something like high grade blotting paper: soft and absorbent, yet tough enough to take vigorous brushstrokes. The absorbency means that the paper soaks up the paint as soon as your brush touches the surface; thus, the exact character of the stroke is held absolutely intact, as precisely as your fingerprint. The paint doesn't wander around on the surface of the paper, blurring into other wet strokes and washes and losing its individual shape. On the other hand, I hasten to point out that Japanese paper is *unlike* ordinary blotting paper in that the stroke doesn't spread and blur when it hits

the paper, but the paint stays *exactly* where you put it.

As I explained earlier, paper which is soft and absorbent makes corrections difficult. Hard as such corrections may be on one of the soft European papers, they're really *impossible* on Japanese papers. Because the liquid color soaks in instantly, there's no chance to change your mind once the brush hits the paper, and no way of getting the paint back out once the paper drinks it up.

This is why it's such good experience to work on Japanese paper. Every step is so final, so irrevocable, that you're forced to plan your attack with great care and not muddle around on the paper, brushing and rebrushing your color until it turns to melted mud. You're forced to be absolutely decisive and to develop the valuable habit of spontaneity—because the paper won't let you work any other way. The paper is a tough taskmaster: it won't let you hesitate, won't let you change your mind, won't let you patch up a mistake, won't let you get away with *anything*! Japanese paper trains you to think out each stroke carefully beforehand, then make a decisive attack.

Working on Japanese paper isn't only good training in decisiveness and spontaneity, but the surface also lends itself to a number of techniques particularly suited to acrylic watercolor painting. Japanese painters work with water soluble inks which can be varied greatly in consistency; the artist prepares the ink as he paints, pulverizing a dried stick of ink and adding varying amounts of water—sometimes producing ink as thick as syrup, sometimes producing ink which is thin and runny. It depends on the kind of stroke he wants to make. As you'll see later on, this is one of the great advantages of acrylic watercolor: you can vary the paint consistency to suit the requirements of different parts of a picture. And Japanese paper is designed specifically to absorb paint that's thick or thin or somewhere in between.

Japanese paper also has a very appealing, ragged surface. It has a fibrous, fuzzy quality that's particularly good for a quick drybrush stroke—if you don't go back over it—and which has a wonderful way of softening a stroke that's too harsh.

There are so many different kinds of Japanese paper, with so many different baffling names, that I won't try to review them all here. They're cheap enough for you to buy a sample of each one in the store and try them all out. You'll find that some are as thick as cardboard, while others are as thin as newsprint. The thin ones are tougher than you

think, and are often harder to tear than a thick European paper. Many of these papers are intended primarily for printing woodblocks, but they can turn out to be excellent watercolor papers too.

Even if you don't plan to work on Japanese papers—except as an experiment—you'll find them a rewarding experience and marvelous discipline, particularly if you tend to overwork a picture.

Fabric

I said earlier that acrylic watercolor will stick to a variety of surfaces that won't hold traditional watercolor. At certain times, the Chinese masters painted on fine grained beige silk. Although this works well with water soluble Chinese inks, it doesn't work nearly as well with *our* watercolors. However, the tenacious adhesive quality of acrylic emulsion will allow you to paint on a variety of fine grained fabrics. The trick is to thin your tube color not with plain water, but with a combination of water and acrylic emulsion, or with straight emulsion. I'll tell you more about how to do this in Chapter 5, on washes.

What fabrics might be suitable? I don't really think you have to start with silk, which is a pretty expensive material for experimental painting. But I've tried unbleached muslin, which has a very attractive off-white tone. I've tried scraps of smooth cotton, left over from my wife's sewing projects. I've had interesting results on scraps of smooth canvas left over from oil painting—raw canvas, that is, not the kind you buy in the art supply store, coated with white oil paint—and I've had good luck with the kind of canvas panels sold for oil painting, which generally have quite smooth surfaces and a white coating which will hold washes of acrylic paint. The kind of canvas to avoid, of course, is the stuff that comes ready-prepared with an oily white coat that's meant specifically for oil painting; the one surface that acrylic *won't* stick to is anything that's oily.

The behavior of a fabric will be greatly improved if you prime it with acrylic gesso. Read on.

Acrylic Gesso

Over the centuries, artists have discovered that paintings in practically every medium are strengthened if the artist begins on a luminous white painting surface. Even if the artist decides to tone this white surface, a kind of inner light seems to shine through and adds luminosity to his colors. Thus, the time-tested ground for an oil painting is a layer or two of white lead oil based paint. For panel paintings in oil or tempera, the traditional ground is gesso, which is basically a mixture of animal hide glue and a chalky pigment called whiting.

To provide a suitable ground for acrylic paints, the manufacturers have developed a product which is called acrylic gesso. This is simply a thick mixture of acrylic emulsion, a dense white pigment, and some inert chalky ingredients to lend body. The principle is essentially the same as the gesso of the old masters, but the animal hide glue is replaced by the more tenacious, more flexible acrylic emulsion.

Acrylic gesso will stick to almost anything suitable for painting. For example, if you find a fabric that has a texture that you like, you can easily convert this fabric to a painting surface with one or two coats of acrylic gesso. If you find a slightly rough piece of wood with an intriguing texture which you don't want to smooth down, even this will convert to a painting surface with acrylic gesso.

For many painters the best news about acrylic gesso is that it can rescue an expensive piece of paper which you've spoiled with an unsuccessful painting. At the beginning of this book I warned you not to throw out a spoiled painting. Naturally, if the picture is on a sturdy piece of paper, you should try first to rescue the sheet by painting another picture on the back of the spoiled one. But if you've spoiled *both* sides, a coat of acrylic gesso will turn that paint-covered sheet into a fresh, white surface so you can start again. Here are some suggestions for applying acrylic gesso.

Applying Gesso on Fabric

Acrylic gesso comes in a can or a jar. Some brands are thicker than others. That is, some have the consistency of thick cream, while others are more like pancake batter. Try a couple of brands and see which you prefer.

If you'd like to try painting an acrylic watercolor on the kind of linen canvas used for oil painting, buy the raw brownish canvas in an art supply store, and nail or staple the fabric to a wooden stretcher frame just like that used for an oil painting. Scoop the gesso—preferably the thicker kind, but the thinner kind will do—out of the can or jar with an old soup spoon, and spread the thick white paint over the canvas with a big putty knife. Press the gesso into the fibers and scrape away any ridges of paint as the blade moves

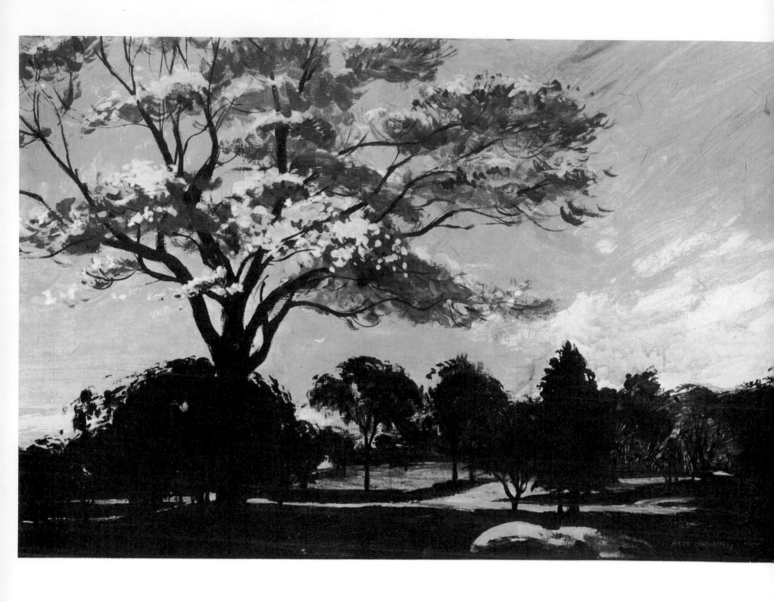

Dogwood in Park *by Hardie Gramatky, N.A., A.W.S.,*
acrylic on gesso board, 12¼" x 18½", collection Miss Helen
Heinrich. Applying his liquid color in fluid, scrubby strokes
—thin enough to remain translucent, but slightly thicker
than traditional watercolor—Gramatky has chosen a
scumbling stroke for the texture of the trees. A thinner,
streakier version of this stroke is used for the sky. Because
this type of stroke retains the impression of the bristles, the
entire surface of the painting communicates a sense of
vibrant action. You can feel the movement of the leaves
and branches, the direction of the clouds and wind.

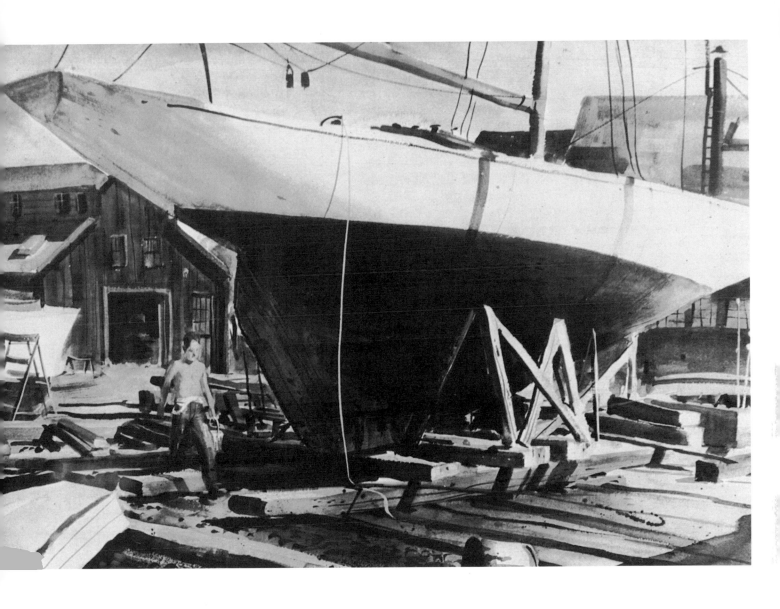

The Red Hull *by William A. Hanley, A.W.S., acrylic on watercolor paper, 21"x29", collection Thomas Bill. The rounded form of the boat is rendered in a series of graded washes, and the shadow beneath the boat is a less obtrusive graded wash that moves from semi-dark in the foreground to light at the rear. A dark graded wash, like the one on the lower portion of the hull, is always difficult. This one is even more difficult because it's light at both ends and dark in the middle. This job is vastly easier in acrylic than in traditional watercolor because you can build your gradations in a series of light washes, one over the other, until you get the variety of tone you want.*

49

along. The putty knife is better than a brush because the flexible metal blade leaves the weave of the canvas intact, while the brush is apt to leave strokes that introduce their own texture. Two thin coats of gesso are always better than one thick one. One thick coat is more likely to cover up the grain of the fabric. And if you're going to cover up the grain, why work on fabric in the first place?

Particularly if you're working on a fabric that's thinner than canvas—muslin, let's say—you may not want to stretch the fabric on wooden stretcher bars, since the stretched fabric will be too bouncy to work on comfortably. You *could* simply tack the fabric down to a sheet of board, apply the gesso, and then start painting as soon as the gesso dries. But acrylic emulsion is such strong stuff that it's inclined to penetrate the fabric and glue it to the board! So it's better to stretch a thin fabric on wooden canvas stretchers, apply the gesso, let it dry, then remove the fabric from the stretchers and tack it to the drawing board for painting.

An even better solution is to glue the fabric—before the gesso is applied—to a board and then apply the gesso. This gives you a really durable fabric covered panel which can take painting, repainting, and lots of punishment. If your first painting on the panel doesn't go well, you can simply apply another coat of gesso and start again.

Buy a sheet of ¼" untempered Masonite at the lumber yard and cut it to the size you want; you can buy thinner Masonite, but the thicker kind is less likely to warp when the fabric shrinks and begins to pull. Make sure that the fabric is an inch bigger all around than the Masonite panel. Place the fabric face down on a sheet of newspaper, and brush a thick coat of acrylic medium on the back of the fabric, as well as on the panel. Then press the panel down onto the fabric, flip the panel over with the fabric side up, and rub the fabric down with the palm of your hand until it adheres smoothly without any bubbles or puckers. The emulsion will penetrate the fabric, dampen it, and the fabric should shrink tight as it dries. You can then trim off the excess fabric with a razor blade.

Another method is to cut the fabric a good 2" bigger all around than the panel. You dampen the fabric, apply a coat of acrylic medium right out to the edges, center the panel on the glue coated side of the fabric, and fold the excess fabric back onto the rear of the panel. This means that the excess fabric isn't cut off, but sticks to the back of the panel. As the fabric dries and shrinks, the 2" of extra fabric on the back of the panel, firmly glued down, will hold tight and strengthen the bond.

Remember that you're gluing the fabric to the panel *before* you apply the gesso. After the fabric is glued down and bone dry, you apply the gesso. If the fabric is rough, apply the gesso thinly with a putty knife and scrape off any excess that sticks up. If the fabric is smooth, thin the gesso with water, and brush it on in a series of thin coats, so it sinks in and doesn't obliterate the grain.

A word of caution about fabrics: They're unpredictable. Some shrink more than others. Some contain stiffeners that affect their behavior in all sorts of odd ways. If you're going to invest the time and labor in making a bunch of fabric coated panels, it pays to do some testing in advance. Cut off a small piece of the fabric, wash it, see how much it shrinks on drying, and see if its character changes or if any stiffener gets washed out in the process. As double insurance, it's even worth the time to take a small rectangle of fabric and glue it onto a small panel to see how the cloth behaves.

As a general rule, I'd be inclined to give *all* fabrics a gesso coating. Good watercolor papers are manufactured to retain their color even on long exposure to light. But raw or undyed fabrics can't be trusted to do the same. That glowing white fabric may begin to turn yellow, and that delicate, unbleached beige may eventually turn brown—like too many Chinese paintings on silk. Unless you're willing to take your chances on the color stability of a fabric, better use gesso.

Applying Gesso on Panels

The panel material that's now universally recommended for oil, tempera, and acrylic painting is untempered Masonite. (The tempered kind looks more appealing because it's got a harder surface; but it contains a waxy material which may threaten the adhesion of your paint.) Some varieties have one smooth side and one rough side with an ugly, regular pattern. But I've also seen some varieties with one smooth side and an equally attractive rough side, which has a pleasantly irregular, fibrous quality. If you can get the second kind, you have the advantage of two sides to paint on. Otherwise, stick to the smooth side.

Gesso panels were originally developed for tempera painting and the ideal was an ivory smooth surface. When oil painters work on gesso panels, they generally prefer a smooth surface too. But watercolor washes—and acrylic watercolor washes— are hard to control on a smooth surface. So if you

work on the smooth side of a Masonite panel, begin by roughening it with coarse sandpaper. Sand the surface until it's fuzzy. Then apply two or three coats of very thin gesso, which will stiffen the fuzz, and preserve it, rather than cover it. Apply the coats at right angles to one another: that is, the first coat should be stroked from right to left, while the second coat should be stroked from top to bottom. Naturally, if you can find the kind of Masonite that has a rough, fibrous side—but not a patterned side—you won't have to do any sanding. Just apply several coats of thin gesso.

You can also create an attractive canvas-like surface on a Masonite panel by the way you apply the gesso. If you apply the gesso straight from the can—don't add any water—the bristles will leave delicate grooves in the white surface when it dries. Carefully brush your first gesso coat from top to bottom, watching to make sure that the grooves remain in the brushstrokes. When the first coat is dry, apply the second coat with all your strokes running from right to left. This will suggest the crisscross of a woven fabric, which can be very pleasant to paint on.

The whole idea of roughening the surface of the panel or creating a canvas-like texture is to preserve or create an irregular surface. Oil or tempera will cling to a smooth surface, but thin washes of color need a rougher surface to grip the liquid paint and to keep it from running where you don't want it to go. Washes of acrylic *will* stick to a smooth surface if the color is modified with lots of medium, but this restricts you to working with fairly gummy paint. If you want to experiment with a smooth surface, it's better to try smooth watercolor paper, which is more absorbent than acrylic gesso and will hold the paint better than a polished gesso surface. For acrylic watercolor painting, a gesso panel should always be faintly rough.

You can also use a sheet of illustration board for a gesso panel; this sort of board isn't necessarily cheaper than Masonite, but it's obviously more convenient because cardboard weighs a lot less. To give the smooth board a texture which will be more receptive to washes of acrylic watercolor, apply your gesso by the same crisscross method that I recommended a few moments ago. You'll notice that the board begins to curl when you put your first coat of gesso on one side. As soon as that coat is dry to the touch, flip the board over and apply another coat to the back. That will start the board warping in the opposite direction, and the equal pull on both sides will flatten the board out.

In the same way, when you apply your second coat to the first side, you must apply a second coat to the back. To keep the pull on both sides equal, each side should get the same number of coats. This also gives you a two sided panel to paint on if your first painting doesn't succeed.

Applying Gesso on Paper

It's pointless to paint a coat of gesso on a fresh, new sheet of watercolor paper, but gesso can give a new life to an unsuccessful painting. However, only a fairly heavy sheet will respond well to gesso. A thin sheet is likely to buckle when the gesso is applied, and may never quite regain its shape. But a 200 lb. or 300 lb. sheet is stiff enough to retain its shape even when several coats of gesso are brushed on. In a roundabout way, this makes the more expensive, heavier sheets of watercolor paper an economy measure, as I've already said. With the aid of acrylic gesso, you can reuse the heavier sheets, not just once, but several times if necessary. Although there's a limit to how many coats of gesso you can apply before the gesso gets thicker than the paper, you can probably paint out a couple of unsuccessful pictures on both sides—if you don't apply the gesso too thickly—before the texture of the paper begins to disappear under the gesso. At that point, the paper begins to lose the character of paper and to feel more like a panel. But you can reuse it even then.

There are two ways to apply gesso to paper, depending on the sort of surface you want.

Simply tack down the sheet at the corners just as you would when you're starting to paint. If you want to retain the original texture of the sheet, apply several very thin coats of gesso. Don't use it just as it comes from the can, but thin it with water, and work with a large, soft hair brush that leaves no bristle marks in the paint. Let each coat dry thoroughly before you apply the next. Because it's well thinned with water, the gesso will lightly coat the paper and won't fill in the peaks and valleys.

When you've painted out and painted in several pictures on both sides of the sheet, you *will* find that the original texture has been lost. At that point, I suppose that you could toss out the sheet if you absolutely insist on retaining the original texture. However, you can now create a new and different painting surface if you wish. Using thicker gesso and a stiffer brush, you can crisscross your strokes to produce the canvas-like surface I

recommended when I talked about Masonite panels. Once again, remember that the first coat should run at right angles to the second coat. That is, one coat should run from top to bottom, while the other coat should run from right to left. This crisscross texture will blend in a very subtle way with what's left of the texture of the paper, giving you a surface which is even more like canvas than the surface of the Masonite panel.

Although I've said that acrylic gesso will give you a fresh painting surface on a spoiled sheet of paper, you'll discover that a gesso coated sheet does behave differently from a bare sheet of watercolor paper. The most important difference is that the gesso coating isn't as absorbent as the bare fibers of the paper. The liquid paint is more inclined to rest on the surface of the paper, rather than sink in. You must keep a careful eye on your washes to make sure that they don't run away with themselves. On the other hand, the tougher, less absorbent surface, sealed off and hardened by the gesso, gives you much more freedom to wipe out and make corrections while the paint is still wet.

Tinted Painting Surfaces

Chapter 5 will tell you how to lay a flat, transparent wash of color on a white sheet of paper. Because acrylic paints dry waterproof, this is the simplest way to convert a white sheet into a tinted sheet. And because the wash is transparent, the luminous white of the sheet will shine through and continue to lend luminosity to your colors.

You can also tint a sheet of fabric, a gesso panel, or a reconditioned sheet of spoiled paper. Just add a few drops of tube color to the gesso. A faint touch of phthalocyanine blue and somewhat more burnt umber or burnt sienna will give you a beautiful range of cool or warm grays, depending on the ratio of cool and warm colors in the mixture. If you add only a speck of blue, letting the burnt umber or burnt sienna predominate, you'll get beautiful gray-browns. If the blue dominates the brown, you'll get delicate, smoky gray-blues, with the brown cutting the intensity of the blue just enough to eliminate that cloying baby blue feeling. A touch of yellow ochre will add a hint of gold to the mixture; or mixed with the gesso all by itself, yellow ochre will give the surface a feeling of delicate sunshine.

You'll think of plenty of other combinations.

But keep your tints pale and stay away from saturated colors. You don't want to lose the luminosity of the painting surface. Nor do you want the tinted surface to swallow up the colors you put over it. This is why a dusty yellow like yellow ochre is better than a vivid yellow like cadmium. For the same reason, avoid bright pinks, greens and violets, and when you use a vivid blue like phthalocyanine, be sure to add it a speck at a time; this color is so powerful that a little goes a long way.

Preparing Textured Surfaces

You may not only want to alter the color of your painting surface, but also its texture. Acrylic gesso lets you do this with ease.

Let's take something simple. Painters sometimes wish they had a gritty surface something like sandpaper. To prepare this type of surface, just collect some clean sand from a beach or from your building supplier, paint a coat of fairly thick gesso on a Masonite panel, and then sprinkle the sand on the gesso while it's wet. When the gesso dries, a fair amount of sand will stick. Dust off the grains that don't stick. Then paint a second coat of gesso over the sand which has stuck to the first coat. This restores the whiteness of the surface and assures you that your paint will stick.

An important trick in getting an evenly textured surface is to dump on more sand than you think you'll need. It doesn't hurt to cover the entire coat of wet gesso with a layer of solid sand; you can then dump nearly all of it into your children's sandbox and only a very thin layer of sand will stick to the gesso. This is the way to be sure that there won't be any gaps in the sandy surface.

You can use the same technique with almost any granular substance. The early cubists liked to texture a surface with coffee grounds. I've often thought of doing it with oatmeal. Sawdust would work too.

If you're texturing a large panel, don't cover the entire surface with gesso and then start sprinkling the sand. By the time you start throwing on the sand, a lot of the gesso will be dry. It's easier to apply the gesso to an area about a foot square and *then* sprinkle on the sand. Then go on to an adjacent area and do the same thing. When the entire surface has received its first coat of acrylic gesso and its coat of sand, you can give the whole area its final coat of gesso.

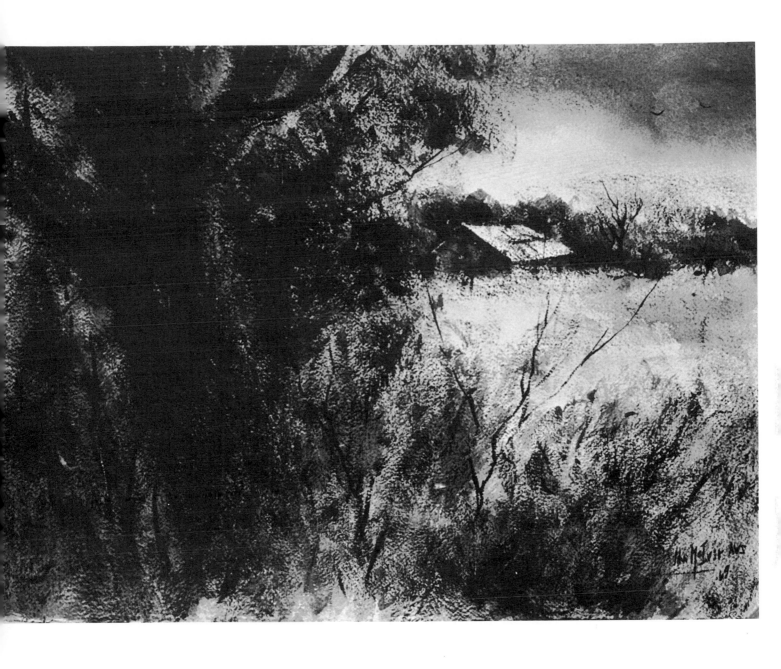

Wood's Edge *by John McIver, A.W.S., acrylic on 300 lb. rough Arches watercolor paper, 22"x30". This extremely bold use of drybrush exploits the coarse texture of rough watercolor paper. For such effects, handmade paper is distinctly superior to machine-made paper. The heaviest drybrush effects can be achieved with tube color blended with gel medium and just a touch of water. Although, at first glance, the picture seems to be entirely drybrush, the artist has delicately enriched the drybrush tones with washes that move in behind the strokes and integrate the dark and light pattern. (Courtesy Risley's Gallery, Evansville, Indiana.)*

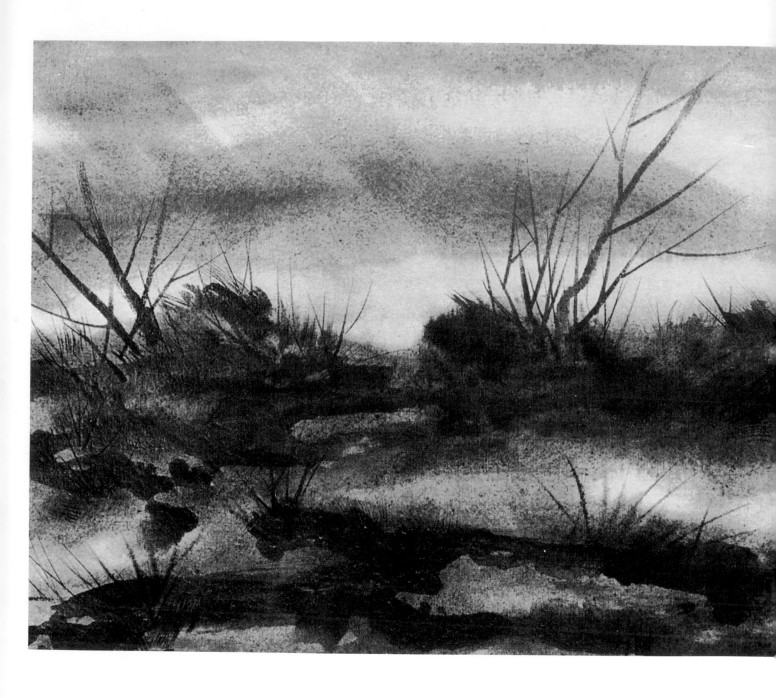

Winter Trees by Victor Ing, A.W.S., acrylic on canvas, 19"x24". Although canvas is an unlikely surface for traditional transparent watercolor, this material can be very receptive to acrylic watercolor. A fine grained canvas, primed with several thin layers of gesso, can be useful for the type of wet-in-wet painting shown here. The liquid color settles into the fibers of the canvas and takes on the delicate texture of the cloth. It's often easier to control the random, unpredictable spread of a wet-in-wet wash on canvas than on paper. It's also easier to wipe away lights and areas that need correcting. In this wet-in-wet painting, the artist has established the general distribution of lights and darks wet-in-wet, then added sharper details, like branches and other growth, when the surface is semi-dry or completely dry. The distant trees are painted on a dry surface, while the foreground growth is stroked into a semi-dry surface and allowed to blur very slightly, but not enough to swallow up the stroke.

4.
Colors
and
Mediums

When you paint in traditional watercolor, the only medium that you normally add to your color is plain water. Periodically some manufacturer introduces a gel or a paste which can be added to watercolor to alter the brushing consistency of the fluid paint. Occasionally, watercolorists experiment with tricks like adding starch to produce a pastier paint. But such things rarely catch on, and most painters in traditional watercolor stick to a simple mixture of tube color and water.

You can do the same if you paint your watercolors in acrylic; mixed with plain water, acrylic paints behave more or less like traditional watercolor, with the additional advantage that the paint dries waterproof. But you'll miss the full potential of the medium if you don't try the various additives that make acrylic the most versatile watercolor medium devised by man. These additives aren't merely gimmicks, introduced to inflate the manufacturer's profits. They give you unprecedented control over the brushing qualities of your paint, luminosity of color, drying time, and surface finish.

Gloss Medium

When I described how acrylic paint was made, I explained that the liquid adhesive—the glue that binds the dry color to the painting surface—is a milky plastic emulsion that dries water clear. This emulsion is sold by the bottle. If you brush the pure emulsion, straight from the bottle, on a bit of paper, you'll see that this *acrylic medium* dries to an absolutely colorless, glossy finish. As soon as the water in the emulsion evaporates, the microscopic particles of plastic form a tough, durable skin which will no longer dissolve in water.

Now, if you add this milky medium to a blob of tube color instead of adding water, you get a new kind of watercolor. The pasty tube paint dissolves in the medium to form a thick fluid that's roughly the consistency of maple syrup. For the moment the paint looks a bit milky—not completely transparent—because the medium has a faintly whitish tone when wet. But when this paint dries, it's every bit as transparent as the purest watercolor wash. Yet the color has a new luminosity, an inner light like a varnished oil painting.

The brushing quality of this fascinating mixture is a bit like oil paint too. It's thin enough to be applied with a soft sable brush in a smooth, regular

coat. But it's just thick enough to be applied with a stiffer bristle brush, which makes a distinct stroke and leaves the marks of its bristles. Thus, you have the choice of smooth or textured color.

If you've painted in traditional watercolor, you've probably learned, by bitter experience, that it's unwise to go back and try to push around a wet passage once it's begun to settle into the paper. But acrylic medium thickens your paint just enough to give you that vital extra time to rebrush a wet passage and get it right before it dries. The paint still dries quickly, but it remains viscous just a moment longer.

However, you'll probably find that mixing tube paints with *pure* acrylic medium makes the paint a bit too thick for most purposes. You'll find such paint perfect for strong accents and big, rugged strokes—like tree trunks, for instance—but you'll want somewhat thinner paint most of the time. The trick will be to thin your paint first with water, then add a brushful of medium to get the consistency exactly right. I keep a paper drinking cup filled with acrylic medium right next to the quart jar of water that I use to thin my paint. In this way, I can add the necessary brushfuls of water and medium to make my paint thinner or thicker, as I see fit.

Matt Medium

Traditionally, a painting in watercolor has a matt (non-glossy) surface. Most watercolorists will rebel at the very idea of adding a glossy medium to a watercolor wash, which then comes out looking something like a glaze in an oil painting. Fortunately, acrylic medium comes in two forms: the gloss medium, which I've just described, and matt medium, which dries to the non-glossy finish which most watercolorists actually prefer.

The chemical composition and behavior of matt acrylic medium are essentially the same as those of gloss medium, with just one difference: the matt medium contains an inert substance that takes the shine out of the paint. When wet, matt medium looks just as milky as gloss medium, but it dries clear as glass, without any hint that a medium of some kind has been added to your paint. Drying time and brushing qualities are the same for both matt and gloss mediums, which have exactly the same consistency and exactly the same effect on the behavior of your paint. In fact, when they're in liquid form, it's virtually impossible to tell the difference between matt and gloss medium; the difference shows up only when they dry.

Whether you prefer matt or gloss medium is purely a matter of taste. Gloss medium does seem to add luminosity to your colors, much as a layer of varnish gives a bit more glow to an oil painting. On the other hand, much of the charm of traditional watercolor lies in subtle color and atmospheric delicacy, for which a matt surface may seem more appropriate. The choice is up to you.

Gel Medium

Acrylic medium comes in a third form, called gel. This is thick, pasty stuff which comes in a tube like paint. When squeezed from the tube, it has the same cloudy, milky look as the matt and gloss mediums when they're still wet in the bottle. But gel medium, too, dries clear.

Gel was developed primarily for painters who want to use acrylic like oil paint. Mixed with tube color, gel keeps the paint stiff and buttery for so-called impasto painting, which generally means a heavy buildup of color, with lots of rough brushstrokes and knife strokes.

Watercolorists, of course, generally deal in thin layers of liquid color. Thus, impasto painting seems to be at odds with the essential nature of watercolor. If you're using acrylic as a watercolor medium, I don't think it's likely that you'll want to pile on big gobs of color thickened with gel medium. On the other hand, there *are* some ways in which gel medium can be used to extend the range of watercolor techniques without turning your picture into a gummy pile of paint.

Every watercolorist does have certain moments when he wishes that he had just one or two brushfuls of really thick paint for a passage that needs more than usual texture. I've often felt this when I tried to render a particularly craggy rock formation or a particularly rugged tree stump in the foreground. If you don't overdo it, gel medium is just what you need for these rare moments. Just one dab of gel medium, added to some paint straight from the tube, undiluted with water, and applied with a really stiff bristle brush, and you have a brushful of paint quite unlike anything you can get in traditional watercolor. Yet gel dries absolutely transparent and this transparency will harmonize with the more fluid passages in the rest of the painting.

But I repeat: don't get carried away with the

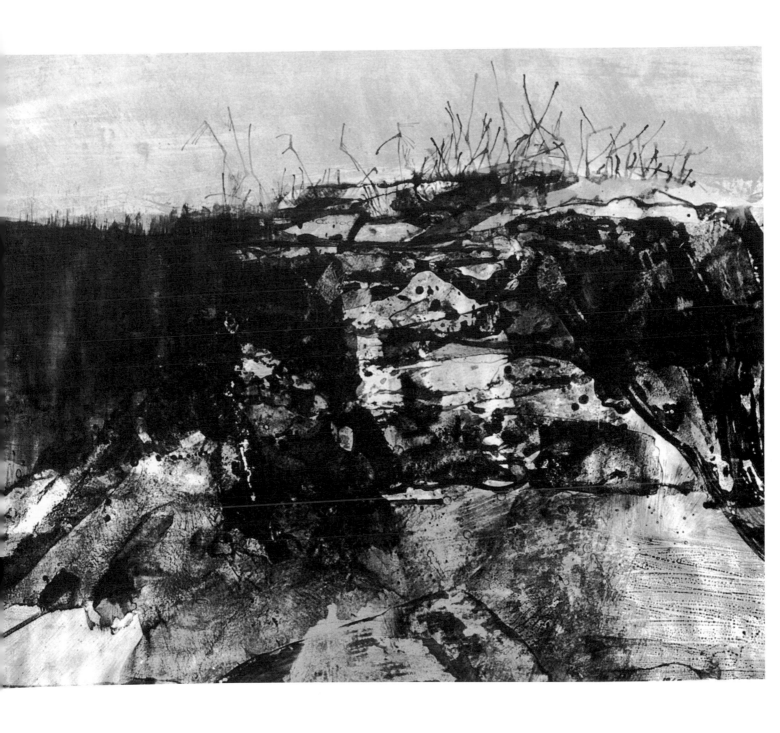

Drought *by Gene Matthews, acrylic, watercolor, and dry pigment on foil paper, 18"x24". Because acrylic paint and medium will adhere tenaciously to almost any kind of paper, Matthews has chosen a metallic surfaced paper for his lively landscape study. In the lower right hand corner, you'll see how the liquid color has formed streaks and beads on the nonabsorbent surface, and this accounts for the fascinating, blotchy, speckled quality of the painting as a whole. It's worth noting that dry pigment can be mixed with pure acrylic medium to make your own paint, or the pigment can be sprinkled on a wet layer of medium previously applied to the painting surface.*

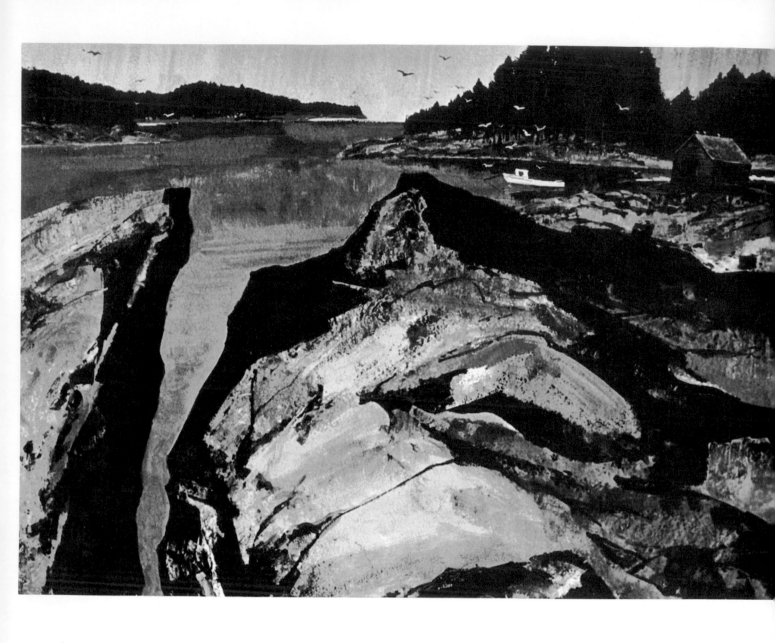

Back Cove, Pemaquid *by Norman Kenyon, A.W.S., acrylic on Arches watercolor board, 18"x25". To render the rich, irregular textures of rock formations like these, you have the option of using acrylic tube color, very slightly diluted with water, or you can develop the right paint consistency by adding matt or gloss medium—or even the much thicker gel medium, which gives you a consistency more like oil paint. Thick acrylic tube color on heavily textured water-color paper is particularly effective for drybrush passages like the patch of light at the middle of this composition.*

fascination of this luminous, transparent paste. A few notes of it may be fine, but too much gel and your painting will cease to be a watercolor. At that point, if you really fall in love with gel medium, you're no longer thinking like a watercolorist, but more like an oil painter; put away your watercolor brushes, get yourself some big bristle brushes and palette knives, and start working on canvas.

Testing Mediums

Before you start painting with these three different acrylic mediums, here are some tests that are worth trying. These little exercises will help you to find out more about how each medium will behave in action.

(1) Gather some scraps of watercolor paper that are too small, too battered, or too dirty to use for anything else. You'll need plenty of these scraps for this and the following tests.

Now squeeze out a dab of some cheap color—earth colors like burnt umber cost a lot less than the cadmiums—since it's silly to waste your most costly colors on this sort of thing. Pick up some paint on a sable brush, without any water, and paint a block of color about 2" square. Then pick up another dab of color, thin it with a little water, and paint another block about the same size. Keep repeating this process, thinning your tube color with more and more water, and paint blocks of color that get lighter and lighter.

The whole idea is to see what you get when you use only water as your painting medium. This is what you'd do if you were painting in traditional watercolor, with no matt, gloss, or gel medium. You'll find that acrylic tube paint does behave like traditional watercolor, with one notable difference: when you paint in traditional watercolor, you use just a touch of tube color and a great deal of water; when you paint acrylic watercolors, you'll use proportionately more tube paint and less water. This is why tubes of traditional watercolor are so small and tubes of acrylic are so much bigger. A tube of watercolor is much more concentrated: it's practically all pigment, with just a bit of gum arabic binder. Acrylic paint contains much more binder—acrylic emulsion, that is—which dilutes the pigment and takes up more room in the tube. In both cases, you get about the same amount of color for your money. It's just that one paint is more concentrated than the other.

(2) Squeeze out some more color and pour a little gloss medium into a paper cup next to your water jar. Pick up a touch of color on a sable brush, then pick up a dab of medium, and mix them together on your palette. Be sure to mix them thoroughly so that no streaks or bubbles of milky medium remain. Then paint another block of color on one of your paper scraps. Now pick up some more color on your brush, some more medium, and this time some water. Mix them thoroughly on the palette and paint another block of color.

Keep repeating this process, adding a bit more water each time, so that the amount of medium in the mixture keeps diminishing.

The purpose of this exercise is to let you examine the effect of color thinned only with medium and then compare this with the behavior of color that's thinned with varying proportions of medium and water. Then, when you actually go to work on a painting, you'll know when you want fairly thick paint (thinned only with medium), when you want somewhat thinner paint (thinned with varying proportions of medium and water), and when you want really thin paint (diluted only with water).

It's also important to get used to the process of combining color, medium, and water. Because you're dealing with three materials, each with a different consistency, this takes a bit more care than just picking up a touch of watercolor on the tip of your brush and swishing it around with water. You must keep your eye on the paint-acrylic medium-water mixture, making sure that it's thoroughly blended before you apply it to paper.

(3) I recommended that you try the last test with gloss medium. Now do the same thing with matt medium. As I said earlier, you'll find that they behave in exactly the same way. But they obviously dry to different finishes. Study these finishes carefully and see which one you prefer. If you've been brought up on traditional watercolor—like me—you'll probably prefer the matt medium. But don't be a conformist. If you really prefer the look of the gloss medium, stick to your guns!

You might want to try a compromise between the matt and gloss mediums. You can produce a semi-gloss surface by mixing matt and gloss mediums half and half in a paper cup. Try thinning your paint with this mixture and see what kind of finish you get.

(4) Now squeeze out a small gob of gel medium on your palette. Using a bristle brush, pick up some tube color and mix this with the gel medium. Apply this stiff, pasty mixture to the paper with a quick, direct stroke. Don't iron the color out. When this dries, you'll find that you have something which is not only impossible in traditional watercolor, but just as unlikely in oil painting: a transparent impasto. The thick, dried paint will retain the grooves left by your bristles.

Now mix some more color with some more gel medium and paint it on the paper once again. But this time, spread the color out a bit more, dabbing and patting and stroking to produce a variety of brush textures. You'll find that the paint retains these strokes and textures very precisely, just as oil paint would, and remains transparent.

Now try thinning your mixture of color and gel with just a touch of water. If you don't add *too* much water, the paint will take on a bit more fluidity, but will still be stiff enough to retain interesting strokes and textures. However, if you add lots of water—and maybe you ought to try it—you get fluid paint that's no different from tube color which has been diluted with gloss medium. This obviously defeats the purpose of the gel. If you want paint which is creamy but fluid, you're better off using gloss or matt medium.

When you look at dried patches of color modified by gel, you'll notice that the gel dries to a rather high gloss. This is one more reason for not using too much gel in an acrylic watercolor. It can be distracting to see all those gobs of shiny paint sticking out from the surface. One way to tone down this effect is with a touch of matt varnish where it's needed; I'll say more about varnishes later on.

One important tip about mediums. It's best to buy mediums made by the same manufacturer who produces the tube colors you buy. The manufacturer compounds these mediums to harmonize with the chemistry and behavior of his own colors.

Retarders

Several manufacturers now produce retarders to slow down the drying time of acrylic paint. These retarders are really intended for painters who prefer to use acrylics in techniques similar to oil painting. If you're painting a head, for instance, you may want your paint to dry more slowly so that you have lots of time to stroke and restroke the shadows on the side of the face, in order to get just the right soft transition from dark to light. But when you're painting in watercolor, this sort of thing is less important. In fact, one of the things you *want* is rapid drying so that you can put one wash over another. Retarders are rarely used by watercolorists who work in acrylics.

However, there just might be moments when you *do* want to add some retarder to slow down the drying of a particular passage. If so, remember that retarder works well only with fairly thick paint. A big, wet wash—like a sky—is mostly water, and retarder won't have much effect. But if you're working with a thick mass of color, like a clump of foliage, then retarder might be worth adding. But don't use the retarder as a crutch that supports you when you're indecisive. Don't slow down your drying time so you have more leisure to brush the paint back and forth, to change your mind, and to turn your painting into mud. It's better to do without the retarder and guess right the first time.

Modeling Paste

Like retarder, acrylic modeling paste is meant primarily for painters who want to work with thick paint, more like oil than watercolor, in an impasto technique similar to oil painting. Modeling paste comes in cans and has a consistency something like putty or clay. The paste is a mixture of acrylic emulsion and some granular substance like marble dust. You can mix it with acrylic color to get the thickest paint you've ever seen. Working with stiff bristle brushes, knives, and other tools, you can produce amazingly three dimensional surfaces.

But this kind of paint isn't much use to the watercolorist, who works primarily with fluid, transparent veils of color. However, modeling paste does offer some intriguing possibilities if you'd like to experiment with various textured painting surfaces. For example, you can tint the paste with acrylic color, trowel it onto a sheet of untempered Masonite, and texture the wet paste in a number of ways. With an ordinary pocket comb, you can groove the wet surface with hundreds of straight or wavy or zigzag lines. You can take a sheet of coarse fabric—much too coarse to paint on—and press this lightly into the wet surface of the paste to make a delicate "mold" of the fabric's surface, which you *can* paint on. If you'd like to paint on a surface that has the feel of weathered wood, you can press

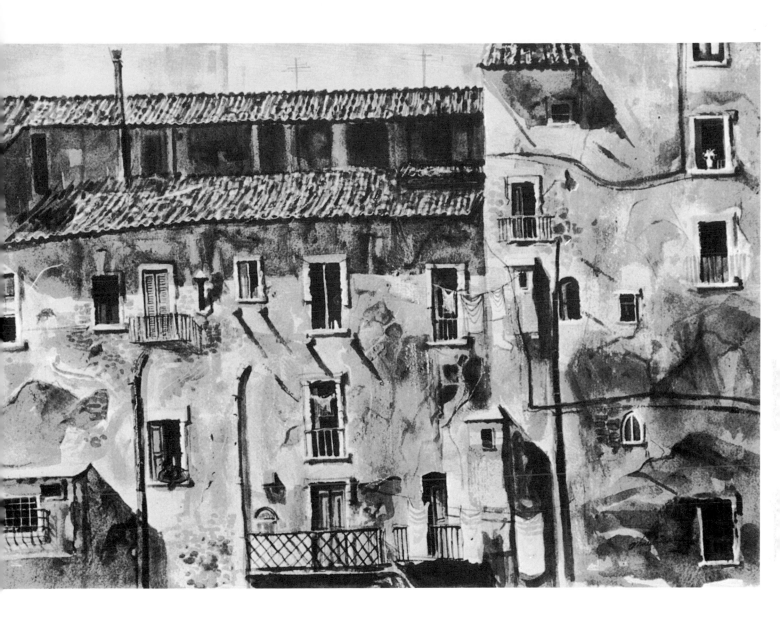

Roman Wall *by Jay O'Meilia, A.W.S., acrylic on 300 lb. watercolor paper, 21"x29". This study in textures is an intriguing combination of strokes and washes. The shadow in the lower left is an irregular graded wash that sinks into the texture of the paper to produce a granular tone. The shadow beneath the second rooftop is an even more irregular wet-in-wet passage. And the constantly changing tones of the wall show touches of fluid drybrush, scratching and scraping, and a cumulative buildup of one delicate tone upon another. When working with very thin washes of acrylic, it's wise to add a touch of matt or gloss medium, since the tube color may lose its adhesiveness when a wash is mainly composed of water.*

Hooded Figures *by Douglass E. Parshall, N.A., A.W.S., acrylic on gesso board, 20"x30", collection Mr. and Mrs. Grant C. Ehrlich. A traditional technique of the old masters was to paint shadowy backgrounds and the shadowy portions of figures in transparent color, then to block in the lights in semi-opaque color. Acrylic lends itself particularly well to this technique, as this figure painting demonstrates. The darks are washed on thinly, blurring into one another. On the other hand, the lights are applied with rough, shorter strokes, and with distinctly thicker paint. However, note that the lights aren't completely opaque; they're translucent enough to allow the shadowy tones beneath to shine through. In this way, the lights and shadows integrate very effectively.*

some rotten old boards into the wet paste to leave still another kind of imprint.

The possibilities seem unlimited, but the danger here is that the texture can become so insistent that it overwhelms the painting. Since dried modeling paste isn't nearly as absorbent as a sheet of watercolor paper, working on such a surface may be tricky. A fluid wash may be hard to control and is likely to run to unexpected places. Adding some matt or gloss medium to your liquid color will give you more control on this kind of surface.

To be perfectly frank, I don't recommend that you paint acrylic watercolors on this kind of tricky surface until you've mastered more reliable surfaces like watercolor paper and gesso. Later on, concocting some wild texture with modeling paste on Masonite may be a refreshing change of pace, or just plain fun for an afternoon, but for most painters the traditional surfaces will be the right.

Varnishes

Acrylic emulsion serves not only as a painting medium, but also as a varnish for the finished painting. Some manufacturers recommend that their matt or gloss medium be used both to thin your paint and to varnish the painting when it's done. Other manufacturers make mediums and varnishes which come in separate bottles, because the varnish is a slightly modified version of the medium. If the manufacturer of your colors sells mediums and varnishes separately, don't get them switched; follow his instructions.

If you're accustomed to painting in traditional watercolors, you may wonder why I'm talking about varnishing at all. After all, no one varnishes a traditional watercolor. When I was a student, I tried varnishing a watercolor with the damar retouching varnish used for oil paintings; the result was disastrous—my colors were completely distorted. So far as I know, no one has come up with a satisfactory varnish for watercolors. Nor does any watercolorist lose sleep over this, since his paintings are normally exhibited under glass anyhow.

Nor is it necessary to varnish acrylic watercolors if you're going to exhibit them under glass. They don't really need the protection of the varnish. But some watercolorists *do* wish that they could exhibit their paintings without glass, like oil paintings. There's no question that a sheet of glass—with its shiny surface and reflections—is simply a necessary

evil to protect fragile watercolor paper and water soluble colors from polluted air and greasy fingers. Thus, if you do have the urge to eliminate glass, you might want to try painting acrylic watercolors on gesso panels or on canvas coated with acrylic gesso, which are then varnished and exhibited in the open air like oil paintings. Of course, you may be annoyed when someone says, "but that's not a watercolor!" Expecting to see watercolors under glass is an ingrained habit which is hard to break.

Like acrylic mediums, acrylic varnishes come in two varieties: matt and gloss. They're equally durable and which surface you prefer is a matter of taste. Before applying one of these varnishes to a dry painting, it's best to dilute it half and half with water. Brushed on straight from the bottle, both these varnishes—and the matt varnish in particular—sometimes dry to a faintly cloudy film. Dilution with water seems to eliminate this problem.

Like the mediums, you can mix matt and gloss varnish to produce a semi-gloss surface. This lends just a touch of luminosity, but minimizes glare.

Recommended Basic Palette

Nearly all the colors used in acrylic painting are the same as those used in traditional watercolor painting. Thus, if you have a palette of favorite colors for watercolor painting, the simplest course would be to buy their counterparts in acrylic. However, it may be helpful if I recommend a list of basic colors for acrylic watercolor painting. The following colors should serve most of your needs, although I'll recommend some "optional" colors later on.

Ultramarine blue: This slightly warm blue is on the palette of practically every watercolorist I know. It's not a color that socks you in the eye, and not a tremendously strong color in mixtures—but it knows its place. When mixed with yellows, it tends to make restrained (rather than brilliant) greens that stay on the painting surface, rather than pop out at you. Mixed with various browns, ultramarine blue makes a handsome range of subtle warm and cool grays. It will cool down another color without overwhelming it.

Phthalocyanine blue: In contrast to ultramarine blue, thalo blue is cool and brilliant. Just a touch of it goes a long way in a mixture and is likely to obliterate the other colors in the blend unless used with great care. Thalo blue has great luminosity and transparency. Mixed with yellows, it makes

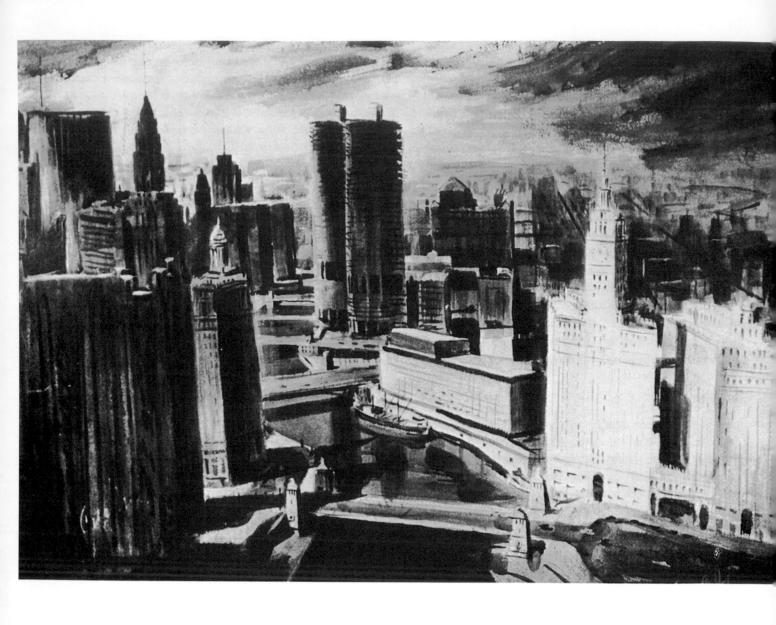

Up the River *by Earl Gross, A.W.S., acrylic on watercolor board, 21" x 30", collection Chicago Historical Society. This ambitious cityscape is notable for its rich tonal range, from the glowing lights of the buildings at the right to the deep shadow tones of the buildings at the left. Observe how the darks are built up, stroke upon stroke, not only on the buildings, but in the dramatic darks of the sky in the upper right. The atmospheric perspective of the receding cityscape in the upper right is also built stroke upon stroke, with the veils of color becoming more and more delicate as the city approaches the horizon. (Courtesy Oehlschlaeger Galleries.)*

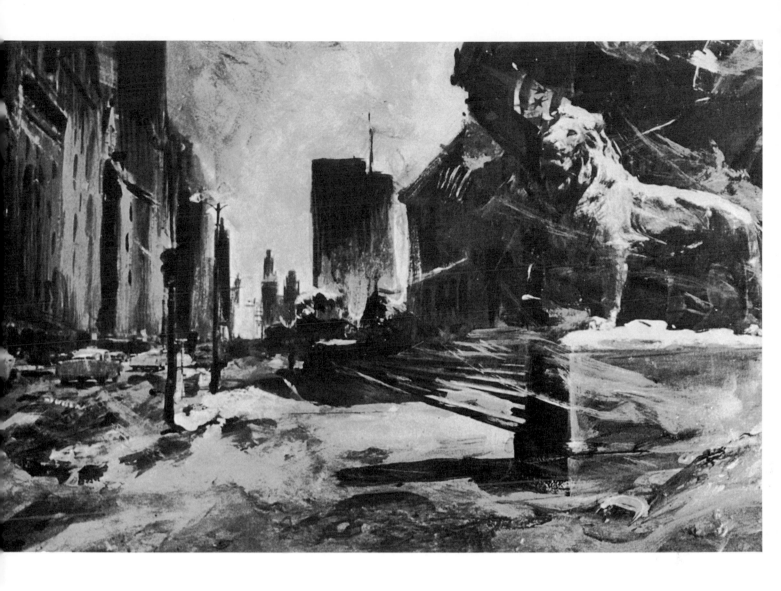

Boul' Mich *by Earl Gross, A.W.S., acrylic on mounted watercolor paper, 12"x18", collection Mr. and Mrs. Roy Lang. At first glance, this acrylic watercolor appears to be predominantly opaque. But the scrubby, seemingly casual brushstrokes leave behind a fascinating pattern of semi-opaque broken color. In the lower left hand corner, the strokes merge, overlap, but always shine through one another. The snow blowing in from the right is rendered with veil-like strokes of semi-opaque color that never quite conceal what lies beyond. The darkest shadows, like the two in the center of the composition, still give a feeling of transparency. (Courtesy Oehlschlaeger Galleries.)*

brilliant greens. Mixed with transparent reds—not the more opaque cadmium reds—it makes glowing purples. Unlike the subdued, workmanlike ultramarine blue, thalo blue is a standout, a dazzler. You need them both.

Cadmium yellow light: Once again, this is a basic color which almost every watercolorist uses. Cadmium yellow often comes in light, medium, and dark shades, but it's best to use the lighter shades since it's easy enough to darken them a bit by adding a touch of one of the earth colors. All three of these yellows make luminous oranges when mixed with reds, luminous greens when mixed with thalo blue, subtler greens when mixed with ultramarine blue, and golden brown colors when mixed with the earth tones.

Yellow ochre: This is a subdued, earthy yellow which will warm many other colors without taking command, as the more brilliant yellows are inclined to do. A touch of yellow ochre will warm a gray without turning it to green. An undertone of yellow ochre will warm any wash that's laid over it. John Pellew said that when he painted acrylic watercolors, he sometimes gave the paper a pale wash of yellow ochre before he started to paint. Mixed with blues, yellow ochre produces subdued greens that melt back into the atmosphere of a landscape. Mixed with earth browns, yellow ochre will give you warm, golden tones that are never brassy. Somewhat similar to yellow ochre is raw sienna, which is somewhat darker and tanner. It has a bit more glow than yellow ochre and makes richer greens. You may want to try them both and see which you prefer.

Cadmium red light: The cadmium reds come in light, medium, and dark shades, but the lightest is most useful because you can easily darken it. Used straight from the tube, this red makes a tremendously powerful note in the picture, singing out like a trumpet. Mixed with other colors, it either dominates or turns most of them to mud. Most watercolorists keep cadmium red on the palette for those special moments when they need a brilliant red note, but they rarely use it in mixtures. However, it does mix well with the other cadmiums; blended with cadmium yellow, it makes a stunning orange. Cadmium red can be toned down slightly with a touch of brown. Or it can be intensified—if that's possible—by adding crimson, which makes an even richer red.

Naphthol crimson: Most watercolorists carry cadmium red light as their warm red and alizarin crimson as their cool red. However, there seems to be some chemical conflict between the alizarin crimson dye and the acrylic emulsion. So color manufacturers have come up with several crimsons that do the job just as well. One is naphthol crimson; you may also want to try thalo crimson. Both of these colors are brilliant and transparent, in contrast with the more opaque cadmium red. They'll make intense purples when mixed with thalo blue. They'll enrich cadmium red. They also make fascinating, strange, hot tones when mixed with earth browns.

Burnt sienna: Although yellow ochre and raw sienna are also earth colors—they were literally dug out of the ground before chemical laboratories started making them—most people think of the earth colors as browns. Burnt sienna is a particularly brilliant, transparent red-brown, which mixes well with a variety of other colors. Blended with ultramarine blue, burnt sienna will make a wonderful range of grays. Mixed with various yellows, burnt sienna will yield glowing, golden tones. And it produces unexpected subtleties when mixed with those powerful reds. Just a touch of blue will turn burnt sienna into a much deeper brown.

Burnt umber: This sonorous brown is the deepest of the earth colors. For lowering the tone of other colors, burnt umber is far better than black, which is likely to turn rich color to mud, while burnt umber adds a warm glow even when it reduces intensity. Like burnt sienna, this deeper brown yields splendid grays when mixed with blue. A touch of burnt umber will turn a green mixture into a deep, dark, shadowy forest tone. It will subdue a red or orange, but not destroy it. When you're tempted to reach for black, try burnt umber instead.

Mars black: Although ivory black is the usual black in watercolor, the more powerful mars black has taken its place in acrylic. Many watercolorists avoid black altogether, but you may want to have mars black on hand for an occasional accent. Black is the worst possible color for toning down other colors, but if you think of black as a color in itself—as the Chinese and Japanese masters did—then new possibilities open up. Try using other colors to modify black, rather than the other way

Shed #1 *by Larry Webster, A.W.S., acrylic on Strathmore hot pressed board, 30"x40". For the watercolorist, the most difficult surface of all is hot pressed paper or board. On this extremely smooth, shiny surface, liquid color dries almost instantly, and every stroke retains its precise shape and texture, resisting any attempt to change it or blend it. Webster has made creative use of this apparent limitation and built up a fascinating variety of strokes to render the surface of the old wooden structure. Notice where he uses short, scrubby strokes, and where he uses long, streaky strokes. The transparent shadows at the top of the composition are a particularly impressive example of the translucency of acrylic, even in a very dark wash.*

From Portrero *by Rex Brandt, A.N.A., A.W.S., acrylic and watercolor on paper, 16"x28", collection Joan Irving. This mixed media cityscape—combining acrylic with traditional transparent watercolor—shows the broad, decisive strokes for which this painter is well known. The sky and water are particularly interesting because the artist has avoided the usual tendency to treat these in flat or graded washes. Instead, broad, flat, vertical strokes are placed side by side to produce a vivid atmospheric vibration.*

around. Try adding other hues to produce warm blacks and cool blacks, reddish blacks, and still other blacks that have a life of their own. But black shouldn't be used to make grays. Blue-brown mixtures will make vastly more interesting grays than any black.

Titanium white: The fascination of traditional watercolor is its transparency. Even when they switch to acrylic, many watercolorists prefer to retain this transparency. They're inclined to feel that it's cheating if they add opaque white to cover up a mistake or add a light note that they couldn't get any other way. But even if you go along with the tradition that watercolor *must* be transparent at all costs, I think that titanium white ought to be on your palette if you're going to paint watercolors in acrylic.

The usual white in traditional watercolor is so-called Chinese white, which does tend to turn your colors chalky if you use too much. But the titanium white manufactured for acrylic painting needn't turn your transparent color to a cloud of chalk. On the contrary, faint touches of acrylic titanium white will turn transparent washes to delicate hazes of color which give an even greater sense of atmosphere, without destroying the transparency of your painting. I'll explain how this is done in Chapter 7. In the meantime, do take my advice and buy a tube of titanium white.

Of course, if you're not a purist about transparency, titanium white is extremely handy for adding a touch of light where you need it. If it won't keep you up nights, you'll find it convenient to add titanium white to some other color for a bright clump of flowers in the shadow of a rock formation, for a brightly clad figure in a shadowy interior, or for a tiny patch of sky shining through a clump of trees.

It seems to me that these ten colors form a reasonably complete palette that will solve most of the problems you face in an acrylic watercolor. To be perfectly honest, you can probably get along with even *fewer* colors. Particularly when they paint outdoors, I know a number of watercolorists who don't carry more than half a dozen tubes.

You'll notice that I've left out any mention of green, since your two blues and two yellows will give you a fairly wide range of greens, which can be enriched still further by adding some touches of earth color. For the same reason, I've left out any

mention of orange, since you have two reds and two yellows, as well as the earth colors, to mix more shades of orange than you can buy. You also have enough blues and reds to mix a variety of purples on those rare occasions when you need them.

In short, I've followed John Pike's theory that the irreducible palette is essentially a palette of primaries: blue, red, and yellow, with a warm and cool version of each. These six tubes, plus a hot and a subdued earth brown, will take you a long way before you need any other colors. Even the black and white are optional.

When you shop for your colors, you'll find that acrylics come in tubes, jars, and sometimes in plastic squeeze bottles. For leisurely work in the studio, jars and squeeze bottles are probably just as convenient as colors in tubes. But for all around use—including work outdoors—tube colors are your best choice. If you've already painted in watercolor, you're probably used to tube colors anyhow, so stick with them.

Colors You Might Want to Add

I don't mean to lay down the law that these ten colors are the *only* ones you'll use for acrylic watercolor painting. I'm simply suggesting these ten tubes to get you started. Later on, you may discover lots of other colors that you prefer, and you'll probably develop your own personal palette which reflects your own special preferences. Here are some other colors which you might want to try.

Cerulean blue: Like the cadmiums, cerulean blue is a rather heavy, dense, somewhat opaque pigment for watercolor. But it's just transparent enough, and it has a wonderful cool airiness that's just right for skies and distant objects in the landscape. In mixtures, cerulean blue produces silvery grays and airy greens which suggest space and atmosphere.

Cobalt blue: This is another very delicate blue, somewhat warmer than cerulean, which many watercolorists like for atmospheric effects. It's not an all-purpose blue—not a workhorse like ultramarine or thalo blue—but has a soft, melting tone, quite unlike any other cool color on the palette. Because it has very limited tinting strength in mixtures, cobalt blue will cool and tone down another color without dominating the blend. Many painters like it for cool shadows.

Phthalocyanine green: Like thalo blue, this is an extremely brilliant, transparent color, which socks you in the eye when used alone, and which has so much tinting strength that it tends to dominate other colors when mixed with them. Nonetheless, thalo green is a good all purpose green if you must have this color on your palette—although I still think you get better greens by mixing them. Although thalo green tends to look a bit garish when used all by itself, it can be subtly modified with touches of brown, blue, yellow, and even red to produce more interesting greens, which still remain luminous and transparent. Be careful when you mix thalo green with other colors, though, because it's powerful enough to dominate almost any mixture; add just a touch at a time until you see what you get.

Hooker's green: This has always been a great favorite with watercolorists who like to have a ready made green that can be used without much modification for foliage and other landscape elements. Hooker's green *is* a convenient time saver, and is easily modified by a touch of yellow, blue, or brown.

Naples yellow: Although many watercolorists object to Naples yellow because it seems a bit too dense and opaque for transparent painting, it has a particularly soft, sunny quality, unlike any other yellow. It's bright, but it doesn't bounce out at you, and has a delightful way of keeping its place in the atmosphere of a picture. Naples yellow imparts this sunny softness to reds and browns, producing soft, golden tones, and can also give you some interesting, offbeat greens.

Cadmium orange: Although you can easily create this color by mixing cadmium yellow and cadmium red, you may find it a convenient time saver to have cadmium orange on hand. Like the other cadmium colors, this one is intense, very powerful in mixtures with other colors, and slightly opaque. You can tone it down with a touch of brown, but a touch of blue or green may turn it to mud.

Other cadmiums: I mentioned earlier that there are various shades of cadmium yellows and reds, ranging from light to dark. Although I recommended buying the lighter tones, since you can easily darken them, you may want other shades at some point. The darkest cadmium red, for instance, is a sonorous, deep red, which you won't use often because it has tremendous weight in a picture. The darkest cadmium yellow is also a heavy, sonorous hue which seems to fall into a kind of middle ground between cadmium yellow and cadmium orange. Cadmium vermilion is a particularly bright, hot red-orange, stunning when used as an accent here or there. None of the darker cadmiums can be considered essential for your palette, but they're so beautiful that I can understand the temptation to buy them and try them out. If you find that they lie around the studio unused, you can always lighten them up by mixing them with the other cadmiums to produce more versatile colors.

Red oxide: Among the most fascinating of the earth colors are the various iron oxide reds. In oil painting, these are called Venetian red, light red, English red, and various Italian names which have gone out of use. In acrylics, these are generally called red oxide, iron oxide red, or light red. These are all strong, deep, faintly brownish reds, which look like various shades of the red clay used for roof tiles along the Mediterranean Coast. They tend to be dense and a bit opaque, but they're unique among the hot colors in that they don't leap out at you but tend to hold back a bit because of their earthy tone. They have a special combination of richness and restraint.

Raw umber: This is a curious, almost indescribable earth tone, which varies a bit from one make to another. Raw umber is a kind of yellowish-greenish-grayish-brown, which sometimes looks like just plain mud, but which may be just right when you want a smoky, remote, earthy tone. It does have an atmospheric quality unlike any other warm tone on your palette. It also has very limited tinting strength and will gently tone down another color without radically altering the hue. You can mix it with almost anything without doing irreparable damage. As you thin out raw umber, it tends to get yellower, and the grayish tone disappears. In a perverse way, the value of this strange color lies in its weakness. It comes amazingly close to the vague color of dust blown along a dirt road.

Payne's gray: Although most watercolorists admit that you can mix practically any shade of gray with various combinations of blue and brown, there *is* one ready made gray which a lot of painters carry. Payne's gray is a particularly airy,

Sea of Grass *by Fred Messersmith, A.W.S., acrylic on 200 lb. paper, 22"x30". Although it's hard to scratch an acrylic painting when the surface is completely dry, acrylic color lends itself to a great deal of texturing while it's still wet. An amazing variety of thick and thin lines can be struck into the surface, provided that the instruments are slightly blunt, not sharp enough to damage the surface of the paper. If you add a fair amount of acrylic medium— liquid or gel—the paint will take on a gummy consistency which is even easier to scrape and push around. Be sure to* squeeze *the color out of the paper, not scratch or abrade the painting surface.*

atmospheric color which watercolorists often carry as a time saver. It's useful for distant, atmospheric tones, and for modifying blues and greens to make them more atmospheric too.

Every manufacturer's catalog contains many more colors that I haven't mentioned. There are a number of new yellows, reds, and violets—modern dye colors—which are available only in acrylics. These new dyes are brilliant, transparent, and tantalizing. But let me repeat my warning against cluttering up your paintbox with too much gear. You need very few colors to paint a successful acrylic watercolor. What you *do* need is mastery of these few colors. If you can't handle a few colors well, having lots of colors won't make the job any easier.

If you like to have lots of colors on hand—as many watercolorists do—the trick is to use just a few of them in any one painting. There *are* experienced watercolorists who keep two dozen tubes of color on hand, but they rarely use more than six or eight for a picture. The whole idea is to visualize your picture in advance, then pick the limited number of tubes that will do the job. This is when you may want to pull out an "optional" blue for a particular sky effect, or one of the red oxides for an autumn landscape.

How Colors Behave

As you begin to try out the colors on your palette, you'll discover that no two colors behave exactly alike. The hues themselves are different, of course; but this isn't what I mean. You must get used to the actual *handling* qualities of each color. Here are some points to watch for.

Pigments and dyes: As you thin out some of your tube colors, you'll see that they're composed of granules of color that may separate and have to be stirred carefully to make sure that they hold their place in the mixture. These are the so-called pigment colors. On the other hand, you'll find that some tube colors, when you thin them out, behave like brightly colored smoke and instantly penetrate the water, medium, or other colors in the mixture. These non-granular colors are the dyes.

It's terribly important to know which of your colors are pigments and which are dyes. The pigments—which include ultramarine blue, the cadmiums, and the earth colors—are likely to rest on the surface longer, allowing you to push them

around with the brush more freely. The dyes—thalo blue and green, hansa and AZO yellow, the naphthol reds, etc.—tend to penetrate the paper almost immediately, and take very little pushing around with the brush. Thus, you must plan your attack with special care when you're working with dye colors. The pigments are a bit easier to handle and are less likely to get out of control.

Opacity and transparency: As I hope I've made clear already, some colors are dense and opaque, while others are more transparent. All colors, when thinned with water or acrylic medium, are reasonably transparent, but some are like sheets of cloudy glass, while others are like sheets of clear glass. The cadmiums and the iron oxide reds, for example, have a bit more *covering power* than thalo blue or naphthol crimson or burnt sienna. The latter are as clear as stained glass.

These questions of opacity and transparency are particularly important when you lay one color over another. A very transparent color will allow the underlying wash to shine through; the underlying and overlying colors will appear to mix and form a third color, like two sheets of clear, brightly colored glass. But an overwash of slightly opaque color will cloud the underlying color and may overwhelm it. Thus, a wash of AZO yellow over a wash of blue gives you a clear, bright green; the blue will shine through the yellow. But an overwash of cadmium yellow is more likely to cloud the underlying blue and form a yellowish haze which allows less of the blue to come through.

Don't interpret this as some sort of law against using the more opaque colors as overwashes. There are times when this is just what you want. You don't *always* want a transparent overwash that allows the underlying color to come through full force. The point is simply that you must know which colors are more opaque, which are more transparent, so you can get the effect you want.

Tinting strength: You'll recall that I warned you against sloshing too much thalo blue or thalo green into a mixture. These colors have exceptional tinting strength, which means that they have a strong influence on any mixture in which they're used. The same is true of the cadmiums. Ultramarine blue and most of the earth colors, on the other hand, have less impact on a mixture and you can use them more freely without fear of spoiling the blend.

So then, you must get used to the various tinting strengths of each color on your palette. By practicing, you can learn how much to add to get the exact tone that you want.

Behavior in mixtures: The color textbooks all tell you that blue and red make violet, blue and yellow make green, red and yellow make orange, etc. Theoretically, this is all true. But tube colors don't always obey the rules. Your basic palette—if you accept the ten colors I've recommended—contains two blues, two yellows, two reds, and two browns, not only because they're different colors in themselves, but because they behave quite differently in mixtures.

Color mixtures can be unpredictable. Try mixing ultramarine blue and cadmium red, for instance. Do you get a bright, clean violet, as you might expect? No, you get a weird tone, unlike anything you might expect unless you've tried this before. I won't tell you what it is; you try it. I won't catalog all these unexpected possibilities here, but you'll soon find that each color on your palette has its own peculiar way of acting in combination with each other color on your palette.

In the concluding section of this chapter, I'll explain how to test out your various colors so you can learn how to predict their behavior when you start to paint.

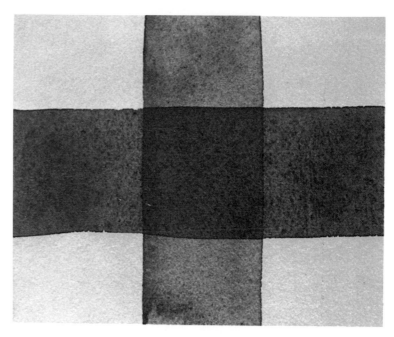

One way to learn how your colors behave is by optical mixing. Make a stroke of one color, let it dry, then cross it with a stroke of another color. You're "mixing" the two colors by laying one over the other like two sheets of colored glass. The effect is quite different from mixing the two colors **physically** on your palette, then applying the mixture as a single stroke.

Testing Colors

It makes no sense for me to try to describe how each color on your palette will behave in actual painting practice. You just have to experience it for yourself. You've got to see it. The easy way is to test out your various colors on odd scraps of paper, rather than find out the hard way when you're smack in the middle of a painting. So gather up some more scraps of paper; they don't really have to be expensive watercolor paper, since any white, sturdy sheet will do. Now squeeze out a dab of each color on your palette, fill your water jars, and take hold of your biggest sable brush.

(1) First you're going to wash each color on your palette over a dried wash of every other color on your palette. Wet your brush and dip it into the first color on your palette; then add some water

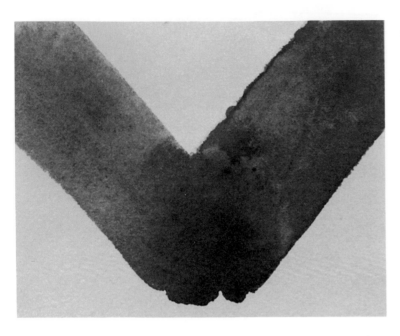

A useful way of finding out how your colors behave when mixed is to paint a stroke of one color, then paint a stroke of another color so that the two intersect while still wet. At the point where the two strokes meet, a third color will appear, and you can compare this with the two original colors.

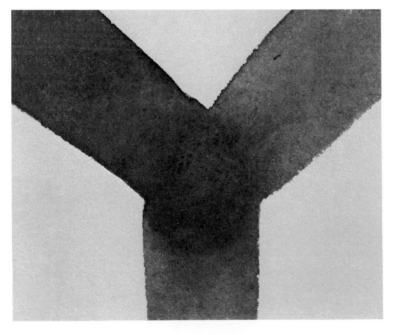

See how three colors intermix by painting a strip of each and bringing them together (while wet) in the form of a Y. At the intersection, a third color will result. Using plenty of cheap scrap paper, try this with all the colors on your palette.

and paint a strip of color about an inch wide and a foot long. Do the same with every other color on the palette. You can skip the black and white, but you should have a test strip of everything else.

When all these test strips are dry, mix up a big wash of the first color on your palette. Then paint a little bar of color—about an inch wide and 3" long—that crosses each test strip like a bridge going over a highway. Repeat this process with every color on your palette, so that each foot-long test strip has eight or ten or twelve little bridges of color running across it.

When you've done all this, go back and look at each test strip very carefully. See what color you've made at each point where the overwash—or bridge—crosses the underwash. Note which overwashes are transparent and allow the underwash to shine through; equally important, note which overwashes are slightly opaque and tend to cloud the underwash. Note how different blues, different reds, different yellows, etc., produce different colors, and not always the ones you expect.

(2) You've now tried what might be called *optical* mixing. That is, you haven't actually mixed the colors while they're wet; instead, you've mixed them in the eye of the observer, who sees the two colors as one, even though they were applied to the paper separately.

Now you're going to mix the colors—mix them physically—while they're actually wet. You're going to mix *every* color on your palette with *every other* color on your palette.

Again, you're going to paint two strips of color which meet. But this time, they'll meet when they're wet. Dip your brush quickly into the dab of color on your palette, add some water, then paint a strip about an inch wide and about two or three inches long. Wash your brush, pick up another color from the palette, add some water, and paint a similar strip that forms a kind of V with the first strip. The two strips will mingle at the point where they meet—you can mingle them with the brush if they don't do it by themselves—and form a small pool.

When each V dries, compare the arms of the V—the two strips of pure, unmixed color—with the pool in which the colors have become mingled. Observe which color has more tinting strength, which color dominates the mixture. Try to remember the unexpected colors that turned up. If you were particularly observant while you were

mingling the wet colors, you may have noticed that some colors were granular—the pigment colors—and tended to stay on the surface of the paper, while the dye colors penetrated the mixture immediately and also sank right into the paper.

(3) Now, if you really have patience, you can repeat the wet mixing process with three colors. This time, you'll be painting three bars that make a Y instead of a V. You'll need lots more paper.

Once again, observe which colors have the greatest tinting strength, and which tend to dominate the mixtures. You'll also observe some really startling blends, which you might never expect when you mixed just two colors.

Now spread out these three batches of tests and look at them again. First compare the two kinds of mixtures: the optical mixtures in which you laid one strip of color over another, and the physical mixtures in which you blended two or three colors. It should be obvious that optical and physical mixtures produce quite different effects. Remember these differences when you start to paint, and decide in advance which type of mixture is right for each passage in the painting.

You should also compare the nature of the two color mixtures and the three color mixtures. One tremendously important lesson is that the *more* colors you mix, the *less* brilliant the blend becomes. Unless you have a terribly good reason—let's say you're shooting for a color you can't get any other way—avoid mixing more than two or three colors at a time. It's very rare that you need more than three colors in a single mixture. Four colors are likely to mean mud. Three colors are often unnecessary and even downright dangerous. If you *must* resort to three colors, let two of them dominate and just add a touch of the third to modify the mixture ever so slightly.

5.
Wash
Techniques

Despite its apparent simplicity, every professional painter knows that watercolor (which includes acrylic watercolor) is the most difficult of all painting media. What makes watercolor so demanding is just this: it takes a great deal of skill and practice merely to put color on the painting surface. The beginning watercolorist is constantly amazed—and often discouraged—to discover how hard it is to cover a piece of paper with a flat tone without streaks, blotches, and other unpleasant surprises. To produce a graded color area—one that moves from light to dark or from dark to light—is even harder. And the task of producing a solid area of really dark color is enough to make many beginners give up watercolor altogether.

In watercolor painting a flat or graded area of color is called a wash. Learning to lay a wash is basic training for the watercolorist. One of the great arguments in favor of acrylic as a watercolor medium is the fact that acrylic emulsion can make washes a lot easier. I'll explain why in this chapter, which reviews the basic wash techniques and shows how these techniques are simplified and enriched when you paint watercolors in acrylic.

Washes with Acrylic Mediums

For the wash exercises in this chapter you'll need some pieces of paper about the size of the page you're now reading. Although I don't advocate using cheap paper for painting, I suppose you can use some cheap, student grade watercolor paper for these preliminary tryouts, or you can use the backs of some spoiled paintings. You'll also need your largest round or flat watercolor brush. Fill a big jar or bowl with clear water for diluting your tube color. And pour about an inch of matt or gloss medium into a paper cup. Pull out an inexpensive tube of earth color—like burnt umber—and squeeze a dab onto your palette. Finally, keep a saucer handy for mixing batches of liquid color.

In the exercises that follow, you're going to try laying washes *with* and *without* acrylic medium. In the previous chapter, you've already had some experience with the ways in which color behaves when you add plain water and when you add various acrylic mediums. But you haven't actually covered a large area with liquid color. That's what you're going to do now. You're going to see how a slight addition of acrylic medium alters the behavior of a wet wash, and equally important, alters

the character of the wash when it dries. This subtle change in the character of the dry wash is particularly important when you plan to put one wash over another. And the unique quality of a dry wash of acrylic watercolor will turn that old bogey—the very dark wash—into a much less scary process.

Before you begin, I should repeat one piece of advice. A saucerful of acrylic watercolor takes more stirring—and more repeated stirring—than traditional watercolor. Remember that you're compounding three ingredients: color, acrylic medium, and water. To make sure that they're properly blended, stir them thoroughly when you first mix up your batch of color. Stir them again each time you dip your brush into the saucer to pick up more color. You'll soon learn to work quickly, dipping and stirring at the same time, so that there's no delay in the painting process. A wash must be laid quickly, and you mustn't pause between strokes.

Flat Washes

As I'm sure you know already, a flat wash is an even area of color, the same density from top to bottom, without any lighter or darker patches. Here's the usual way of laying a flat wash in traditional watercolor.

(1) Tape or tack your sheet of paper to your drawing board and tilt the board up at the back—so that the back end is 4" or 5" higher than the front end. This will give you a tilt of about 20° or 30°; the exact tilt is a matter of taste and experience. Some watercolorists like a steeper tilt than others; remember that the steeper the tilt, the faster the color will roll down the paper toward you.

(2) Mix up a fairly light wash of color in the saucer, just a bit more than you think you'll need to cover the paper. This first time, just use tube color and water, no acrylic medium. Stir the mixture thoroughly.

(3) Dip your brush into the liquid color and make sure that the brush is fully loaded. Paint a strip of liquid color across the top of the sheet, working with a slow, steady, firm stroke. Don't be impatient; don't move your brush too quickly, or you'll leave behind little bubbles of white paper.

(4) Because your drawing board is tilted, you'll notice that the liquid color tends to move downward toward you, forming a long, narrow pool

The basic watercolor technique, which you must master before going any further, is the flat wash. Notice the slightly granular quality where the color settles into the texture of the paper.

This strange and fascinating wash was laid on cold pressed watercolor paper, which was previously coated with a thin layer of acrylic gesso. The gesso reduces the absorbency of the paper, retaining the streaky texture of the brush used to apply the gesso. The liquid color rides on the surface and retains the unique character of this ground.

along the bottom edge of the stroke. Now dip your brush back into the saucer, stir quickly, and paint a second strip of color just beneath the first. Actually, the second strip should just overlap the bottom edge of the first, so that the pool of color rolls down across the second strip and forms a new pool along the bottom edge of your second stroke.

(5) Repeat this process of dipping, stirring, and charging your brush, then painting fresh strips of color until you get to the bottom of the sheet. Each new strip of color should slightly overlap the preceding strip of color so that the "bead" keeps moving down across the paper and reforming at the bottom of the stroke. What you're really doing, in a sense, is methodically advancing a pool of liquid color across the surface of the paper.

(6) You've now covered the paper with color, but there's a pool of color at the very bottom of the sheet. If you leave the pool there and let it dry, your wash will become suddenly darker at the bottom. There may be some times when you're going to want this effect, but this is an exercise in flat wash technique, so let's eliminate that pool. Wash out your brush in clear water; give the brush a quick shake or snap with your wrist as you do when you're shaking down the mercury in a fever thermometer. This will get rid of most of the water in the brush, but the hairs will still be wet. Draw the tip of the moist brush along the bottom edge of the paper and you'll see that the brush acts like a blotter, soaking up the pool of liquid color, which runs right into the brush. Then wash out the brush once again—never let acrylic color dry in the brush—and the job is done.

If you've had lots of experience with traditional watercolor, your wash will be smooth and even, with no trace of irregularity. But if you're like most students, you'll be horrified to see that the dry wash contains lighter streaks, darker streaks, patches of lighter and darker color, and blotches where it looks like your brush contained too much water or too little. There may also be faintly hard edges where one stroke ends and another begins.

Now try the same exercise again, this time adding a brushful of acrylic medium to the mixture of water and tube color in your saucer. Be sure to stir very carefully. Before you even touch the paper with your brush, you'll notice two things about the liquid color in the saucer: the color will look a bit cloudy because of the milky tone of the acrylic

medium; and the liquid paint will seem just a tiny bit thicker than it was when water was the only liquid you used in the mixture. The cloudiness will disappear, of course, as soon as you apply the wash to the painting surface; and the wash will dry completely clear. It's the consistency of the paint that comes as a welcome surprise.

When you begin to apply your strips of color, you'll discover that the slight admixture of acrylic medium changes the flow of the wash. The pool of color rolls more smoothly down the paper. The paint seems to iron out to a more consistent, less irregular film, less likely to get streaks and hard edges between the strips of color. You're also less inclined to get unpredictable light and dark areas. I can't guarantee that adding a touch of acrylic medium will make a flat wash as easy as rolling off a log; it still takes practice, and you must still be prepared to ruin some sheets of paper. But there's no question that a touch of acrylic medium makes the task less chancey.

Graded Washes

Once you're reasonably sure that you can lay a flat wash efficiently, the next step is to try a graded wash. This is a color area that starts out light at one end and gradually darkens as it approaches the other end. Or it may go from dark to light. It is the classic sky wash, which moves from deep color at the top of the sheet to a delicate glow of light at the horizon. The process is essentially the same as laying a flat wash.

(1) Tape or tack a fresh sheet of paper to your tilted drawing board as I described a moment ago.

(2) Mix up a batch of color in your saucer as you did before. This time, you won't need quite as much color.

(3) Draw your first strip of color slowly and firmly across the top of the sheet, just as you did when you began your flat wash.

(4) Before dipping your brush back into the saucer for a fresh load of color, pick up some clear water on the tip of the brush from the big jar or bowl. Then pick up some fresh color from the saucer, and quickly stir them together on the surface of the palette to make sure that you have a slightly lighter tone. Then draw your second strip across the paper, slightly overlapping the first strip and pulling the pool of liquid color down to the bot-

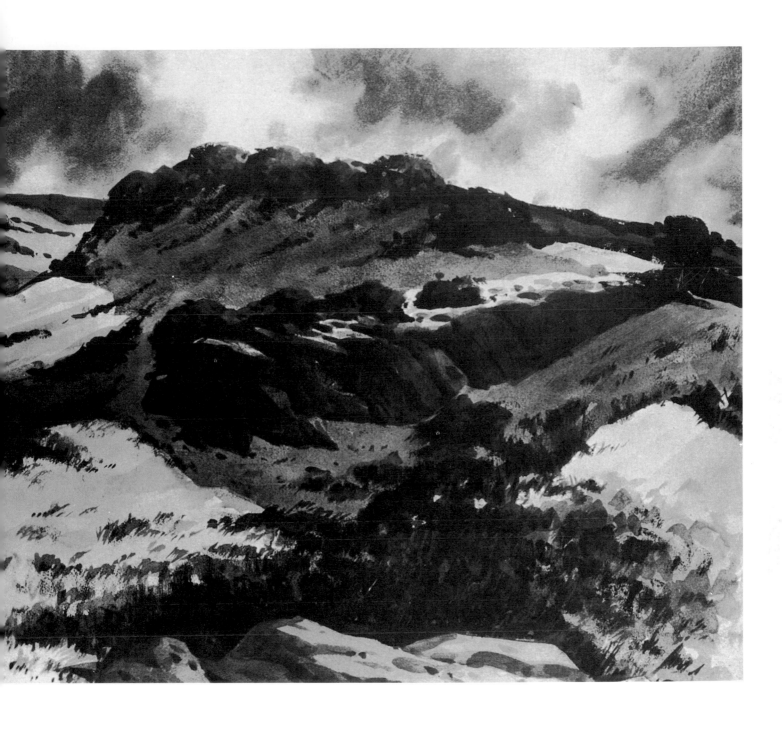

Sand Dunes *by Joseph L. C. Santoro, A.W.S., acrylic on watercolor paper, 20"x24". The painter describes his procedure: "I first made several thumbnail sketches about 2"x3" in pencil to plan my composition and tonal values. The sky was the only area that I wet before painting, for I did not want any hard edges." Painted in transparent color throughout, Sand Dunes combines wet-in-wet technique in the sky, multiple superimposed washes on the dunes, and a rich accumulation of drybrush in the scrubby foreground growth. Thus, there's an interesting contrast between the soft edges of the clouds, the hard edges of the dunes and their shadows, and the roughness of the drybrush passages. (Photo M. Grumbacher, Inc.)*

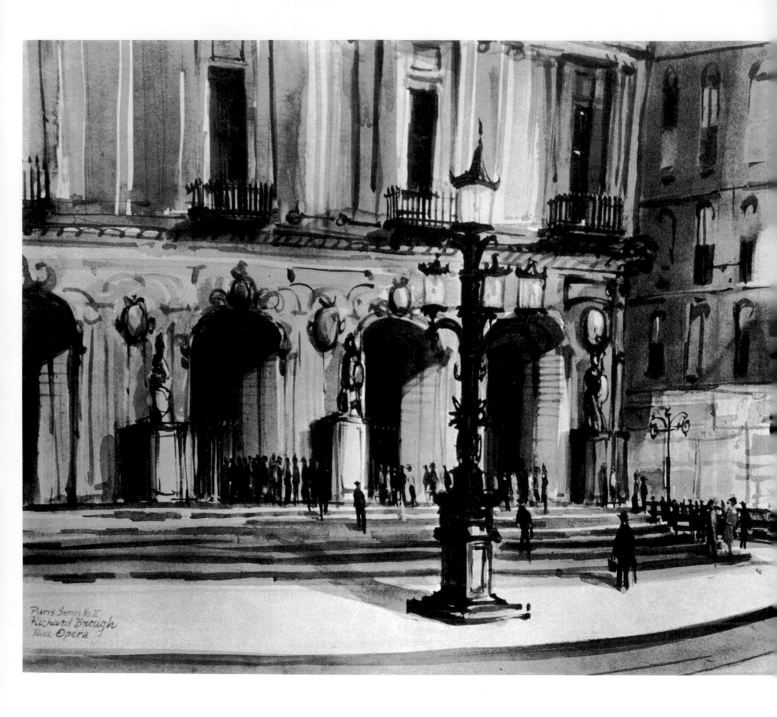

Paris Series No. II
Richard Brough
Rue Opera

Rue Opera *by Richard Brough, acrylic on watercolor paper, 16"x20". This architectural study was painted in just two hours. The artist explains that he used acrylic "in a manner similar to watercolor. I washed the basic tones in the large areas first," knowing that with acrylic "you do not disturb the under color with the glazes applied." The architectural detail is developed in a series of transparent strokes, which tend to remain individual strokes rather than coalesce into a wash of continuous tone. To retain the casual flavor of a picture painted in "one stand from start to finish, to retain the original thought and spontaneity," Brough has purposely left strips of white space between many of his strokes. (Photo courtesy M. Grumbacher, Inc.)*

tom of the second strip. You'll see that the second strip is just a bit lighter than the first, although the two strips should merge and not look like a dark strip and a light strip side by side.

(5) Repeat the process of picking up water on the brush and then some liquid color, adding more water and less color to each successive brushload. Each strip you draw across the page will be lighter than the preceding strip. In the same way, the pool of color will get paler and paler as it rolls down the sheet. If you add enough water to the last few strokes, the wash will gradate to almost pure white paper at the very bottom of the sheet.

(6) Wash out your brush once again, flick out the excess water, and use the tip of the brush to soak up the pale pool of water at the bottom of the sheet.

You may also want to try reversing the process as some watercolorists do. This means adding more color and less water with each successive stroke. Thus, you get a wash which is lightest at the top and darkest at the bottom. If you live in an industrial area where there's often a layer of smog along the horizon the sky gets lighter as your eye moves up and this reverse gradation will be familiar.

As you did with the flat wash exercise, you should try a graded wash first with just water and tube paint. Now you're even more likely to get streaks and hard edges. Then try the same thing with a brushload of acrylic medium mixed into the wash. The paint will go on much more smoothly and you've got a much better chance of getting a smooth, even gradation.

Now, what can you do with those streaky, blotchy washes that didn't come out well? One of the miraculous things about acrylic is that each wash dries waterproof. This means that you can go over an unsuccessful wash and try again—and again. The second wash won't disturb the first and get you into even more trouble. Try laying one, two, or even three flat washes over one that hasn't turned out right. Try the same thing with a graded wash that hasn't turned out right. You probably can't hide the streaks and blotches altogether, but the later washes may veil your earlier mistakes and improve things more than you might think.

As you learn to lay washes with acrylic watercolor, it's important to experiment with different proportions of water and medium. Depending

Once you've mastered the flat wash, you must master the graded wash, which is equally important. A graded wash can move from dark at the top to light at the bottom—as you see here—can go from light to dark, or even from dark to light to dark again.

The dark wash is the most difficult of all effects in traditional watercolor painting. Acrylic makes the job much easier. Since a wash of acrylic becomes insoluble when it dries, you can lay a series of light washes on top of one another until you get the dark tone you want. Several light washes are much easier to apply than one dark one!

A dark, graded wash—extremely difficult in traditional watercolor—can be executed in one of two ways. Either you can put down a series of pale graded washes, one over the other. Or you can begin by putting down a couple of light, graded washes, and then put a series of flat light washes over these to get the density you want. The secret, of course, is that light washes are a great deal easier to lay than dark ones. The odds are against your laying an effective dark wash in one go, while it's comparatively easy to get the same effect in a series of light washes.

upon your very personal technique, you may prefer more medium or less. It's also worthwhile to discover just how much acrylic medium you can add; oddly enough, *too much* medium can cause streaks.

In Chapter 4, I explained the difference between dye colors and pigment colors and pointed out that dyes penetrate the paper, while pigments rest on top. In general, it takes more skill to lay a wash with a dye color, which is more apt to cause streaks if you hesitate or fumble. The pigment colors are easier.

So try laying a flat wash and a graded wash with every single color on your palette. No two colors will behave alike. Each one has its quirks, and it's vital that you discover what they are.

Dark Washes

If you've wondered why so few night scenes are painted in watercolor, it's because dark washes are so difficult. Most watercolorists—even professionals—avoid them like the plague. It's very hard to lay a really dark wash without streaks or irregularities. And if the wash doesn't come out right the first time, you're taking your life into your hands if you go back into the wash and try to correct it. There's so much color piled up on the paper, the odds are ten to one that you'll get more streaks and blotches if you try to even out the tone with a second wash over the first.

In traditional watercolor painting, the recommended method of laying a really dark wash is to mix up a cup, glass, or saucer of liquid color that's just the tone you want. You have to use plenty of color and test the tone out on a scrap of paper to make sure it's right before you start painting. You have just one chance to get the wash right. When you've got the tone you want, you lay the wash just the way you would a flat or graded wash. You then watch it dry and pray that you don't get too many streaks, because you can't touch up the dry, dark wash without *picking up* color.

If you've suffered through the dark wash nightmare with traditional watercolor, you'll find acrylic watercolor the answer to your prayers. Because each wash of acrylic dries waterproof and won't be disturbed by the next wash laid over it, you can lay a dark wash as a *series* of lighter washes, methodically building up from light to dark. Every begin-

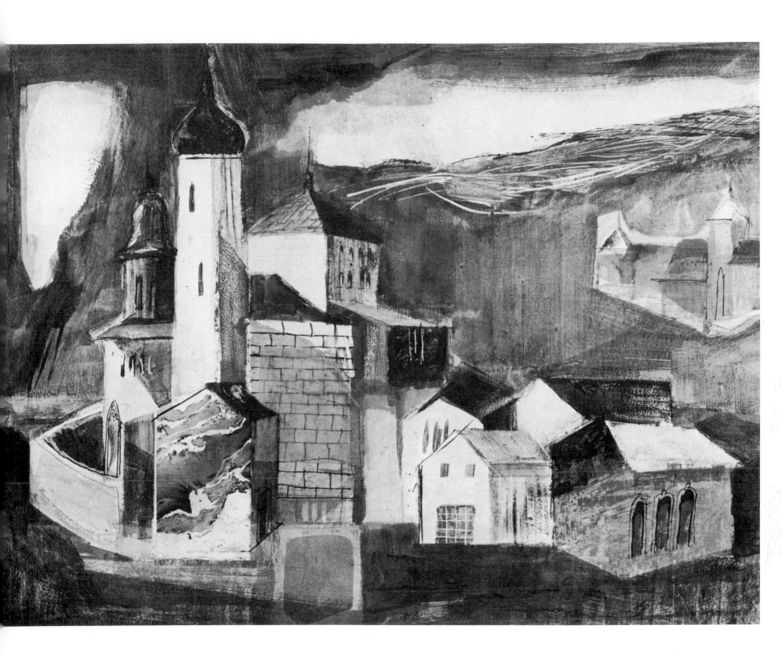

Ault Town *by William Strosahl, A.W.S., acrylic and collage on gesso board, 20"x24", collection Rosemary Strosahl. Acrylic lends itself equally well to smooth washes, like transparent watercolor, and to irregular, textured washes like those in this painting. These broad, streaky strokes give the transparent and semi-transparent color a powerful sense of movement and rhythm. The viewer can sense the presence of the painter's hand, sweeping the color across the painting surface. The vitality of this picture stems from the contrasts between the geometric, architectural subject and the rough, varied texture of the paint. The collage elements are interwoven so delicately that they harmonize perfectly with the painted passages and become almost invisible— they simply add an unobtrusive touch of texture.*

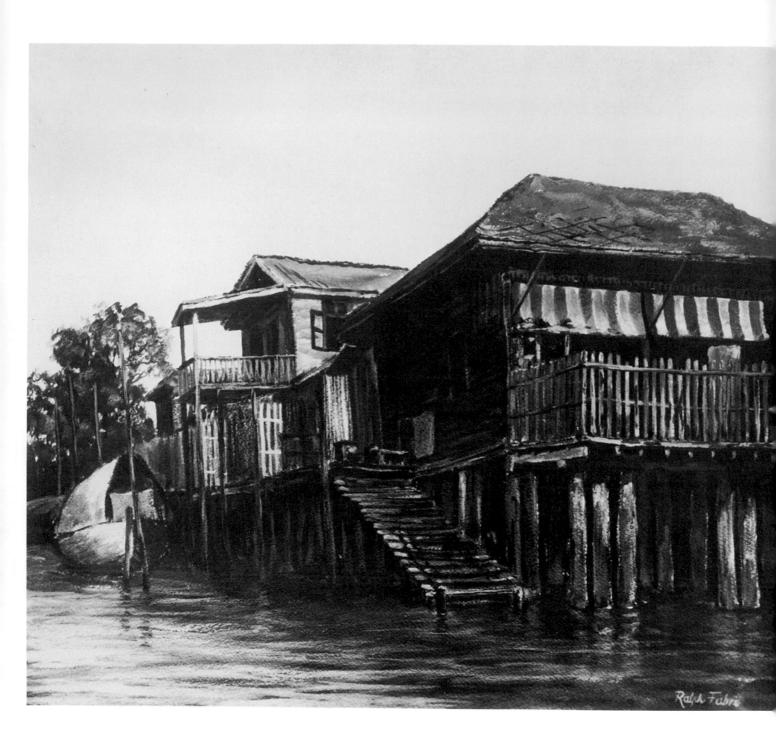

Houses of Bangkok *by Ralph Fabri, N.A., A.W.S., acrylic on watercolor paper. A charcoal layout was reinforced with thin yellow ochre outlines, and the artist began by painting the cloudy sky. "I painted this into the roofs and trees," says Fabri, "then established the forms and colors of the subject with thin washes. Next, I painted the water of the canal and the dark section under the houses all across, before indicating the stakes in various colors. Also the tree trunks and foliage. I added details with direct brushstrokes,* *using little or no water." The artist points out that the waterproof quality of acrylic "made it especially easy to paint the fences right over the background with a small bristle brush. At the end, I pulled certain parts of the picture, such as the dilapidated yellow and red striped awning, together by applying thin washes with a flat sable brush. I used reddish washes over the dark sides of the houses, and ochre wash over the water." (Photo courtesy M. Grumbacher, Inc.)*

ning watercolorist knows that it's a lot easier to lay a pale wash than a dark one. So you needn't mix the final dark tone in a cup and pray that you've gotten the tone right. You mix a medium tone and then lay one flat or graded wash over another until you get the exact density you want.

If you want to lay a dark graded wash, you can put down a couple of graded washes and a couple of flat washes over them; the first two washes will establish the gradation, while the next two will darken the sheet evenly, allowing the gradation to shine through.

Be ,sure to try this with just tube color and water, then with tube color, acrylic medium, and water. You'll find that the addition of some acrylic medium not only makes the job easier, but allows the color to retain a certain degree of luminosity despite the darkness.

If this is your first experience of laying one wash of acrylic watercolor over another, you'll make another delightful discovery. You'll wonder why each successive wash seems easier than the one beneath it. The later washes go on more smoothly and evenly than the earlier ones. What's happening, of course, is that the acrylic emulsion is progressively toughening the surface of the watercolor paper, making the sheet slightly less absorbent each time you apply a new layer of color. In Chapter 3, you may recall my mentioning that the relatively nonabsorbent papers take color more easily; thus, it should be no surprise that a surface which has been toughened by several layers of acrylic paint will be easier to paint on.

You also have the chemistry of acrylic paint working in your favor. It's the nature of a dried acrylic film to attract and hold a fresh layer of acrylic paint applied over it. The two layers lock together and become one continuous film. They reinforce each other. This is exactly the opposite of traditional watercolor, in which each successive layer of paint is a threat to the layer underneath. Chalk up one more point in favor of acrylic.

Multiple Overwashes

Think about what I've said and try a series of experiments in which you lay a series of washes of various colors and densities over one another. Building on the exercises you tried in Chapter 4, try laying warm colors over cool colors, cool colors over warm colors, flat washes over graded washes,

One of the great advantages of acrylic over traditional watercolor is that successive overwashes can be applied without any fear that a fresh wash will disturb the dried color underneath. Once a layer of color is dry, it's there to stay, and you can put fresh color over it without any danger of the dry color dissolving and producing a muddy mixture. Here are four successively darker washes, laid over one another. Try this with various color combinations.

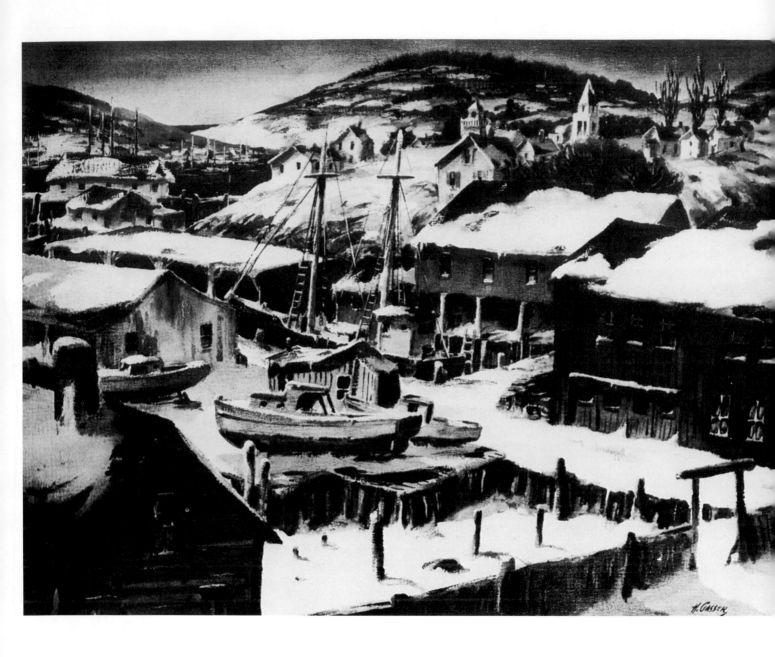

Winter Repair Yard *by Henry Gasser, N.A., A.W.S., acrylic on mounted watercolor paper, 22"x30", collection Milton Gelman. In this complicated interplay of architecture and natural landscape, the artist has used a broad vocabulary of wash techniques. The sky is an irregular graded wash. The buildings combine flat and graded washes. The rich darks of the shadow sides of the buildings make use of the multiple overwashes for which acrylic is especially valuable in building deep, transparent tones. The rough texture of the paper asserts itself frequently through passages like the strokes in the foreground, where it is helpful in rendering the weathered wooden posts.*

and vice versa. Here are some of the fascinating things you'll discover:

(1) The second wash will modify and enrich the first without disrupting the underlying wash by causing streaks or irregularities where there weren't any before. The underlying wash will remain as smooth as ever.

(2) Because the second wash won't disrupt the first, the two won't stir together and produce the muddy tones which are a constant threat in traditional watercolor. Although it should be obvious that two washes are less transparent than one, and three washes are even less transparent, a series of overwashes in acrylic watercolor will probably retain more luminosity than a similar series in traditional watercolor.

(3) This means that you can build up a color effect gradually, in a series of very delicate stages, and develop color effects of greater richness and greater subtlety. If a wash is too cool, for example, an almost imperceptible overwash of warm color will modify it to exactly the hue that you want. The underlying color will be modified without being demolished. Titian talked about applying thirty or forty layers of transparent color in an oil painting, and theoretically this is possible in acrylics as well. I doubt that you'll ever try thirty or forty overwashes, but it's fair to say that acrylic watercolor will allow you more overwashes than traditional watercolor with less loss of luminosity and less danger of turning them into mud.

(4) Because acrylic watercolor allows you this kind of color buildup, you can achieve much deeper, richer color—much greater weight of color—than you may be accustomed to in traditional watercolor. It's the nature of traditional watercolor to lend itself to light, airy pictures. But if your taste runs to sombre, moody effects, they'll be a lot easier to get in a series of acrylic washes.

(5) Because the paper grows less absorbent with each successive wash of acrylic watercolor, you'll find that the drying time of later washes becomes longer than the drying time of earlier washes. The wet paint lies on the surface of the paper somewhat longer. This gives you the freedom and the leisure to change your mind and experiment with special effects in the final stages of the painting.

One note of warning. If you're planning to do a painting that will contain a long series of superimposed washes, be careful about adding *too much* acrylic medium to your paint. Just a little will do. If you add too much medium to your washes, you may find that the painting surface becomes too tough, too nonabsorbent too early in the game. A tough, leathery skin may begin to form on the paper, which may become less responsive to the touch of the brush.

Semi-transparent Washes

As I've already said, most painters in traditional watercolor object violently to adding the slightest touch of opaque color to their transparent washes. They feel that opaque color destroys the delicacy of the medium, cuts down luminosity, and encourages the painter to "cheat" by using opaque color to cover up his mistakes.

In traditional transparent watercolor painting, opaque color usually means Chinese white. This *is* a dense white which is inclined to turn your color chalky, producing an effect more like casein or pastel. As John Singer Sargent demonstrated, modifying transparent color with Chinese white can produce effects of great beauty, but transparency is sacrificed for greater weight and solidity.

If you've tried Chinese white in traditional watercolor painting, and rejected the idea, you'll probably carry over the same objections to opaque white in acrylic watercolor painting. But suspend judgment until you've tried semi-transparent painting in the newer medium. Try a few experiments:

(1) Mix a wash of bright color and then add the faintest touch of acrylic white. When you apply this wash to paper, you'll find that the color is less chalky than a similar wash in traditional watercolor modified by Chinese white. The acrylic white has added a ghostly delicacy to the transparent color which lies on the paper like a semi-transparent veil. The whiteness of the paper still shines through, almost as it would through a transparent wash.

(2) Now mix and apply another wash of pure, transparent color without adding any white. This wash should be a fairly deep, dark tone. When the dark wash is dry, mix a wash of some lighter color, then add a faint touch of white to the new wash. Apply the new, lighter wash over just half of the darker wash. Modified by the second wash, the original color becomes more subtle and melts back into space like the sun covered by a slight haze.

Acrylic can be applied not only in transparent washes, but in hazy, semi-transparent washes. The vertical stroke is a wash of dark, transparent color; the horizontal stroke is a wash of lighter, semi-transparent color, which veils and lightens the darker color underneath. Try this experiment by adding just a touch of white to various colors, and then wash this colored haze over various underlying tones.

Compare the two halves of the dark wash, and you'll see that the part covered by the second wash *is* slightly less transparent, but still luminous.

For this experiment, try an underlying wash of bright, deep red, and an overwash of yellow with just a touch of white. Try the same semi-transparent yellow over a wash of deep blue. If you don't use too much white, you'll get subtle, luminous colors with a minimum of chalkiness.

(3) Paint another wash of bright, deep color—like red or blue—and cover half of it with a wash of a lighter color, like yellow, adding much more white this time, so that the overwash partially hides the underwash. Some red or blue should come through, but the overwash *should* become a bit chalky now. When the overwash is dry, cover it with a third wash of pure, transparent color, with no white added.

The result of this three step experiment will be a complex and fascinating color effect. The first transparent wash will peek through the second, semi-transparent wash, and the third transparent wash will eliminate the chalkiness of the second wash, restoring a feeling of transparency to the whole color passage.

(4) Apply still another bright, deep transparent color. When this is dry, apply a few thick dabs of really opaque color. In other words, squeeze out some white and just add a touch of transparent color to the white. This will give you a really opaque yellow or pink or whatever color you prefer. Lay some strokes of this opaque color over the underlying transparent wash. Now mix a wash of a third color—completely transparent, no white—and lay this over the entire passage, covering both the first transparent wash and the strokes of opaque color. Surprisingly, the entire passage will come out looking transparent. Covered with a wash of transparent color, even the thick, opaque strokes will come through as glowing notes of light. The opaque strokes will actually intensify the transparency of the overlying color.

If you've tried Chinese white in traditional transparent watercolor painting, you'll know that these effects aren't possible. Chinese white turns almost any mixture chalky. And you can't wash transparent color over a thick passage of Chinese white without picking up the opaque color and simply spreading the chalkiness through the painting. But used with care, and not overdone, acrylic white

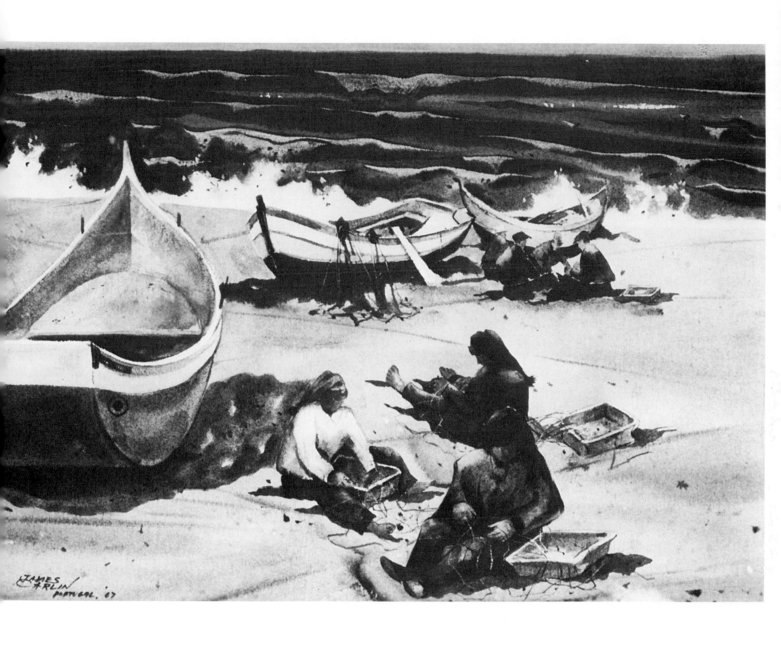

Silent Preparation *by James Carlin, A.W.S., acrylic on 300 lb. watercolor paper, 24"x30". The artist has handled acrylic with the spontaneity and transparency of traditional watercolor, but he has taken advantage of the density of the newer medium in the deep, rich darks of the waves, in the shadows beneath the boats, and in the shadow parts of the figures. While a wash of middle tone is still wet, it's easy to strike back into the wet color with a stroke of thick acrylic which blends wet-in-wet, as you see in the shadows beneath the crests of the waves. The foam is bare paper touched with water at the edges to create a wet-in-wet blend with the darker waves.*

will integrate with your transparent color and won't destroy the luminosity of your painting.

One important tip about washes of semi-transparent acrylic. A wash that contains a bit of acrylic white generally looks more opaque when it's wet than when it's dry. When you brush on the semi-transparent wash, you'll be horrified to see how white it looks; but when it dries, you may be equally surprised to see that it virtually disappears. You may actually wish you'd added more white for just a bit more covering power.

If you're trying to create an extremely delicate, semi-transparent veil, using mostly water and very little tube color, be sure to add enough acrylic medium to the mixture so that it flows on smoothly; this kind of wash is apt to dry to a somewhat irregular surface if you use water alone.

These semi-transparent washes serve two useful purposes, impossible with Chinese white in traditional transparent watercolor technique. Such washes lend a fascinating sense of atmosphere in landscape and seascape painting, particularly when you're striving for the effect of fog, or haze, or a rainy day. For example, you can paint a rock formation in full, rich color then paint a haze over it, so that the rocks melt back into space and give an effect of foggy distance. Or you can create a heat haze in a summer landscape.

The other value of such washes is to tone down colors which may be too insistent and out of key with the rest of the picture. You can even alter the hue if you do it with care. Suppose you have a garish, insistent red and you'd rather have a soft, melting orange. A wash of yellow, with a touch of white, will turn the red to orange and create an almost invisible haze that pushes the color back into its place in the total color scheme of the picture. If the yellow contains little enough white, no one but you will know it's there.

Corrective Washes

Because traditional watercolor remains water soluble even when it's dry, it's obviously a lot easier to correct your mistakes in the older medium. If the paper is tough enough to take the punishment, you can scrub out a defective passage with a bristle brush, or with a sponge. You can even soak the whole sheet in your bathtub, or under a running hose to get rid of most of the color and start over.

Because the new acrylics dry to such a tough,

insoluble film, it's practically impossible to wash out any mistakes you might make. True, if you dilute your tube color with an enormous amount of water and don't add any acrylic medium, this very pale wash won't stick to the paper very tenaciously, and you may be able to scrub it away. But most acrylic washes will resist the most ferocious scrubbing.

Since you can't remove the dried paint, the only way to correct a mistake is to add more paint in the form of a corrective wash. There are two kinds of corrective washes: opaque and semi-opaque. Here's how they work.

If you've painted a section which is a total flop, and you want to go back to the pure white of the paper, the simplest solution is to apply a thin, opaque layer of white. Thin the tube white with matt acrylic medium and a little water, brush the paint on very smoothly, and you'll retain the original texture of the paper. You can then repaint the passage over the opaque white wash just as if you're painting on fresh paper. The only difference will be that the surface of the corrected area will be somewhat less absorbent than the original paper.

I might add that your corrective opaque wash can be any color, not just white. If you're repainting a clump of trees, for example, you might decide that the opaque corrective wash should be yellow to provide a luminous underpainting for the wash of green that will complete the trees. Or if you're painting out a sky, and want to try a sunset effect, the opaque corrective wash might be a pale orange.

Sometimes, of course, you want to *modify* a passage that hasn't come off, rather than paint it out and start over. You may want to hold onto some of the color or texture, just not all of it. Here's where you can try a semi-opaque wash of white or perhaps some other color. Let's think about that clump of trees again. Perhaps the shape and value are right, and you like the rough brushwork that's already there, but the color has turned muddy. A semi-opaque wash of white or soft yellow might let you keep the general shape, tone or texture, but will lighten the clump of trees just enough to receive a fresh wash of color.

By the way, don't use acrylic gesso for corrections. Although I've recommended gesso to paint out a complete picture, so you can start over again, the white tube color goes on more smoothly and is more opaque when you paint out a limited area.

6. Wet-in-Wet Technique

Of all watercolor techniques, perhaps the most fascinating is wet-in-wet painting. However, wet-in-wet effects are also the hardest of all to control—which may account for the fascination of this method.

The simplest way to define this technique—sometimes called the wet paper method—is that it means applying wet paint on a surface which is already wet. You can sponge or brush clear water over your painting surface, then attack the wet surface with a brushload of color. Or you can cover the painting surface with a wash of color into which you brush still more color.

You can wet down just part of the paper, like a patch of sky or a body of water, and limit the wet-in-wet approach to just this area. On the other hand, some watercolorists soak the entire sheet in a bathtub of clear water, or sponge the entire sheet and paint the entire picture wet-in-wet.

What makes the wet method so difficult is that a brushload of color, applied to a sopping wet surface, generally runs off in some unpredictable direction. On a dry surface, a brushstroke lies more or less where you put it. Up to a point, you can control the flow of paint by tilting the drawing board this way and that way, by pushing the paint around with your brush, by sponging out areas that get out of control, and by blasting the wet surface with a hot air dryer (the kind women use to dry their hair) to accelerate drying when you've got the paint where you want it. But the wet paper method is like a wild horse you've never quite tamed. Just when you think you've got him under control, he throws you from the saddle and races off. The fascination of this method is the perpetual, unrelieved battle between you and the medium.

One of the great knacks to develop when you practice wet-in-wet painting is to spot—and take advantage of—the accidents that always happen along the way. As the paint runs away with itself, it often does miraculous things you could never make it do if you tried. Unexpected colors, tones, and textures appear out of nowhere, and you must know when to leave these alone, when to accentuate them, and sometimes when to build a picture around them.

Wet-in-Wet Painting with Acrylic Mediums

The professional watercolorist knows that one key to controlling wet paper effects is learning to control his paint consistency. He knows that a brush-

load of very *fluid paint* will spread a lot further, and a lot faster, on a sopping wet surface than a brushload of *thick, gummy paint,* only slightly diluted with water. Thus, depending upon the effect that he wants, he sometimes uses paint straight from the tube—undiluted with water—sometimes dilutes his tube paint with just a bit of water, and sometimes dilutes it with a lot of water. He also knows that a wet-in-wet effect will look *much* lighter when it's dry, so he always exaggerates the amount of paint that he brushes onto a wet surface.

Having read this far, you already know that one of the great advantages of acrylic watercolor painting is that the various acrylic mediums give you unusual control over paint consistency—far more control than you can get in traditional watercolor painting. In the traditional watercolor technique, all you can add to the paint is water, which will adjust your paint consistency up to a point, but no further. In acrylic painting you not only add water, but you can add various proportions of water and medium so that the brushing consistency of tube paint can be radically altered from moment to moment. In fact, you not only have the liquid matt and gloss mediums, but also the far thicker gel medium, which actually gives *more* body to your tube color, rather than diluting it.

So then, once you master the use of various acrylic mediums, you should have far more control over wet-in-wet painting effects. You can add pure water to your tube paint for very fluid effects, water and a bit of liquid medium for somewhat less fluid effects, lots of medium and very little water if you don't want a stroke to flow too far, pure liquid medium to cut down the flow even more, and pure gel medium for paint that hardly moves, even on the wettest surface. Now, let's try out some of these possibilities.

Controlling Surface Wetness

Before you explore the ways in which acrylic medium can be used to control paint consistency, there's another control problem which beginning painters often overlook when they first try the wet paper method. Not only must they learn to control the brushing consistency of their color, they must also learn to keep an eye on the wetness of the painting surface.

The professional watercolorist knows that there are varying degrees of surface wetness. When you first flood clear water or a wash of liquid color on your paper, the water rests on the surface for a moment, forming a very thin pool of fluid. Then the water begins to soak in. As the water soaks in, the painting surface becomes less and less shiny, moment by moment. While it's soaking in, the water is also evaporating, so there's less and less water *on* the surface, and less and less water *in* the surface. Eventually, the shine disappears from the paper altogether, meaning that there's more water *in* the surface than *on* it. Just before the paper dries, there's a stage when the surface *looks* dull and dry; all but a tiny bit of moisture has evaporated into the air, but the surface is still just faintly wet. Finally, of course, the surface dries altogether as the last bit of water evaporates.

At each of these stages, paint will behave differently on the surface. At the very beginning, when the water is pooled on the top of the paper like a shallow pond, a brushload of paint is likely to go spilling off in all directions, even if the paint is fairly thick. It's almost impossible to control your paint flow at this stage. Then, as the water begins to sink into the surface and the pool begins to disappear, a brushload of paint will still flow freely, but its movement won't be quite so quick and erratic, giving you a bit more control. As the minutes pass, with the water sinking in more deeply and evaporating more rapidly, your paint is less and less likely to disperse and blur; the edges become harder, strokes become more distinct, and paint is inclined to stay where you put it.

As you may have discovered by hard experience, the most dangerous stage is when the shine is completely gone from the paper so that the wash looks dry, but isn't! This is the stage when only the most experienced watercolorist dares to touch the surface for some final note or special effect. The odds are 100 to 1 that you'll ruin your picture if you don't stop painting when the shine disappears from the surface. This is the stage at which the slightest touch of the brush can turn into a gruesome, hard edged fan or blur; when paint gets picked up when you mean to put it down; and when beginners are tempted to give up the wet paper method for life.

To discover for yourself how paint behaves at these various stages of surface wetness, try the following little experiments.

(1) Take a scrap of paper about the size of your hand, and soak it in a sinkful of water until the

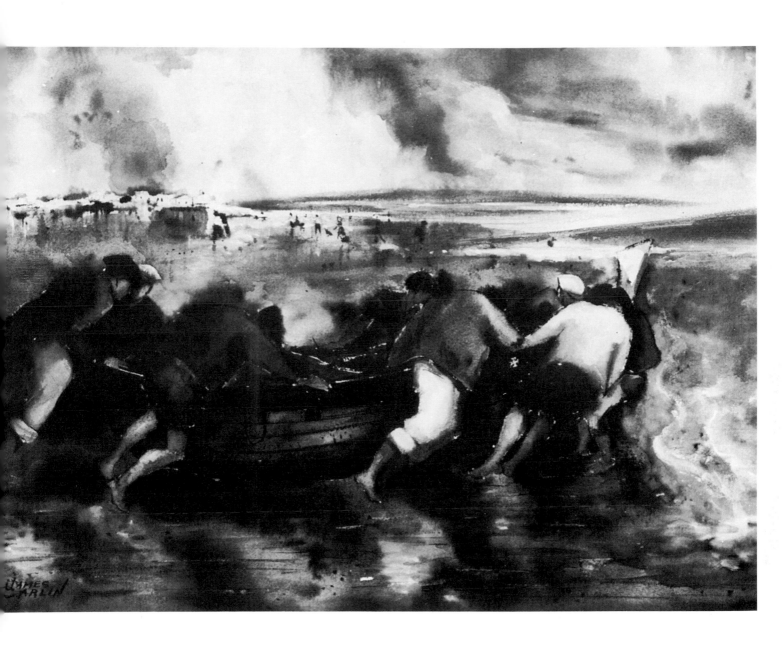

Emergency *by James Carlin, A.W.S., acrylic on 300 lb.
watercolor paper, 24"x30". The wet quality of the picture
matches the nature of the subject. Not only is the sea-
soaked sand—with its blurred reflections in the foreground
and in the middle distance—painted by the wet paper
method, but even portions of the figures blur into one
another and into the background. The sky was begun wet-
in-wet, then adjusted with a few hard edged passages when
the underlying color was dry. Without carrying this device
too far, Carlin has carefully placed delicate lines on the
foreground sand, on the boat, and on the figures, to
sharpen an edge here and there.*

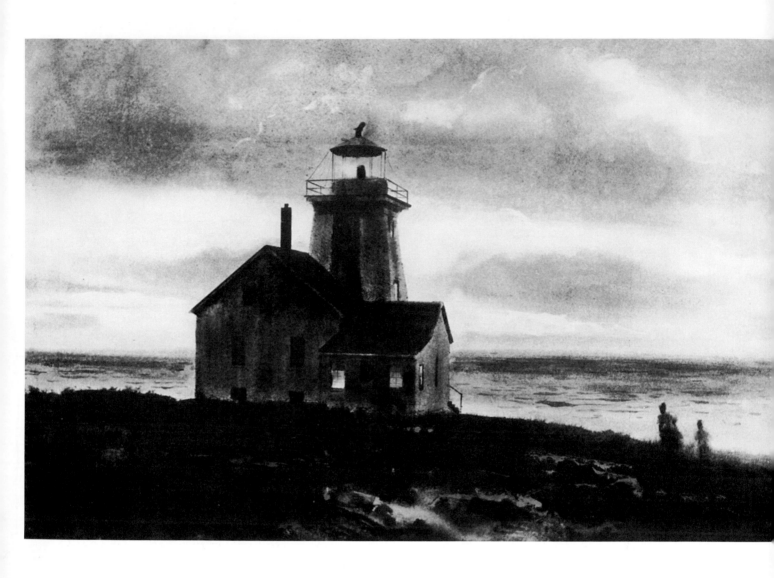

Point Prim Light *by Glenn MacNutt, A.W.S., acrylic on gesso coated Masonite, 24"x36". Although a gesso coated painting surface is less absorbent than watercolor paper, wet-in-wet painting is possible with a lot of practice. This coastal scene shows exceptional control of the wet paper method. The sky is a beautifully controlled wet-in-wet passage with whites deftly wiped out to pick out the edges of clouds and to indicate breaks of light behind the lighthouse. The horizon fuses softly with the sky. The dark mass of the foreground, also painted wet-into-wet, retains a slightly feathery edge where it overlaps the water beyond. Even the figures at the lower right were painted on a wet surface. Only the lighthouse itself has relatively hard edges, since this is the center of interest.*

paper is really saturated and limp. When you take the paper out of the water, hold the little sheet by one corner, so that the excess water drips off. Then, while the sheet is still sopping wet, carry it quickly to your drawing board—which should be flat, not tilted—and apply two strokes of color: one stroke of thick color, straight as it comes from the tube, and one stroke of fairly thin color, well diluted with water.

As I'm sure you realize, this is the stage at which the water forms a pool on the painting surface. Observe how the paint rapidly diffuses into the pool. Then tilt the paper slightly and see how the paint literally runs down the surface of the paper.

(2) Take another scrap of paper, about the same size as the first, and sponge or brush clear water over the surface. This sample paper won't be quite as wet as the paper you soaked in the sink, but there will still be a pool of water on the surface for a short time. With your drawing board level, not tilted, apply the same brushstrokes as you did in the previous exercise. Then tilt the paper once again. The results of both experiments should be more or less the same, with a very subtle difference, because one sheet has been soaked, while the other has been brushed with water.

(3) Brush or sponge clear water on still another scrap of paper, but this time let the water soak in. If you watch the surface very carefully, you'll be able to detect when the pool begins to disappear and the surface begins to absorb the water. The paper will still be shiny. Now try the same two strokes as before, first with your drawing board level, and then tilt it to study the flow of color. It should flow a bit more slowly. The edges of the stroke will still be soft, but not quite as blurred as they were in the previous two experiments.

(4) If any of the sheets from the previous three experiments are still moist, but the shine has disappeared, draw a brushful of paint, well diluted with water, across the strokes that are nearly dry. Watch what happens when the old strokes and the new stroke meet.

(5) Paint a fluid wash of color, well diluted with water, over the entire surface of another scrap of paper. While the pool of color is still very wet, quickly rinse your brush and flick out the excess water. Squeeze the brush gently to remove a bit more water, then draw a line across the wet wash. The hairs of the brush should soak up some of the wet color and leave a light line across the wash. Rinse the brush and remove the excess water once again, and wait while the wash begins to sink into the paper so the original pool is gone. Now, while the wash is still shiny, soak up some more color with your brush.

Finally, rinse your brush and remove the excess water once again, while you wait for the shine to disappear completely from the paper. Pick up a little clean water on the tip of your brush and make a stroke on the nearly dry surface.

By this time, you should have a better idea of the way paint behaves during the various stages of the drying process. You'll notice that I told you to use only tube paint and water, no acrylic medium. Now you're going to try some experiments with acrylic mediums.

Controlling Paint Consistency

For this series of tests you'll need some more scraps of paper (as usual), about an inch of matt or gloss acrylic medium in a paper cup, a dab of gel medium on your palette, and some fresh water. (Be sure to change your water frequently.)

(1) On your first scrap of paper, sponge or brush the surface with clear water. Pick up a brushload of color diluted with water and some acrylic medium, then draw a stroke across the fresh paper. Quickly pick up a second brushload of paint, diluted almost entirely with acrylic medium, and draw a second stroke on the wet paper. You'll see that the more medium you add, the less the paint is likely to flow. The medium helps your stroke stay in its place.

If you have lots of scrap paper to spare, it may be worthwhile to try this experiment when your paper is at the pool stage and then again at the next stage when the pool has begun to soak in.

(2) On a second scrap of sopping wet paper apply a stroke of paint which has been carefully blended with gel medium and just a bit of water. See how the thick paint holds its shape. Once again, it should hold its shape better as the pool begins to soak in.

(3) Cover a scrap of paper with a wash of tube color and water, no acrylic medium. With a damp brush and a damp sponge, try wiping away some areas of the wash. While the wash is still shiny, try adding some more color, diluted only with water.

In wet-in-wet painting, the character of the strokes is strongly influenced by the consistency of your paint. Here, a pale wash was applied over the entire surface of a scrap of cold pressed paper. Into this wet wash, three strokes were painted: at the top, tube color diluted only with water, yielding a fluid, soft-edged stroke; in the middle, tube paint, diluted with acrylic medium, yielding a more sharply defined stroke with somewhat more distinct edges; at the bottom, tube color blended with gel, producing a thick paint consistency that yields a strong, well defined stroke. In short, the thicker the paint, the more distinct the stroke.

If you carefully add and subtract color with brushes, sponges, and paper towels, a wet-in-wet wash can produce effects of remarkable subtlety and complexity. This passage, which resembles a stormy sky, began as a wash of middle tone, somewhat like the density of the lower left hand corner. Lighter tones were lifted out with a damp, wadded paper towel and damp bristle brushes. The darker tones were then added to the wet areas with a sable brush; the dark tones merged nicely with the lighter tones. The smaller flecks of light were picked out with the tip of a bristle brush, while the smaller flecks of dark were added with quick touches of the sable brush into the still wet surface.

Observe how the liquid color responds to being pushed around in this way.

(4) Now try another wash of liquid color diluted partially with water and partially with acrylic medium. Once again, try picking up color and wiping it away with a moist brush and a moist sponge. At the same time, try adding some fresh color that's been diluted mainly with acrylic medium. If you have time, try adding even more color that's been blended with gel medium.

You should discover that this second wash—diluted with water and acrylic medium—has a distinctly different consistency from the wash diluted with water alone, and takes additional treatment with far more ease. Because the paint is just a bit thicker across the entire surface, you have a much greater feeling of control.

(5) Cover another scrap of paper with a wash of color that's been diluted half and half with medium and water. Let this wash dry. Now choose a different, contrasting color and float a second wash over the first. While this second wash is still shiny, wipe some of it away with a damp brush or sponge, then add some more color thickened with acrylic medium and just a bit of water. Try pushing the second wash around, lifting here, wiping there, adding more color, and then taking it away.

Because the first wash has dried and slightly toughened the paper's surface, making it a bit less absorbent, the second wash goes on even more easily, and takes even more manipulation. It may also stay wet somewhat longer, giving you more leisure to get the effect you want.

(6) If one of your test sheets has now dried to the stage where the shine is gone and the paper is only faintly moist, see what happens when you go back into this most dangerous of all surfaces. Pick up some paint which has been diluted with acrylic medium alone—and perhaps just a bit of water which remains in the brush—and draw a stroke on the almost dry wash. Then try another stroke of color blended with gel medium and a bit of water. You'll be surprised to discover that these "afterthoughts" do much less damage than they'd do if you were working without acrylic medium.

In fact, you might want to try rewetting the entire surface with color diluted mainly with acrylic medium and a little water; instead of wrecking the original wash and turning it to mud, you might

just succeed in reviving the original wash and fusing it with the fresh wash so that you get a second chance. This doesn't always work, but it's worth a try if you think you can save a painting this way.

Now spread out this series of experiments and compare them with the previous series in which you worked only with tube color and water. Study the differences in behavior between wet-in-wet effects using tube color and water alone, tube color diluted with water and acrylic medium, tube color diluted mainly with acrylic medium, and tube color blended with gel. Try to remember these differences when you plan a painting, so that you can decide which blend should go where.

Let me make very clear that I'm not upholding the virtues of acrylic medium and trying to convince you to give up diluting your color with water alone. On the contrary, there will be times when tube color and water are just what you need—particularly when you want extreme fluidity. When you want less fluidity, you'll add more acrylic medium; right down to the point where you'll want the very gummy color you get by blending tube color with gel medium. You now have a full range of possibilities from extreme fluidity to extreme "non-fluidity," if there *is* such a word. Thus, your control over wet-in-wet effects should be far greater with acrylic than with traditional watercolor.

Controlling Drying

Because of the nature of his medium, the oil painter has maximum control over the drying time of his paint. He can add oils that retard drying, resins and volatile solvents that accelerate drying, and siccatives that speed up drying enormously. The painter in acrylics—particularly the acrylic watercolorist—never has this degree of control. But he does have more control than most watercolorists think.

I've already mentioned that a blast of hot air from a gun-shaped hair dryer will speed the drying of a passage that you'd like to "freeze" and prevent the paint from diffusing further, as it's apt to do on wet paper. The type of metal tea kettle with a tiny opening that emits a jet of steam will also function as a gun that shoots moisture onto a passage that needs to stay wet longer. In addition, here are a few tips about controlling drying.

(1) It's always tempting to extend drying time by flooding fresh water onto a wet surface. But remember that you can do this only when the surface is still shiny; when the surface shine begins to disappear, additional water may spell disaster.

(2) A sheet of watercolor paper that's been soaked in a tub will stay wet longer than a sheet which has been merely brushed or sponged with water. After all, the soaked sheet is wet all the way through, while the other sheet has merely been coated with water on one side. So if you want a longer drying time, soak your sheet; if you want quicker drying time, sponge or brush the sheet.

(3) Although adding acrylic medium doesn't retard drying time significantly, it does seem to give you more *working time*. That is, the paint remains brushable longer, although the drying time seems to be about the same. In reality, it's working time, not drying time, that counts.

(4) The nature of the painting surface will also have a strong effect upon drying time. Highly absorbent papers tend to hold the water longer and generally mean a longer drying time. Less absorbent, hard surfaced papers often have a shorter drying time because the moisture stays on the surface and evaporates more quickly. On the other hand, the paradox seems to be that an absorbent paper can have less *working time*, while the less absorbent paper can give you more working time; because the paint rests on the nonabsorbent surface, you have a bit more freedom to push it around before it dries. If you've tried Japanese paper as I suggested in Chapter 3, you've discovered that this highly absorbent paper gives you *no* working time; once the paint hits the paper, the stroke is there to stay and there's no leeway to make a change.

(5) When you paint on a sheet that's been soaked in the tub, the surface of your drawing board will also influence drying time. An absorbent surface like wood or fiberboard will soak up some of the moisture and accelerate drying time. A plastic surface or a sheet of glass—which many watercolorists use for the wet paper method—obviously won't absorb moisture and this gives you a longer drying time.

(6) Some painters slow down drying time by placing a wet blotter or a thick wet cloth beneath their sheet of wet paper. This seems to have the

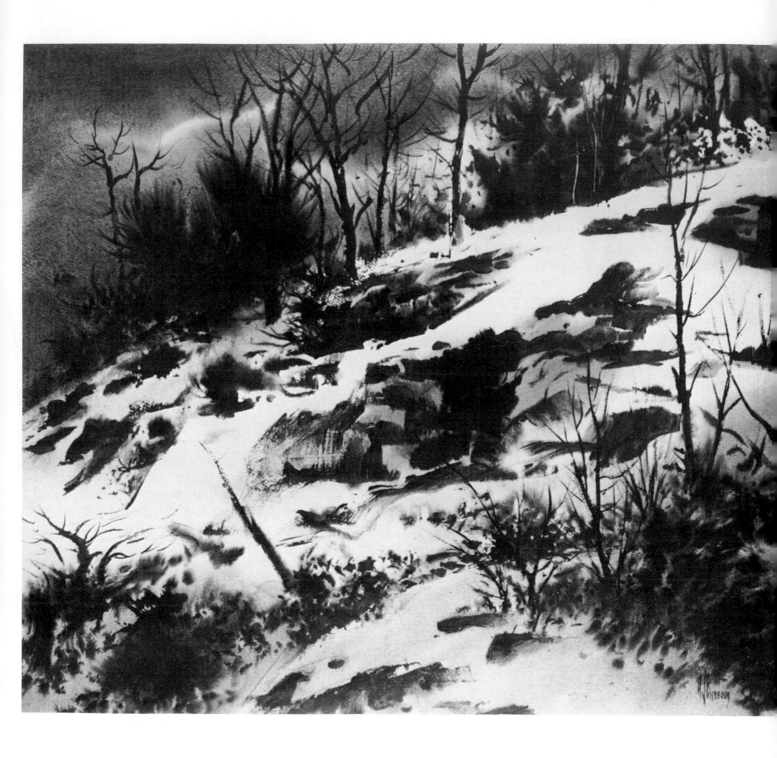

Winter Snow by Arthur J. Barbour, A.W.S., acrylic on watercolor board. The artist says: "First I pencil-sketched the scene from my car window. Large areas of the design were drawn in and mental notes were made on the spot. With the subject fresh in mind, I went to the studio and proceeded to paint. I wet the board with clean water and sponge. The main theme . . . the rocks and snow . . . was painted in first . . . in a transparent manner. Several of the trees were introduced on top of the composition. After the board was dry, I rewet areas and painted in the foreground and sky." It's worthwhile to study the amount of detail suggested within the wet-in-wet sky, the trees, and the growth in the foreground. If the paint is just thick enough and the surface is in the right state of semi-dryness, a stroke will retain its character and spread only slightly. Because acrylic dries waterproof, the surface can be wetted repeatedly and additional color areas painted in or reinforced. (Photo, M. Grumbacher, Inc.)

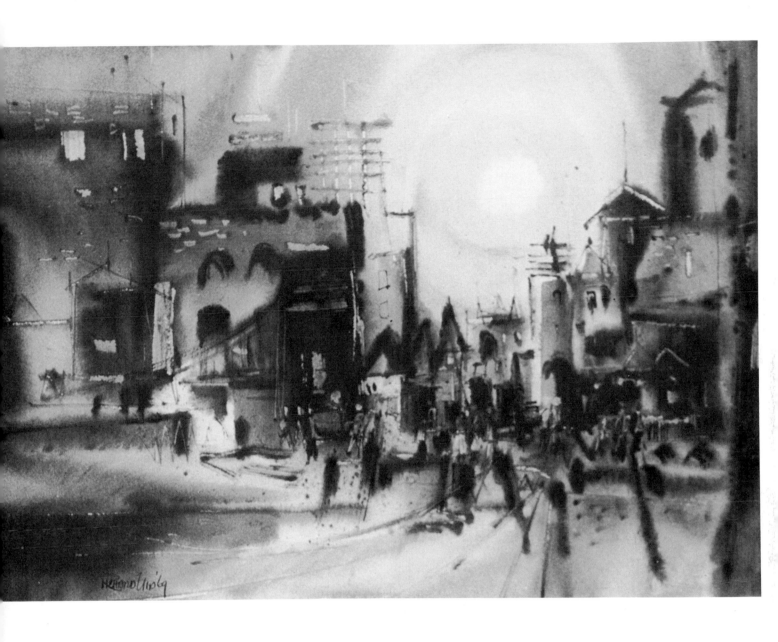

Cityscape with Sun *by Richard Yip, acrylic on watercolor paper, 15"x22½". Because the brushing consistency of acrylic color can be so carefully controlled—with or without the aid of matt or gloss medium—a wet-in-wet painting can hold a surprising amount of detail. What's most interesting here is the way the darks hold their places rather than disappear into a sea of liquid color. Applied thickly enough, acrylic will spread only slightly, and remain solid and distinct, while giving the soft edged look that wet-in-wet painters want. If the surface has just the right degree of wetness and the consistency of the paint is just thick enough, even very delicate strokes will stay put—like the flat, circular strokes surrounding the sun. It's also easy to scrape away wet-in-wet acrylic with a not-too-sharp pointed instrument, as Yip has done to suggest calligraphic accents.*

99

This mottled, graded wash, so different from the smoothly graded wash done with a brush, actually began as a solid wash of color. A damp paper towel—you can also use a sponge—was gently dabbed into the wet surface to lift the color gradually and produce this vibrant, atmospheric gradation.

This graded wash began as a scrap of sopping wet paper. A man-made rectangular sponge was dampened and folded into a rounded shape, something like a natural sponge. This unorthodox painting instrument was then dipped into a gummy mixture of tube color and lots of acrylic medium. The thick color was carefully dabbed into the wet surface with more color applied at the top than at the bottom. The color tended to spread slightly, but the texture of the sponge is still evident.

effect of pumping in additional moisture from the back of the sheet.

If you're going to do a lot of wet-in-wet painting, it's worth the effort to devote some time to trying out these various ways of speeding up or slowing down your drying time—which really means your working time.

Wiping, Lifting, and Scraping

Because the effects of wet-in-wet painting are always so unpredictable, it's not only important to learn how to apply paint, but also how to remove it. I've already pointed out that you can lift wet paint with a damp brush, if you're careful to flick out the excess water and then squeeze out a bit more with your fingers so that the brush acts like a pointed sponge. In Chapter 2, I also mentioned that you can lift and blot out color with paper towels and cleansing tissues. But perhaps the most useful tool for this purpose is the sponge . . .

Before you begin to work, be sure to soak the sponge so that it's absolutely soft and flexible. A sponge which is only partially wet feels stiff and is inclined to scrape the paper, leaving a scratchy trail, rather than wiping out the color. After the sponge is thoroughly soaked, you can squeeze out nearly all the water, leaving the sponge just faintly damp. A soft, damp sponge will wipe the paper amazingly clean, provided that the paper you choose has a fairly hard, nonabsorbent surface. Sponges don't work so well on soft, absorbent papers, which may be roughened and irreparably damaged by any kind of rubbing.

Put down a wash of color and then try different kinds of sponge strokes on the wet color. Try pressing the sponge down and then lifting it up, without moving it across the paper or rubbing. This will leave a mottled, irregular mark; if you press lightly, only a little color will be lifted, while if you press heavily, much more color will be lifted away. Now try a long, slow, wiping motion and see how much color you remove when you press lightly and press heavily.

If you buy a flat, rectangular sponge—the synthetic, not the natural kind—you can cut this into a number of shapes for different painting purposes. You can cut it into long, skinny rectangles for cleaning away strips of color. You can cut it into circular shapes for dabbing and for lifting round areas of color. You can even cut wedge shapes

This irregularly graded wash—which really consists of individual blurs of color roughly placed next to one another—was produced by a sponge on dry paper. The sponge was dampened, wadded into a round shape, dipped into liquid color, and then pressed against the paper in a series of quick up-and-down movements. Each blur of color is an individual sponge mark.

This unusual texture was produced by a combination of gel medium and a man-made sponge. A scrap of watercolor paper was thickly coated with a gummy mixture of tube color and gel. While the paint was still wet, a damp sponge was pressed into the surface. When the sponge was lifted away, the mottled texture of the sponge was imprinted on the paint.

This stipple effect was produced with the irregular tip of a sponge on wet paper. The paper was first covered with a light wash. A rectangular man-made sponge was dampened and the corner of the sponge was dipped into liquid color slightly thickened with acrylic medium. The tiny flecks and blurs of color are quick touches of the corner of the paint-coated sponge. The touches spread softly into the wet surface.

Washes of color diluted with acrylic medium lend themselves to scraping with various blunt tools, provided that the color is still wet. The thin line to the extreme left was made with the blunted point of a metal paring knife. The slightly thicker line was scraped away with a wooden ice cream stick. The still thicker line, second from right, was produced with the side of a butter knife; note the interesting pileup of paint along the edges. The very wide, rough area of light at the extreme right was scraped away with an old, blunt carving knife.

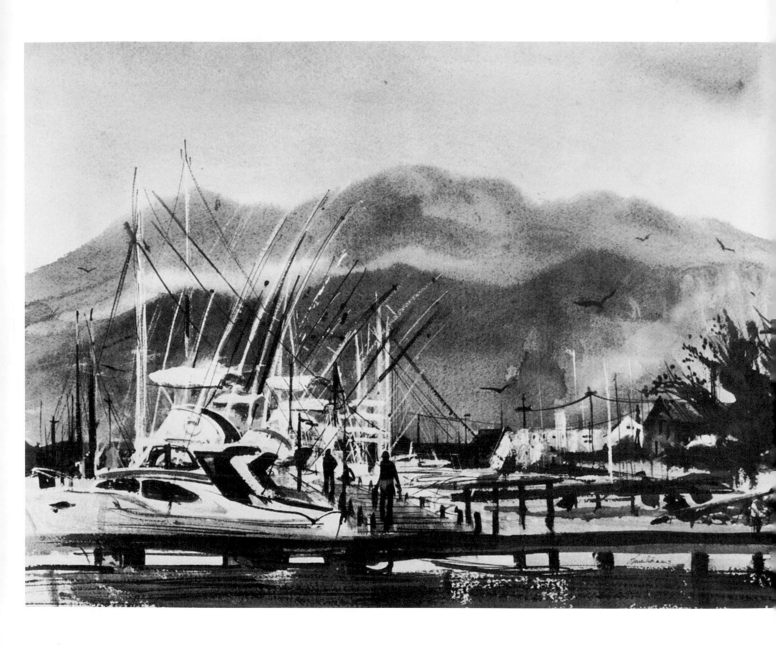

Kingston Harbor *by Jay O'Meilia, A.W.S., acrylic on 300 lb. Arches paper, 21"x29". The scintillating whites of the boats and their masts are dramatized by the big wet-in-wet forms of the mountains beyond, which blend softly into the sky above. The whites were apparently painted over the darker shapes of the mountains and many of the strokes are irregular drybrush, allowing the background darks to come through. The biggest, roughest drybrush strokes are in the immediate foreground. This "rule of thumb" is popular among professional watercolorists: big, rough strokes in the immediate foreground; smoother, more precise brushwork in the middle ground; soft edged passages, minimizing detail, in the distance.*

which will give you surprising precision when you want to lift a small area of wet color.

Nor should you forget the sponge brushes which I described in Chapter 2. The large ones will clear away a big, wide strip of color with one firm stroke. The smaller ones can be handled like brushes, taking away color instead of applying it.

Of course, the sponge isn't only a lifting and wiping tool. It can also be a very effective painting tool. You can use a sponge to dab color straight into a wet wash to introduce a blur of tone, which will quickly melt into the surrounding wetness. A series of dabs, covering an entire area, can produce a lively, irregular, granular tone, which has a texture you can't get any other way. A sponge will carry thick, gummy color that may be too stiff for your brush to carry; on the other hand, you can also soak up a spongeful of very liquid color and literally squeeze this out over the paper, thus introducing fresh color and interesting accidental effects into a wet wash.

When you paint with a sponge, particularly when you're adding color to a wet wash, don't press too hard against the paper, or the sponge will soak up color instead of depositing fresh paint. Pressure is for lifting color; handle the sponge lightly when you paint with it.

The wet paper technique also lends itself particularly well to scratching and scraping. In Chapter 2, I mentioned that it's wise to have a sharp knife handy for scratching dark lines into the wet paint. If the point of the knife digs into the surface of the wet paper, the liquid color will fill the scratch and this will become a dark line. This is an excellent trick for indicating twigs, dark weeds and grass, masts and rigging on ships.

You can also introduce a note of white into a soaking wet wash with a blunt instrument like a butter knife or an ice cream stick. The idea is to draw the tool across the paper in such a way that the paint is squeezed out or pushed aside. You don't dig into the paper, which would produce a dark line, but actually press the color out.

The acrylic mediums make all these tricks easier. Dabbing and pressing paint into a wet surface with a sponge is much more effective if the color is thick and gummy, which simply means adding acrylic medium or gel to the tube color. In the same way, it's much easier to scrape away a wash of wet color that contains acrylic medium, which is thicker and more scrapeable than a wash which contains only water. Try it both ways and you'll

see. I should point out that all the tricks I've described in this section are equally suitable for any kind of wash. You can also go back into a flat or graded wash with a sponge, a knife, or a blunt instrument for scraping paint. But these techniques are particularly useful in wet-in-wet painting, which tends toward an overall blurriness and often needs a change of texture, or a crisp note of dark or light.

Correcting Wet-in-Wet Effects

Once it's dry, correcting a wet paper effect is even harder than correcting a flat or graded wash. Because a wet-in-wet effect is all soft edges and blurry transitions, rather than sharply defined shapes, it may be difficult to paint out an unsuccessful area with opaque white and start over again. If the wet paper effect is confined to an area like the sky, with clearly defined shapes of buildings or mountains at the horizon, you can paint out the entire sky right down to the horizon line, let the white paint dry, and then try a new wet-in-wet attack. But if the entire picture is painted wet-in-wet, with no crisp edges where one color area ends and another begins, then painting out probably won't work. However, there are some last ditch measures which are worth trying if the painting is really a hopeless mess and you have nothing to lose.

(1) Using the flat wash technique described in Chapter 5, try covering the unsuccessful painting with a semi-transparent wash of white or some other color. This will put a white or colored haze over the entire picture, turning all the colors pale, but leaving some hint of the original design. When the semi-transparent corrective wash is dry, you can flood the paper with clear water once again, and try for some fresh wet-in-wet effects that will come closer to your original intention. Try to strengthen the areas that need more punch, but let the weaker areas remain half hidden in the haze.

(2) Again going back to the technique described in Chapter 5, try a graded wash in semi-transparent color, either white or some other light hue. This might be a good solution if your wet-in-wet picture is worse at one end than another. You can even lay a diagonal graded wash, which starts out pale in one corner and gets more and more opaque at the corner diagonally opposite. This is useful if the unsuccessful part of the picture occupies a corner.

(3) A third possibility, certainly the most difficult and hazardous, is to flood the entire picture with

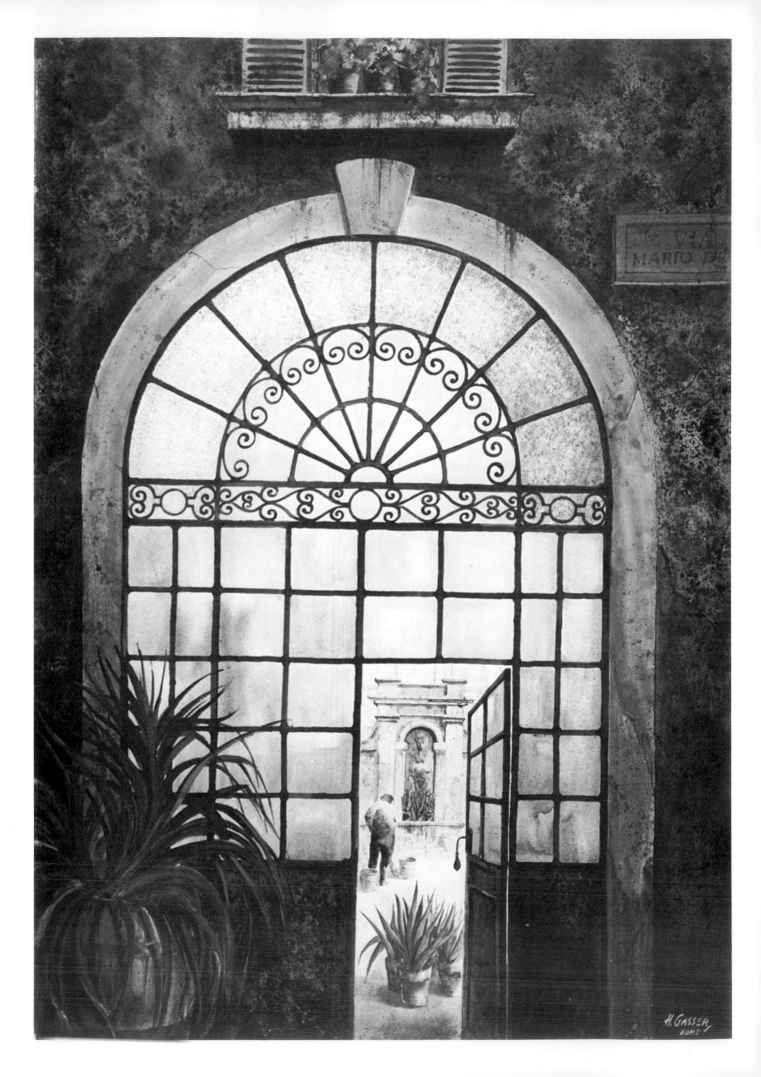

lots of clear water, or soak the sheet in the tub once again, and drop soft blurs of semi-transparent white or some other light color onto the bad spots of the composition, letting these blurs spread and intermingle in their own accidental, unpredictable way. In this way, the semi-transparent haze will cover some parts of the picture more heavily than others. If the haze thickens and thins out in the right places, you have a decent chance to try once again when the haze dries and you start a new wet-in-wet attack.

(4) The solutions I've just suggested—semi-transparent washes that are allowed to dry before you start to paint again—can also be used in a different way. You can flood the unsuccessful painting with one of the half-concealing washes and try a new wet-in-wet attack while the corrective wash is still wet. What you'll get, of course, is a semi-transparent painting, not the traditional transparent one. You might get something that works— and it's your last chance anyhow.

(5) Of course, such radical corrections may not be needed. You may just wish that the colors were a bit different, that you'd put in a blur of foliage here or perhaps a dark cloud where you now have a white one. The solution to these problems is a lot easier. Simply wet the paper once again, and superimpose the new color, the new shape, or the new texture, putting it where you want it and letting it blend into the wetness. When the new wet-in-wet passage has dried, it should merge with the old one. Normally, this corrective method is taboo when you work with traditional watercolor. The second wet-in-wet attack is likely to wreck the underlying color. But remember that acrylic dries waterproof, so that you can pile one wet-in-wet passage over another, building increasing subtlety and richness without any danger that the overwash will dissolve the underwash.

The most serious objection to all these corrective measures—except for the last one—is that they introduce a semi-transparent layer of white or some other opaque color. The purist who believes that only transparent watercolor is the real thing will prefer to chuck the painting and start over again on the other side of the sheet. I won't argue with him. But if that semi-transparent veil of color is applied delicately enough, allowed to dry, and then covered with transparent color, the effect *can* be close to a pure, transparent watercolor. You may even find that alternate washes of semi-transparent and transparent color produce a depth and luminosity that surpass a picture painted entirely in transparent color.

The Open Door *by Henry Gasser, N.A., A.W.S., acrylic on mounted cold pressed watercolor paper, 30"x22". The beautiful precision of the design can tempt you to overlook the intriguing array of controlled accidents and very free painting in this elegant study of a glass doorway. Within the crisp tracery of the ironwork, the panes of glass are painted in an unobtrusive wet-in-wet technique. The curved panes at the top of the doorway appear to be stippled, while the wall surrounding the doorway combines wet-in-wet blurs and dabs with a highly controlled use of spatter and stipple.*

7.
Drybrush, Scumbling, and Opaque Painting

Up to this point, I've focused on all the ways in which the new medium of acrylic can match traditional watercolor—and often beat the older medium at its own game. However, I hope I've also made clear that acrylic adds a whole new range of possibilities to the vocabulary of watercolor painting. If you've tried all the little tests that I've recommended in preceding chapters, you know that the various acrylic mediums give you unprecedented control over the consistency of your paint. You've also gotten a taste of the remarkable ability of acrylic paint to give you complete transparency, complete opacity, and lots of stages in between, ranging from the most delicate semi-transparent haze to the thickest semi-opaque fog.

Once you get going with acrylics, you'll find it hard to resist the temptation to exploit the full range of these possibilities. Watercolorists who switch to acrylic are likely to begin by trying all the traditional transparent techniques which they've mastered in the older medium. After a while, however, they begin to explore all the things that acrylic can do—and that traditional watercolor *can't* do. Thus, many acrylic watercolorists evolve a kind of mixed technique, combining luminous transparent color with more opaque passages.

They find, for example, that acrylic greatly extends the range of drybrush effects that are possible in traditional watercolor. Among other things, they find that they can drybrush light paint over dark, something which is unthinkable in the older medium. They also discover the fascination of scumbling and broken color, both of which are methods of semi-opaque painting which add weight and richness if they're not overdone. And finally they discover that opaque color may *not* demolish a painting after all, but might just enhance it. They're astonished to find that no lightning bolt falls from heaven when they paint their first opaque picture.

Drybrush Washes and Strokes

In traditional watercolor painting, the technique of drybrush is fairly simple. You pick up some fairly liquid color on your brush, then flick out most of the color or wipe the brush on a paper towel, so that just a hint of color remains on the brush. The brush can be just damp or it can actually contain a fair amount of color, but it's not really sopping wet. Thus, you can't really lay a solid wash of color.

You then apply the color to the painting surface by just grazing the paper, rather than by bearing down on the painting surface to cover the paper evenly. You know, of course, that the texture of the paper is uneven; that is, there are lots of little peaks and valleys, which can be very pronounced in the paper designated as "rough" and less pronounced in the paper designated as "cold pressed." As the brush glides over the surface of the paper, color is deposited only on the peaks; there isn't enough liquid color to settle down into the valleys. The harder you press, the more paint you deposit on the peaks and you may force a bit of color into the valleys. But, as I said, you don't really get a solid layer of color.

How you hold the brush is important. If you hold the side of the brush parallel to the surface of the paper, you won't force the color into the valleys; you'll touch only the highest points of the peaks, and that's where the paint will stay. In other words, this is the way to put down the lightest veil of color. On the other hand, if you hold the brush vertically—more or less at a right angle to the painting surface—and force the tip of the brush downwards so that the hairs dig into the paper, you obviously shove more color into the valleys, as well as leaving color on the peaks.

Here are some experiments to try as a means of finding out how your drybrush effects are influenced by the way you hold the brush, by the amount of paint you pick up, and by the consistency of the paint.

(1) Mix a wash of liquid acrylic color, using only tube color and water. Dip your largest flat brush into the wash and lightly shake out some of the liquid color. Hold the brush more or less parallel to the painting surface and press your thumb down against the hairs of the brush as you move across the paper. What you'll get is a kind of "drybrush" wash, which won't give you a solid wash of color, but a layer of semi-liquid color that's broken here and there by lots of little flecks of bare white paper. Such a wash has a rough, vibrant effect, something you may find especially effective for painting the wall of an old building, a rocky cliff, or a country road.

(2) Now take the same brush, dip it into the liquid color once again, and wipe the brush on a paper towel, which will absorb most of the color, but not all of it. Hold the brush at a right angle to the

This is what might be called a drybrush wash. A large, flat brush—round ones don't work so well for this kind of thing—is dipped in liquid color, thinned only with water, and then lightly shaken to get rid of any excess fluid that might drip off the brush. You can then hold the brush roughly parallel to the painting surface with one hand, and pull the brush across the surface as you press the flat of the brush against the paper with the fingers of the other hand. The color doesn't quite cover, doesn't quite sink into all the valleys of the paper, but leaves little flecks of light. This irregular type of wash is ideal for painting the glint of sunlight on water or certain kinds of cloud formations.

If you hold a large, flat brush at right angles to the painting surface—with the brush straight up, that is—and sweep it quickly across the paper with just the very tips of the bristles touching the surface, you get this kind of streaky drybrush wash. The brush should be just damp, not wet. Note that the brush was wetter when it made the strokes at the top of this sample than those at the bottom.

Holding your brush straight up, at a right angle to the painting surface, press down hard so that the bristles are flat against the paper. The brush forms an L, with the handle vertical and the hairs horizontal. If the brush is damp with color, not sopping wet, you'll produce this kind of drybrush effect. The brush was wetter at the top of this sample than at the bottom.

Drybrush strokes can be thick and dark, light and delicate, revealing more paper or less. Try strokes with all your brushes, the large ones and the small ones, the flat ones and the round ones. Try strokes with a fair amount of color on the brush and strokes with very little color on the brush.

painting surface—straight up, that is—and skim the paper with the tip of the brush. See how little color you can deposit.

(3) Pick up some more liquid color on the same brush, get rid of most of it, hold the brush straight up once again, and jam it down hard against the paper as you make your stroke. I don't mean you should wreck your brush by making the bristles splay out in all directions, but rather that you should press down hard enough so that the brush forms a kind of L, with the hairs bending at a right angle to the brush handle. See what kind of color coverage you get this way.

(4) Now take your largest round brush and try the same three exercises. Chances are that the round brush will give you a rougher, less distinct stroke than the squarish stroke of the large, flat brush.

(5) So far, you've been working with fluid paint. Now squeeze out a dab of tube color on your palette and don't add any water. Wet the large flat brush, get rid of most of the water, and dip the brush into the pasty tube color. Drag the gummy color across the paper surface and see how this thicker paint consistency behaves. Do the same thing with a large round brush. You'll find that the stroke has a fascinating, crusty quality which is quite different from a drybrush effect that's executed with more fluid paint.

(6) Try these exercises with your smaller flat and round brushes. With practice, you'll find that you can execute small, precise drybrush strokes that are excellent for painting the grain of wood, the cracks in rocks, weeds and grasses, and other linear elements that need to be broken strokes rather than solid, continuous strokes.

Once you get the hang of it, drybrush is such a fascinating technique that you may be tempted to paint a whole picture this way. Don't! Drybrush is most effective when used sparingly. Use it for that mass of trees on the horizon, but not for the sky; those drybrush trees will look a lot more effective against a flat or graded sky wash, or against a stormy wet-in-wet effect. It may even be a mistake to use *only* drybrush for that rock formation or that old wooden barn. The drybrush will have much more impact if you establish the general color of the rocks or the barn with a flat or graded wash—or maybe a drybrush wash—and then add a few precise drybrush strokes for texture and detail.

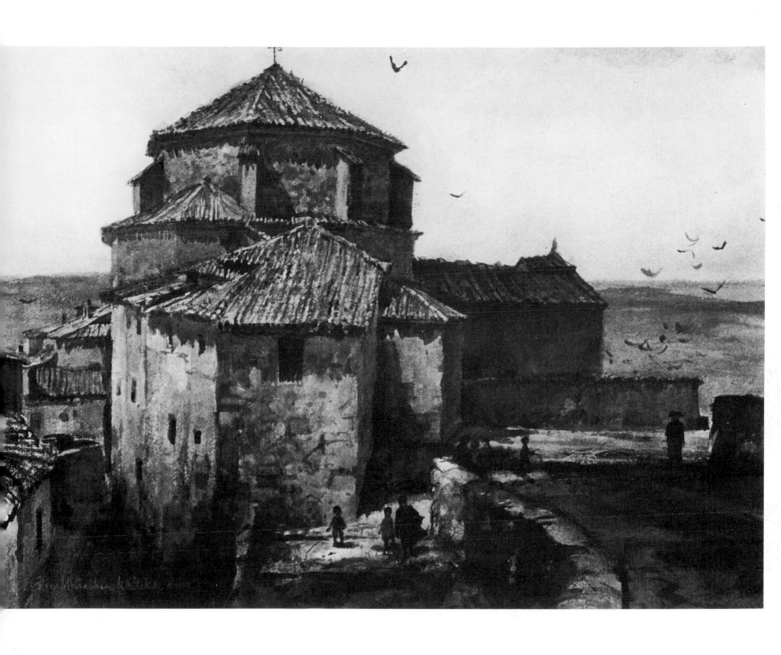

Cuenca, Spain *by Eileen Monaghan, A.N.A., A.W.S., acrylic on 300 lb. watercolor paper, 22"x30". This architectural subject is worth careful study for its combination of strokes, textures, and superimposed transparent washes. The rough surfaces of the walls are rendered by a series of transparent washes, roughly applied with hints of drybrush, to create a sense of broken color. Over and into these washes, the artist has applied a random, but controlled, pattern of smaller strokes to indicate stonework, roof tiles, balconies, etc. Compare the sparkling drybrush strokes (with breaks of light between them) on the rooftops with the delicate precision of the more fluid, melting strokes used to suggest the masonry on the wall at the center of interest. Even within the darks of the shadowy walls and windows, details are suggested.*

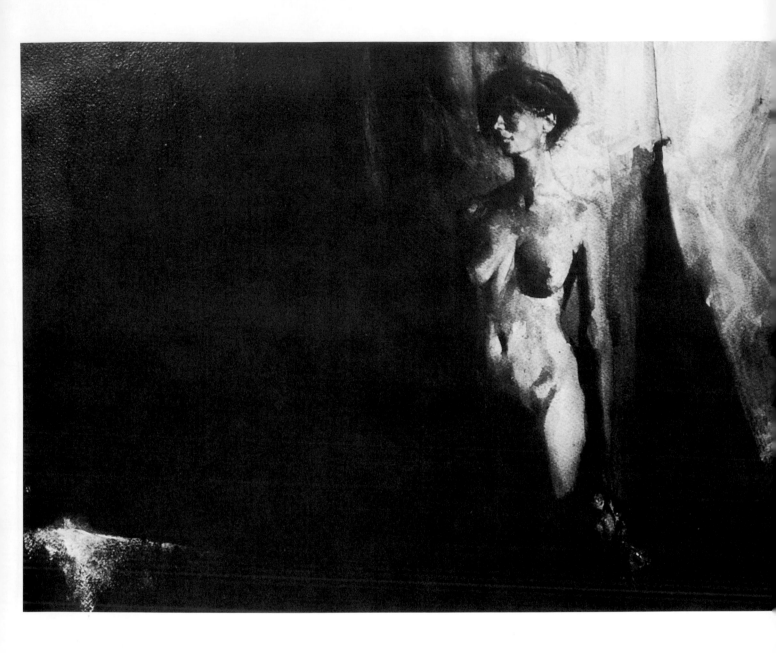

Blind Girl *by Charles Schorre, acrylic on 140 lb. watercolor paper, 20"x24". Here's striking evidence of the remarkable ability of acrylic color to produce rich darks that retain their sense of luminous transparency, even when the dark passages verge on total blackness. It's best to build such passages wash upon wash in order to retain this transparency. Notice how touches of detail continue to emerge from the blackness, just as the girl's figure melts away from light into dark. The light areas are strokes of semi-transparent color which allow tone to come through; study how these touches of light are used to model the nude figure and the scumbled light area behind her head.*

Drybrush and Acrylic Mediums

Now that you've explored drybrush with acrylic tube color and water—which isn't enormously different from working with traditional watercolor—you should now try some of these same techniques with acrylic tube color, water, and various acrylic mediums. The point, of course, is that acrylic mediums give you much greater control over your paint consistency. This greatly increases the range of possible drybrush effects. Here are some more exercises to try.

(1) Mix up a wash of acrylic tube color, dilute it with a half-and-half combination of acrylic medium (matt or gloss) and plain water. This will give you a thicker, creamier consistency than a simple mixture of tube color and water.

Once again, take your biggest flat brush and lay what I've called a drybrush wash. You'll remember that this is the kind of wash that you put down by holding the brush parallel to the painting surface and pressing the bristles down with your thumb or a couple of fingers as you pull the brush along. You'll see that the creamier consistency of a wash that contains acrylic medium allows you to brush the color onto the paper much more smoothly and more easily; the wash literally feels a bit like thin oil paint, although the effect is definitely watercolor.

(2) One by one, pick up each of your brushes—your biggest round brush, your smaller flat and round brushes—and try out all the drybrush exercises I outlined in the previous section. (At this point you're still working with the wash of acrylic tube color, medium, and water.) Above all, you'll find that the slightly thicker, creamier consistency of the wash will make it much easier to drag your brush across the ridges of the paper without the color settling into the valleys. Because the fluid color has been slightly thickened by acrylic medium, the color is more inclined to stay where you put it.

(3) This time, mix up a pool of color that's just paint from the tube and straight acrylic medium, either matt or gloss. This will give you a much thicker pool of color. Go back and try all these drybrush effects once again. Compare the way the brush behaves when you work with these three different paint consistencies: tube paint and plain water; tube paint, medium, and water; and tube paint with just plain medium. As the paint thickens, your brush is apt to move more slowly, the paint is more likely to stay where you put it, and the paint itself looks heavier and more substantial on the paper.

What you're learning is the fact that the range of drybrush effects is much greater than you think, and these effects are determined by many different "variables," to use scientific lingo. You can adjust your paint consistency from very fluid to very thick. You can control how much paint you deposit on the paper by the way you hold the brush: parallel to the paper, at right angles to the paper, or at some angle in between. You can also affect how much paint you deposit by how hard you press against the paper: the brush can glide delicately along, be pressed down by your thumb, be jammed into the paper, etc.

I might add one further "variable": you ought to experiment with *speed*, drawing the brush more quickly or more slowly across the painting surface. A quick stroke with slight pressure will leave only a delicate trace of paint, while a slow stroke with lots of pressure will deposit much more paint.

(4) Acrylic gel medium makes it possible for you to do something which is unthinkable in traditional watercolor. Squeeze out a dab of tube color, and then squeeze out a dab of gel medium right next to it on the palette. Wet a medium sized brush, flat or round, and shake out most of the water so it's damp, but not sopping wet. The brush should have just enough water in it to allow you to blend the tube color and medium into a mixture like stiff mayonnaise. By the time you finish mixing the tube color and the gel, your brush will be covered with gummy paint—really too much to paint with. So wipe the brush on the palette a few times to get rid of some of the paint, leaving just enough color on the brush to make a variety of drybrush strokes.

If the blend is thick enough and if you've got enough paint on the brush, you can build up a drybrush passage that has a slight *impasto*. That is, the paint will be thick enough to stick up a bit from the paper. It won't just *look* rough to the eye; when it dries, it should *feel* rough to the fingertip. Yet the paint will be luminous and transparent.

If you really want to build up your paint texture, allow this rough passage to dry, then brush on some more. By applying several layers of drybrush with gel, allowing each layer to dry before you put on the next, you can produce some really fascina-

Tube color diluted with acrylic medium lends itself especially well to drybrush painting. To paint this sample, a flat brush was dipped into a mixture of tube color, matt medium, and just a touch of water. The brush was drawn down the paper in a series of vertical strokes, starting at the left and ending at the right. With each stroke there was less paint on the brush, and more paper showed through the stroke. The thickness of the paint gives you greater control than you'd get if the color was diluted only with water; the heavier paint is less inclined to flow over the paper, more apt to stay exactly where you put it.

An important rule to remember in drybrush painting is this: the thicker the paint consistency, the rougher and more ragged the drybrush effect. These drybrush strokes were painted with tube color blended with gel medium. Even where the paint is heaviest and darkest, flecks of light still shine through. In the lighter areas the gummy paint rests only on the peaks and never flows down into the valleys of the painting surface. This paint consistency is especially useful for painting rough textures like rocks, tree trunks, and weathered architecture.

ting textures. Rocks can look rockier, weathered wood can look even more weathered, and you can begin to rival the weight and depth of an oil painting. But let me repeat my warning: if ordinary drybrush is to be used sparingly, then this kind of drybrush impasto should be used even more sparingly. Don't let it dominate the picture. Your painting will begin to look like it was executed on sandpaper.

(5) You've just learned that you can put one drybrush passage over another if you allow each layer of paint to dry before you apply the next. This is one of the unique qualities of acrylic; unlike traditional watercolor, acrylic dries insoluble, as I've said, and a fresh layer of wet color won't dissolve or stir up the layer underneath. This can be particularly valuable in drybrush painting. For example, suppose you want to paint an old, crumbling wall in which the gray masonry has been overlaid with traces of paint, a layer of moss, and various stains left by years of exposure to the elements. You may want to apply several different coats of drybrush in several different colors. You can do this in acrylic, but it may be hard to do it with traditional watercolor.

The way to do it in acrylic is to paint the general tones with a flat wash, a graded wash, or perhaps a drybrush wash—whichever you think is best. When this is dry, you can drybrush on one color, let it dry, drybrush on a second color, continuing the process of painting, drying, and repainting until you've got what you want. The final effect can be rich tapestry of color and texture. When you're working in traditional watercolor, each new drybrush application is likely to scrub off or stir up the soluble paint underneath.

(6) Here's another drybrush effect which is possible only with acrylic. Put down a solid, dark tone and then let it dry. When the underlayer is dry, drybrush a lighter, semi-opaque color over it and let this dry. Now apply a transparent wash of color over the previous two coats. You've taken advantage of the unique character of acrylic to drybrush *light over dark*; you've then reestablished the feeling of transparency by glazing a third color over the other two, like a sheet of glass.

(7) For these various exercises, I've assumed that you're going to work on scraps of old watercolor paper. But now try these effects on a variety of other surfaces. Try them on some scraps of old,

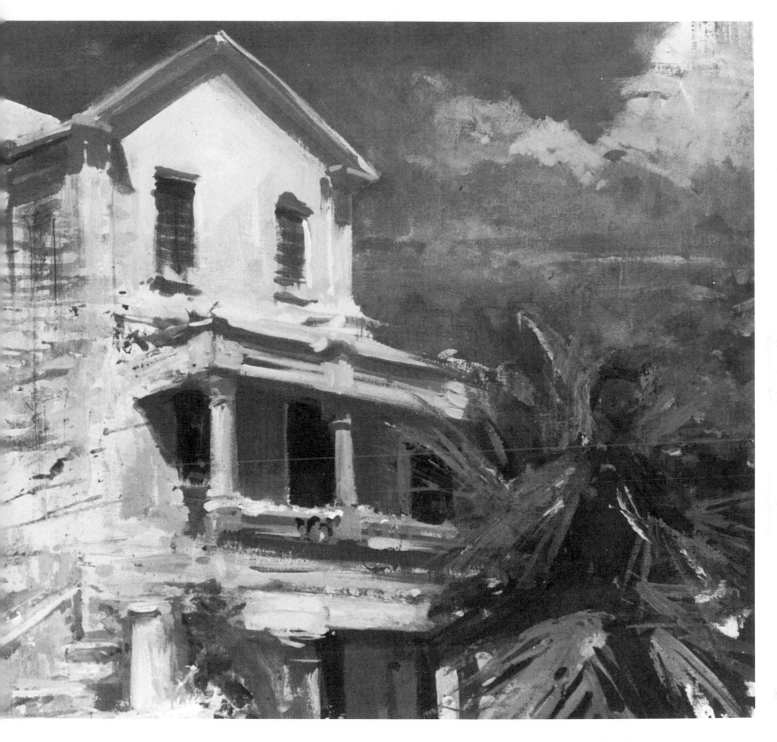

Bermuda Facade *by Everett Raymond Kinstler, A.W.S.,*
acrylic on canvas, 24"x24". Smooth surfaced canvas—
primed with acrylic gesso or left bare, never coated with an
oil ground—is particularly receptive to scumbling. It's some-
thing like working with pastel on textured paper, which
softens and blends the stroke. This is especially evident in
the soft brushwork of the sky. The building itself and the
palms in the foreground are painted in fluid, slashing
strokes, with wonderful spontaneity. For this kind of dash-
ing brushwork, acrylic must be slightly thicker than trans-
parent watercolor and somewhat more opaque.

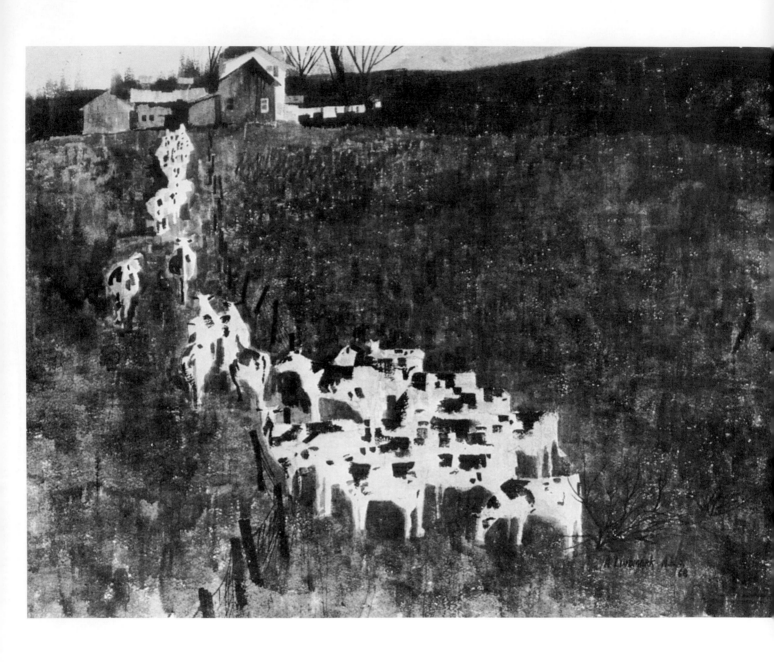

At the Fence by Arne Lindmark, A.W.S., acrylic and water-color on watercolor paper, 22"x28". The entire painting appears to be a mosaic pattern of small drybrush strokes. These small strokes, slightly squarish in character, are laid over one another in varying densities to produce roughly textured tones that range from pale to very dark. The dry-brush strokes render the grass as effectively as the markings that punctuate the forms of the livestock.

smooth canvas or muslin. Try them on illustration board which has been coated with acrylic gesso; the gesso should be brushed on a bit roughly so that it retains the texture of the brush used to apply it. Experiment with drybrush on some absorbent Japanese paper; see how the paint sinks into the soft, fibrous texture, rather than riding on top of the ridges, as it does when you paint on the harder surfaced, less absorbent European paper.

Here's a money saving tip. I've said that an unsuccessful painting can be obliterated with acrylic gesso so you can try again. You can do this several times on each side of a good, thick sheet of paper. But I've warned you that the original texture of the paper eventually disappears and you might just as well be painting on Masonite once you've got several layers of gesso on each side of the sheet. At that stage you may not like the way this thick, multiple coat of gesso responds to washes of liquid color. But such a sheet might be perfect for a painting that contains a fair amount of drybrush. If you've applied the gesso as I recommended in Chapter 3—with each coat brushed at right angles to the preceding coat—you'll have a canvas-like texture on which drybrush can be very appealing.

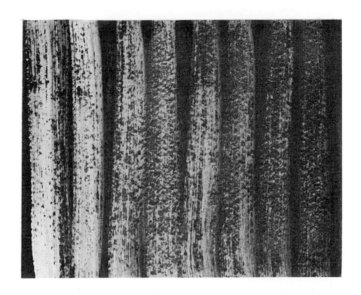

Impossible in traditional watercolor painting, light-over-dark drybrush effects are easy with acrylic. A scrap of cold pressed watercolor paper was first coated with a dark wash. A medium sized flat sable brush was then dipped into a mixture of opaque tube color, acrylic medium, and water. The brush was then drawn downward over the paper in a series of vertical strokes; with each stroke the brush deposited less color and revealed more of the underlying paper.

Scumbling

Scumbling is a word which is widely misused. It has two interlocking meanings and I'll try to explain them both before I go any further.

One way to scumble is to pick up a dab of fairly thick paint on the tip of your brush, and apply it with a kind of scrubbing motion, moving the brush quickly back and forth. In this way, you blur the paint over the surface, very much as you'd blur or blend a stroke of pastel with your thumb. The paint takes on a rough, broken quality, rather than the smooth, flowing quality of paint applied with the kind of slow, steady, rhythmic strokes you use to apply a fluid wash.

Scumbling also means applying a layer of fairly light, semi-transparent or semi-opaque color over a darker underlayer. In this case, the scumbled paint can be fairly thick—as I described a moment ago— or it can be rather fluid and washy. The important point is that the scumble doesn't quite cover the paint underneath, which shines through. In other words, the scumble and the underlying color blend in the eye of the viewer to form a third tone. Thus, you could paint a solid blue sky, and then scumble

Acrylic color mixed with acrylic medium will hold the precise character of the brushstroke in a way that rarely happens with traditional watercolor. This scumbled passage demonstrates the remarkable vitality of acrylic when applied with a rough, scrubbing motion. The brush is moved quickly back and forth, as you would in oil painting, rather than in a slow, rhythmic motion, as you would when you're applying a flat wash. Yet the color remains just as transparent as traditional watercolor.

This scumbled passage consists of semi-transparent and semi-opaque color applied on a dark underwash. The brush was dipped in slightly thickened color, blended with acrylic medium rather than water, and scrubbed over the paper with a quick back and forth motion. Where the color piles up more heavily, the tone is semi-opaque; at other points, the scumbled strokes form a thin veil of semi-transparent color. Throughout the passage, the underlying dark tone shines through. In traditional watercolor this would be impossible, because the scrubbing motion of the brush would dislodge the underlying wash and the two colors would combine, each losing its individuality. Here the colors interact, rather than blend.

in some white clouds which turn bluish white where the sky shines through the scumble.

Actually, these two definitions of scumbling do have one important point in common. Whether you apply thick paint with a scrubbing motion or apply more fluid paint light over dark, you're still working with color that partially hides, partially reveals the color underneath. Either way, you have a chance to achieve some extraordinarily rich color effects. Because wet acrylic paint won't disturb the dry acrylic paint underneath, you can scumble one color over another to your heart's content without producing mud. On the contrary, you can build one color on top of another in a way that's impossible even with oil paint—which dries so slowly that you've got to wait for days before you can paint a second coat.

What are some of the ways in which you can use scumbling to enrich your paintings? I've already said you can scumble clouds of one color into a sky of another color. In the same way, you can scumble the foam on waves. In an autumn landscape where you get a dozen different shades of orange, yellow, and brown, you can scumble one warm tone over another to achieve a richness of broken color which is impossible any other way. Scumbling with thick color is a way of getting a much rougher graded wash, in contrast with the smoothly graded wash you get with more fluid color. Try combining scumbling with drybrush when you paint rough textures like the rocks and weathered wood I mentioned earlier. The list could go on and on . . .

Acrylic mediums are particularly valuable in scumbling. In general, scumbling requires thicker paint than a simple mixture of tube color and water. You're likely to want the creamy consistency of tube color thinned with matt or gloss medium, or the really heavy consistency of tube color blended with gel.

Broken Color

Just a moment ago I used the words *broken color*. This may be an unfamiliar term, so let me explain. Solid color, of course, is a continuous layer that completely covers any color that may be underneath. Solid color can be opaque, which means that no hint of an underlying color comes through; or it can be transparent, like a layer of colored glass, completely covering—but not concealing—the color underneath. The point about solid color,

whether it's opaque or transparent, is that it's continuous, with no breaks.

Broken color, on the contrary, is discontinuous, full of breaks and spaces and gaps that allow the underlying color to come through full strength. If you drybrush one color over another, you get broken color. That is, as your brush skims over the peaks of the paper, lots of paper is left untouched, and the underlying color comes through in the gaps. Scumbling can also give you broken color. If you apply thick color with a scrubbing motion, and scrub with a kind of calculated carelessness, you'll again leave lots of little gaps for underlying color to break through. The result can be a kind of tapestry in which many threads of different colors interlock with one another to produce a depth and complexity that's unique to acrylic.

To get the full impact of broken color, try a series of steps something like the following.

(1) Cover a small rectangle of paper with a layer of solid color, either transparent or opaque.

(2) Drybrush a second color over the first, being sure to allow lots of the underlying color to shine through.

(3) Scumble a thick third color over the preceding two colors—making sure that they're both dry before you begin—using a free, scrubbing motion that doesn't cover the paper completely. Once again, make sure that the underlying colors break through here and there.

(4) Now brush a unifying wash of transparent color over the preceding three layers. You can stop at this point if you like. But you could actually keep repeating and elaborating these steps, in different orders and combinations, for as long as you please.

Let's look, for a moment, at how this broken color sequence might be applied to a specific subject. Think again about that mass of autumn foliage. You could probably begin by painting the entire mass of trees in a dark, solid brown. Over this underpainting, scumble various shades of semi-opaque orange, yellow, red, violet, and smoky gray for a touch of coolness. To suggest the texture of leaves, trunks, and twigs, you might then resort to touches of drybrush: bright flecks for the leaves, darker tones for the bark. A few touches of blue-gray drybrush might be right to suggest breaks in the mass of foliage where the sky shines through. And to unify this complex mass of broken color,

perhaps you'll want to brush on a clear wash of yellow or orange to bring all the tones together—and to restore transparency to all that semi-opaque brushwork.

Opaque Color

Some colors are naturally opaque; that is, if you paint them on straight from the tube and brush them on in a solid layer, they'll cover up what's underneath. Among the naturally opaque colors are white, of course, the cadmiums, Naples yellow, and the various iron oxide reds. Other colors are naturally transparent; even when applied straight from the tube, you can see through them to what's underneath. Most of the blues (except for cerulean) are fairly transparent; so are most of the greens (except for chrome oxide green opaque), the crimsons, the umbers, and the siennas.

You can make a transparent color opaque by adding white or some other opaque color. Conversely, you can make an opaque color transparent by thinning it out with water or by blending it with acrylic medium. An opaque color also becomes more transparent if you scrub the paint on thinly with a scumbling motion. And if you apply a transparent color thickly enough, it does tend to cover up what's underneath; but thickly applied transparent color tends to look murky and blackish, losing its vitality.

A painting executed in opaque water based paint—which can be traditional watercolor mixed with opaque white, casein, designer's colors, poster color, or acrylic—is called by the French word *gouache*. The technique of painting in gouache (or opaque watercolor, as we call it in the United States) is really quite a separate subject, and needs a book in itself.

Although opaque color can be useful in acrylic watercolor painting—as you've seen throughout these chapters—I think its place is in combination with transparent, semi-transparent, and semi-opaque color. To use acrylic simply for solid tones of opaque color is really throwing away the greatest advantage of the medium: the ability to produce passages that range from complete opacity to glassy transparency, with every conceivable gradation in between.

I've already pointed out how to use thick, opaque color in scumbling—which converts it to semi-opaque color—for accents like a break of light through the trees, and for veils of semi-opaque

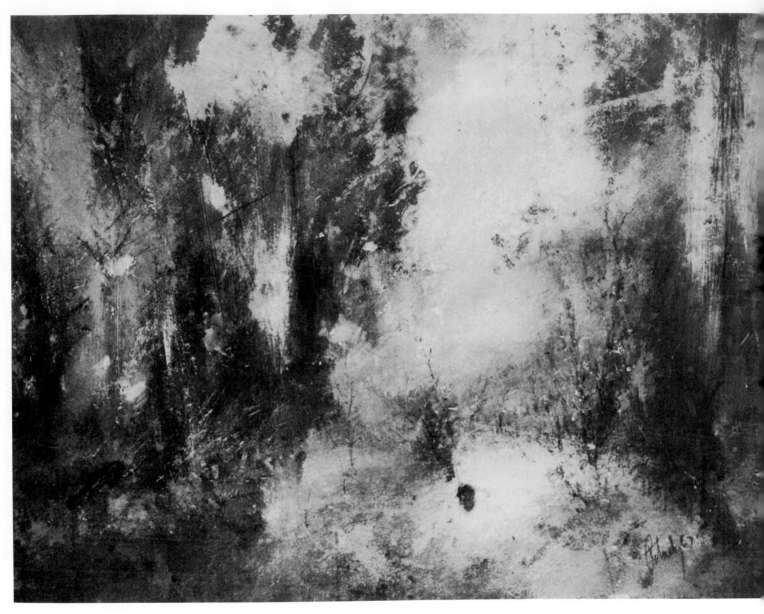

Morning in the Woods *by Stephen Potasky, acrylic on 140 lb. watercolor paper, 20"x24". The artist began by soaking the paper in water for ten minutes, then stretched and stapled it to a plywood board. "After the paper was dry," he explains, "a fast sketch was made. The paper was again wet with a 3" brush, and large tones were worked, leaving areas of white. With smaller brushes, details were added until the paper was dry. Then, to bring out the white areas, the paper was rubbed with steel wool and zircon sand. The painting was reworked with . . . tints to give it the 'fresh' watercolor effect." The completed painting was mounted on a sheet of Masonite and sprayed with matt varnish through a mouth atomizer. Although dried acrylic is generally difficult to remove, industrial abrasives* can *be used to lighten selected areas or erase them altogether. This technique can be especially useful to introduce luminosity by scraping down to the bare paper. (Photo courtesy M. Grumbacher, Inc.)*

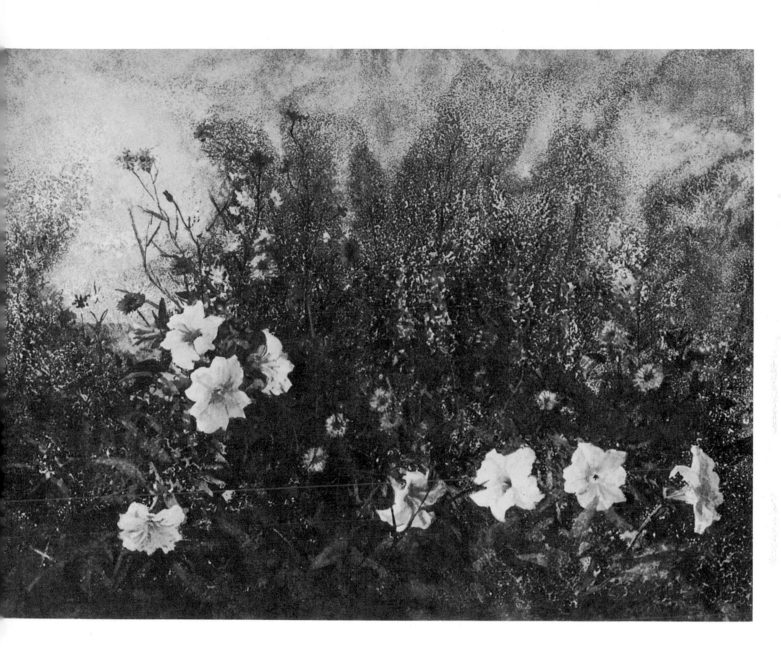

Ragged Robin *by John W. McCoy, A.W.S., acrylic, oil, and watercolor on watercolor paper, 22¼"x30¼". This unusual mixed media painting exploits the obvious fact that oil and water won't mix. The granular texture is a controlled accident that occurs where the aqueous and oil media meet and part company. Marble textured Victorian decorative papers are produced by a somewhat similar method and combinations of acrylic and oil washes are worth trying for other kinds of accidental textures. (Courtesy Coe Kerr Gallery, Inc.)*

tone that can subdue or modify another color. Beyond this, I think the single greatest value of opaque color is in a technique derived from the old masters of oil painting: a watercolor version of *underpainting and glazing.*

(1) A flat, solid area of opaque color can be an excellent first step before you go on to transparent or semi-transparent overwashes. A sunrise or a sunset, for example, may look a lot richer when the transparent colors of the clouds and the sun's rays are painted over a solid foundation of dusty yellow or even over a contrasting cool tone. A mass of green trees might gain in depth and subtlety if the transparent greens were applied over an underpainting of opaque brown.

You could, of course, underpaint the sky or the trees in transparent color. But the opaque underpainting lends a sense of weight and solidity that's radically different from a transparent undertone.

(2) The opaque underpainting doesn't have to be a simple flat tone. Modeling light and shadow can be a great deal easier when you work with thick, opaque color. Among other things, you can paint out a mistake and start over. Suppose, for example, that you want to render the complex geometric shapes of a cathedral or some other difficult piece of architecture. A simple solution might be to mix up two or three flat tones to paint the lights, halftones, and shadows. Having rendered this in opaque color—perhaps only in shades of black, white, and gray—and having made all the necessary corrections by painting out and repainting, you can then work freely over this opaque underpainting in washes of luminous, transparent color. You'll still get a transparent watercolor, but with the solidity and precision you need for a difficult subject.

This, by the way, is the way the old masters painted portraits. The face and hands are always the hardest part of a portrait, and the old masters generally preferred to paint these in shades of gray or brown, solving the problems of modeling three dimensional forms before they had to worry about color. When the forms were fully realized in monochrome, and this underpainting was dry, they could then go back into the picture with rich, transparent color that allowed the underlying forms to shine through.

(3) An opaque underpainting can lend not only color and three dimensional form, but texture. Your flat color or your modeling can be done in really thick paint—perhaps further thickened with gel—which will hold the lively texture of your brushstrokes. Then, when your washes of liquid color go over the dried underpainting, the fluid paint will settle into this irregular texture, which strikes through and enlivens the overpainting.

Let's go back to rocks and trees again. The bark on the tree trunk can be underpainted with rough strokes of thick color that really look and *feel* like bark. And if your strokes of thick color follow the direction of the slabs of rock, they'll create a rocky texture which is accentuated by the overpainting.

This rough underpainting not only enlivens overwashes of transparent color, but creates a marvelous surface for drybrush and scumbling. If the thick underpainting has peaks and valleys of dry paint, your drybrush strokes will leave lively flecks and scrubs of color on a textured surface which you've prepared *yourself*—a custom-made surface —for a specific purpose, carefully planned in advance to suit the subject.

(4) I said earlier that you can paint out an unsuccessful passage with opaque color and start over. I should emphasize that this opaque color needn't be white, but can be *any* color, preferably some color that complements or reinforces the colors that will go over it when you try again.

When you underpaint in opaque color, don't just stick to obvious color combinations. Yellow or brown *may* be the right underpainting for green trees, but some contrasting color like red or orange or violet may do surprising things to an overwash of green. A delicate yellow underpainting—not cadmium yellow, but yellow ochre—can lend an unexpected glow to a blue sky. I've seen orange brickwork underpainted with green, brown rocks underpainted in blue, beige sand underpainted in violet, and still more surprising uses of contrasting colors. Try out what looks like the "wrong" color a few times and see what happens. You may be in for some wonderful surprises. Remember, if it turns out to be a mistake, you can always paint the whole thing out with some other opaque color and try again.

Mixed Media

More and more contemporary artists are turning to *combinations* of media to broaden their range of technical possibilities. Of all the painting materials available, acrylic is most adaptable to mixtures

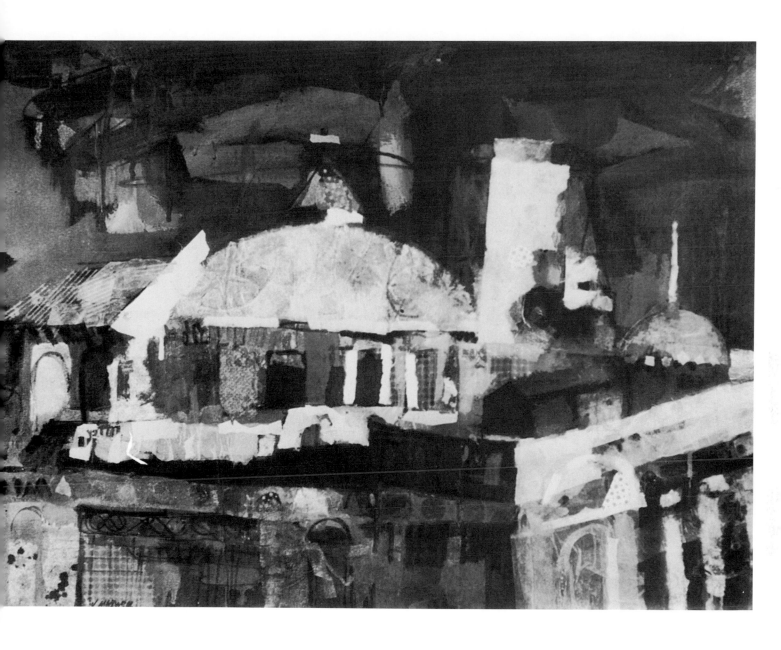

Rooftops *by John Maxwell, A.W.S., acrylic and collage on watercolor paper, 26"x32". Thin, decorative papers and fabrics can be pasted to the painting surface with matt or gloss acrylic medium—or can be stuck right down onto the wet paint. If the paint has enough body, it will act just like an adhesive. To integrate the collage elements with the rest of the pictorial design, you can paint washes and strokes of color right over them, modifying the pasted patterns, but not obliterating them. It takes a good deal of looking to see where Maxwell has used bits of collage in this very subtle painting. Freely applied strokes of runny color move into, behind, and over, the collage passages and thereby knit the entire picture together.*

with other media. Here are a few possibilities worth exploring.

(1) Perhaps the most common mixed media combination is a blend of acrylic and traditional watercolor. Many painters find that they like to begin the picture with fluid, delicate washes of traditional watercolor, which establish the broad areas of the design. On top of this thin, washy foundation, they then build more solid shapes, textures, lines, and masses in the heavier acrylic paint.

(2) Acrylic can also be combined with other water based paints. I know several painters who combine acrylic with tube casein, which yields an unusual crusty, matt texture, something like pastel. They actually mix casein and acrylic paint together, or they use the acrylic mediums to dilute and extend casein tube color.

(3) Matt or gloss acrylic medium, all by itself, can produce glowing, translucent paint when mixed with liquid dyes, transparent watercolor, and colored drawing inks. This is a favorite medium of illustrators, who find these combinations particularly vivid for reproduction in magazines.

(4) An even more surprising combination is matt or gloss acrylic medium with pastel. You can begin a painting with pastel on paper, then brush acrylic medium into the pastel strokes so that the dry pigment blends with the medium to produce a unique kind of paint. You can do the same with charcoal or chalk.

This is only the barest hint of the possibilities of acrylic in mixed media painting and drawing. I've said nothing about the possible combinations of acrylic watercolor with pen line, brush line, pencil, wax crayon, and all the other drawing media that may be lying around in your studio. Once you get going with acrylic watercolor, it's tempting to yank out every medium you find in your drawers and find out how the various combinations work.

A Final Note on Collage

Because acrylic medium—and the paint made with that medium—is such a powerful and permanent adhesive, many painters in acrylic have found ways of incorporating collage elements. Collage is really an independent medium, of course, and this brief, final note will hardly do it justice. But there are a few obvious ways of combining collage with acrylic watercolor—and these are worth trying as an introduction to acrylic collage.

(1) The simplest collage medium is paper. Inexpensive white or colored tissue can be used to build up textures or your painting surface; over these textures, you can apply washes of transparent color, drybrush and scumbling effects, or opaque color as an underpainting for transparent color. Paste down the tissue with a generous layer of matt or gloss acrylic medium, then cover the tissue with another layer of medium, which thus provides a receptive surface to the paint that follows. The tissue needn't be applied flat, but can be crumpled, wrinkled, or torn. This creates a much livelier texture to paint on.

(2) Another way to use paper is to hold onto your old, spoiled paintings, cut them up or tear them up, and then paste them onto a fresh surface. I don't guarantee that this collage of bits and pieces will give you a new and effective painting in itself. But it may give you some rough and unexpected color areas which will fire your imagination and give you the basis on which to build a new pictorial design.

(3) You can also assemble bits and pieces of textured cloth, plain or patterned, and wash acrylic watercolor over these. Once again, paste them down with an underlayer of acrylic medium, and then cover them with some more acrylic medium to create a receptive painting surface.

(4) Finally, you can incorporate all kinds of textural materials into your acrylic watercolor collage. There may be places where you want to apply a layer of acrylic medium and then sprinkle on some granular stuff like sand, coffee grounds, pencil shavings, or sawdust. You can then leave these textures alone, or you can apply washes of color over them.

The complete vocabulary of possibilities is far too vast to summarize. What I do hope you'll do is try a few of these ideas and then take off from there. The sky's the limit.

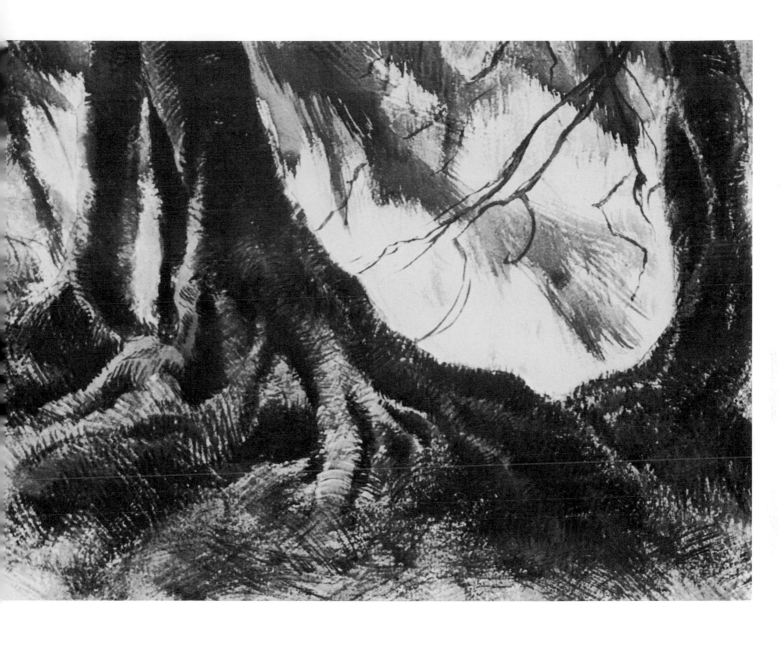

Edge of Light *by Gerald Grace, A.W.S., acrylic on water-color paper, 21"x29½". This unusual drybrush technique is less familiar in painting than in pen and ink drawing, where cross-hatching is a time-honored way of building rich tone and elaborate texture. The rugged, sinuous forms of the tree trunks and the winding roots in the foreground are methodically painted in a series of short, overlapping strokes that curve around the cylindrical shapes and accentuate their three dimensional quality. The hanging foliage is also expressed in ragged strokes that follow the direction of the form. Knowing that drybrush can be over-used—and can become overwhelmingly monotonous—the artist has wisely left spaces of bare paper to act as a foil for his brushwork.*

Demonstrations

DEMONSTRATION 1:
TRANSPARENT WATERCOLOR TECHNIQUE

Good Harbor Beach, October by John C. Pellew: Step One

The artist begins by sketching in his composition with diluted burnt umber. He works with a No. 5 round sable brush and simply indicates the large, abstract shapes of the composition. The big shape of the cloud shadow in the foreground "contrasted nicely with the sunlit area beyond," says the artist, "so I gave it plenty of space." For this reason, Pellew explains, "I kept my horizon line well above the center." At this preliminary stage, Pellew draws the absolute minimum number of lines necessary to rough in the major shapes, but makes no attempt to indicate details or even a touch of tone.

126

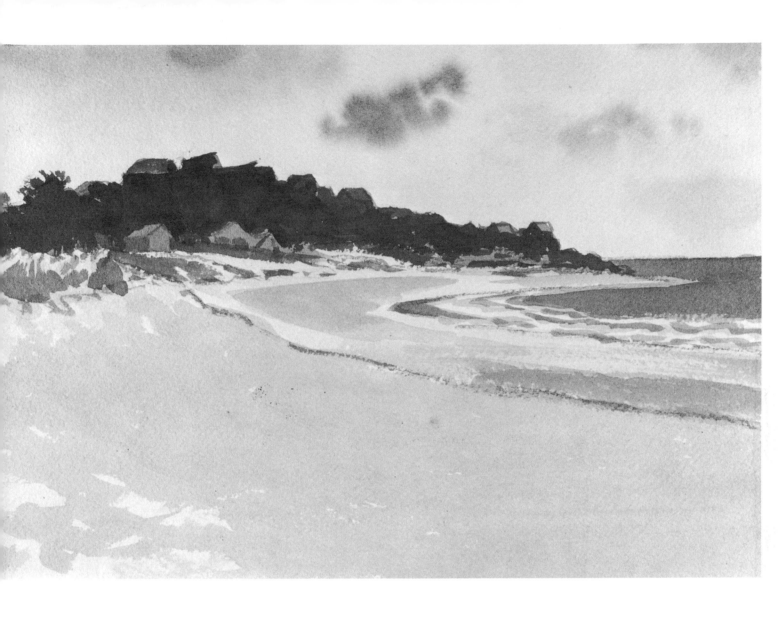

Good Harbor Beach, October by John C. Pellew: Step Two

The sky is the first thing painted. "After wetting the area with clean water, applied with a 1" flat oxhair brush, I waited until the shine was off the surface." Working with diluted thalo blue, he finishes the sky, "keeping it very simple, so that it won't compete with my interesting busy foreground." Next, he puts in the big mass of the headland with its clutter of houses; he uses mixtures of thalo blue, Payne's gray, raw sienna, and burnt umber. This is purposely left unfinished. Now, working down the sheet, he puts in the blue of the ocean, leaving white paper for the surf, and then paints the bright, sunlit part of the beach. When this is dry, he mixes a puddle of yellow ochre, warmed with a little burnt sienna, and paints in the middle tones seen above on the curve of the distant beach; this also goes over most of the foreground. Finally, some yellow-green is added for the beach grass atop the dune.

127

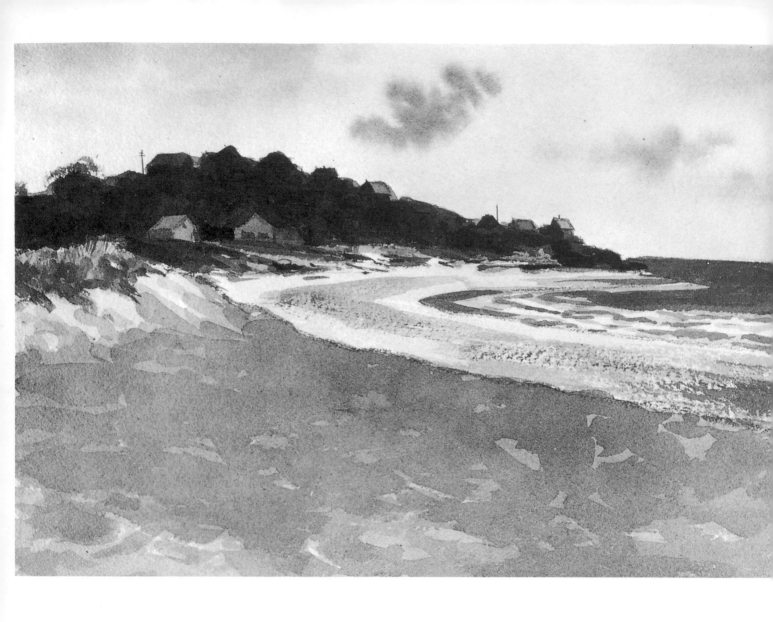

Good Harbor Beach, October by John C. Pellew: Step Three

*"Time out for a smoke while everything dries," says Pellew.
Now the headland is given its finishing touches "taking care
not to overdo the details," the artist emphasizes, "which
were all too plainly visible." The tone of the ocean is dark-
ened and some drybrush is used to give textural interest to
the distant beach. "A few cool green tones are introduced
into the beach grass on the sand dune, leaving only the large
foreground to deal with. Of course, I knew when I started
that the cloud shadow would disappear from the landscape
as I painted, so I studied its color and tone at that time, and
finally painted it from memory." The cloud shadow is
Payne's gray, a little thalo blue, and a touch of burnt
umber, grayed with a little opaque white. This is painted
over the warm underpainting and allowed to dry. Finally, a
darker mix of the same colors is used to give the shadow
area some variety.*

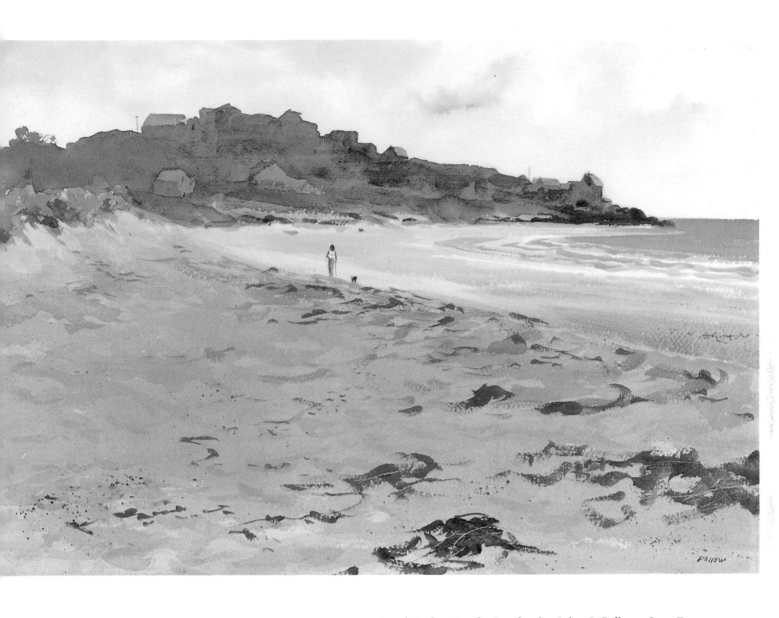

Good Harbor Beach, October by John C. Pellew: Step Four

*The last steps in the painting are details, like putting in the
seaweed left by the outgoing tide, and indicating the small
figure. A No. 9 round sable is used for the seaweed and a
No. 2 round sable for the figure. The seaweed is raw sienna,
burnt umber, and Payne's gray, rather loosely mixed. The
girl's shirt, of course, is opaque white. Except for that one
opaque touch, the picture is entirely transparent. Pellew
points out that: "This painting is a good example of one of
the many problems that bedevil the landscape painter: the
change in light. Sunlight and shadow won't stand still. That
first impression—the effect that attracted you in the first
place—must be captured. The landscape before you changes
so fast that you've got to keep that effect in mind and face
the fact that most of the picture will have to be painted
from memory. I liked the cloud shadowed foreground and
kept this first impression in mind even though the actual
effect lasted only two or three minutes." The painting
is a half sheet (15"x 22") of 300 lb. cold pressed paper.*

129

DEMONSTRATION 2:
TRANSPARENT, SEMI-TRANSPARENT, AND SEMI-OPAQUE COLOR

Boats by Hardie Gramatky: Step One

*The artist begins by sketching in the composition entirely
in line, with a few dark notes to indicate prominent touches
of shadow. These dark touches are sparingly placed on the
central boat and on the wheels. The rhythmic forms of the
boats are indicated with swinging, gently curving lines. The
abstract basis of the composition is clearly indicated at this
stage. The division of the picture plane is the result of very
careful study and nothing is left to chance: note how the*
*area above the boats is divided by the masts into a variety
of shapes, no two of them the same. Although it's easy to
correct acrylic by resorting to opaque painting, Gramatky
doesn't leave compositional decisions to chance or to last
minute impulse, but begins with a complete pictorial de-
sign. This actually allows him to work more spontaneously
when he begins to apply paint, because the basic framework
of the picture is complete from the very beginning.*

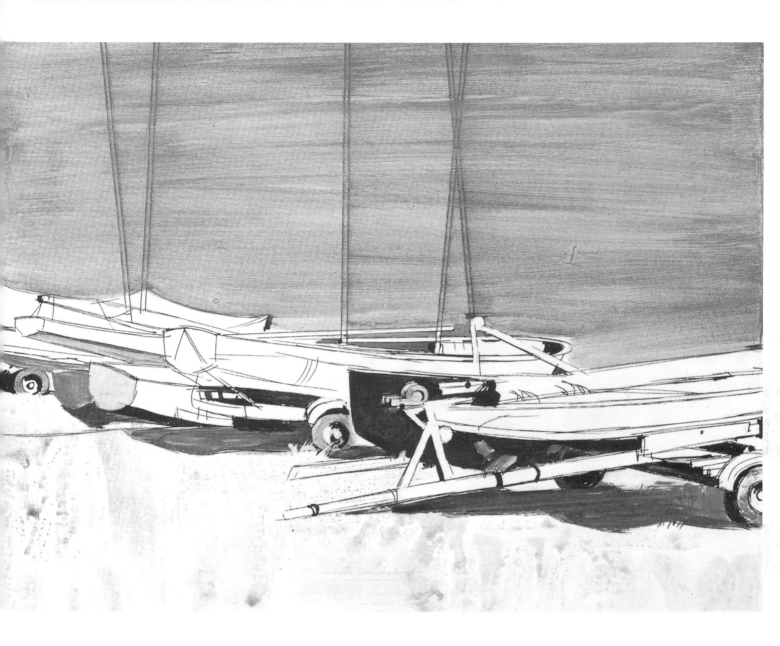

Boats by Hardie Gramatky: Step Two

The next stage is to establish the color areas. Gramatky sets the color key to the entire picture with the bright "spring green" foreground, which is a luminous, transparent wash. Notice the interesting texture of the wash, which has the lively, scrubby, bubbly quality of an acrylic wash on gesso. (The picture is painted on a sheet of illustration board coated with acrylic gesso, applied with a slightly streaky texture.) The deep green shadows under the boat are related to this basic foreground color. The artist then concentrates on the excitement of harmonious local colors: the

red and light blue sterns become foils for the dark blue boat and the red pulley at the center of the picture. Gramatky says that he "relates these colors as carefully as if they were the dominant notes in a symphony." A blue-green tone is thrown over the entire background to set off the lightstruck forms of the boats. Throughout this phase of the painting, colors are essentially transparent, and no attention is given to such details as the cast shadows on the boats themselves, or the masts that will loom up before the mass of trees. Gramatky still concentrates on the large shapes.

131

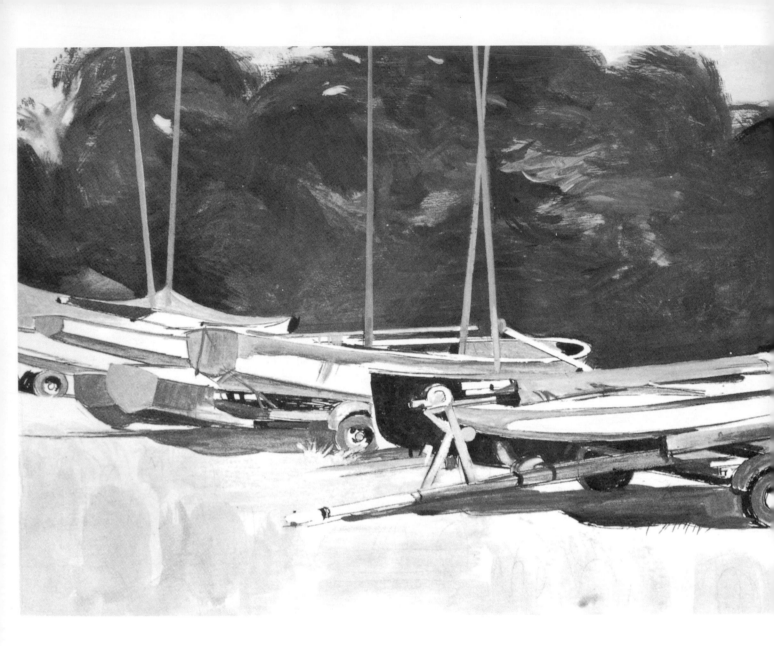

Boats by Hardie Gramatky: Step Three

"Now for the fun," says the artist. Here's where he establishes the final forms—painting the bright white areas on the boats with a loaded brush and fluid, opaque color. The opaque gray shadows on the hulls complete their rounded, rhythmic forms, while free swinging strokes of transparent and semi-transparent color convert the dark background wash to the shape and texture of a clump of trees. The masts of the boats are indicated in decisive strokes of opaque color. Gramatky points out that he avoids using black as much as possible; note that his shadows are as richly colored as the rest of the picture.

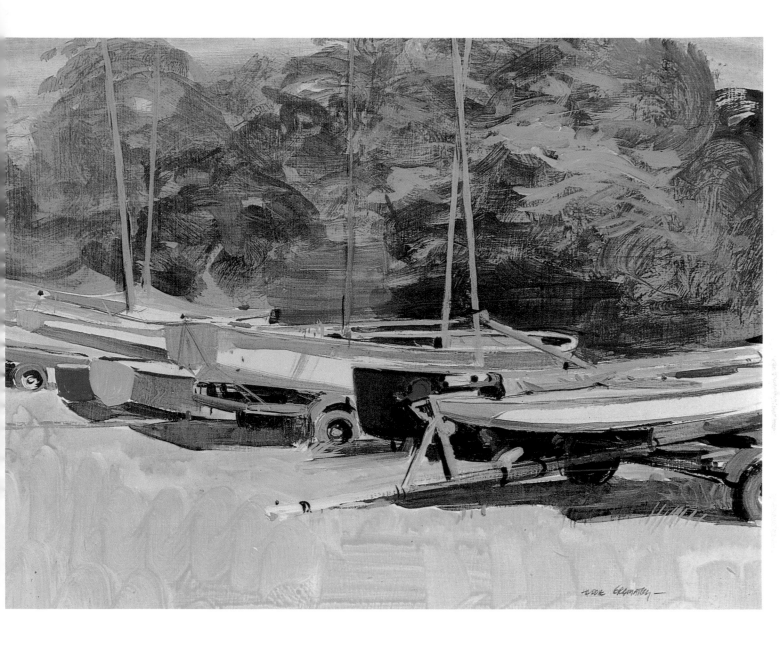

Boats by Hardie Gramatky: Step Four

The final painting is on an 11"x15" sheet of illustration board, coated on both sides with gesso to prevent warping. Gramatky has made full use of the varying degrees of transparency, semi-transparency, and semi-opacity of acrylic. The foreground is a completely transparent wash, with the white gesso ground shining through every stroke. The trees and shadows under the boats are a fascinating blend of semi-transparent and semi-opaque strokes with one color shining through another to create an effect of unusual richness. The masts and the shadows on the boats are heavy, opaque colors. Observe how the streaky texture of the gesso enlivens the washes and strokes applied over this surface. Because gesso is less absorbent than watercolor paper, this specially prepared surface encourages free, spontaneous brushwork as the brush glides swiftly over the painting ground.

133

DEMONSTRATION 3:
TRANSPARENT COLOR WITH OPAQUE DETAILS

Abandoned Farm by John Rogers: Step One

After a precise pencil drawing, the flat tone of the sky is laid in first, covering the mass of trees to the left and even running over the smaller architectural forms that protrude from the roof. While the sky wash is drying, Rogers washes in the tone of the foreground. Next come the tones on the side of the house itself. The sky mixture consists of cerulean blue, cobalt blue, Payne's gray, and a little alizarin crimson. The foreground mixture is yellow ochre, raw umber, and sepia. The side of the house is cerulean blue, cobalt blue, and just a hint of cadmium orange.

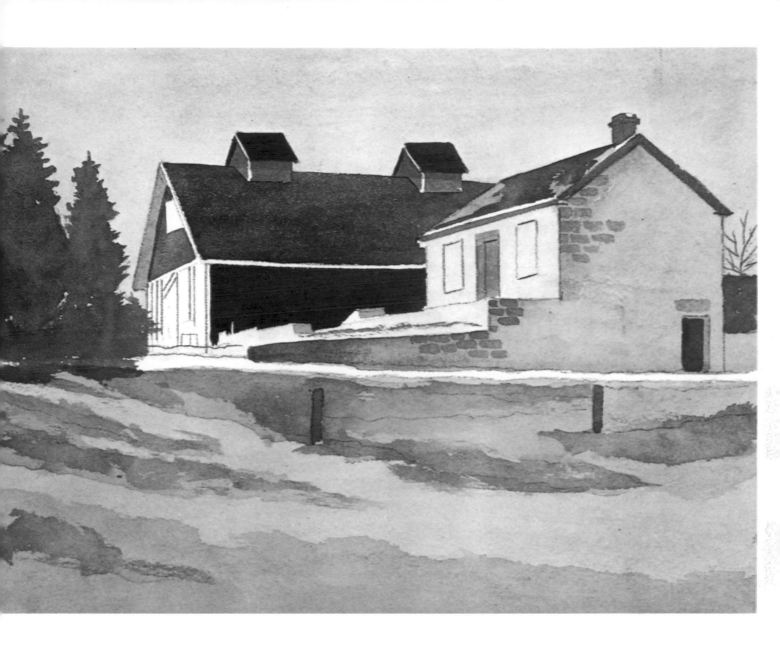

Abandoned Farm by John Rogers: Step Two

Rogers points out that "the entire painting was still done in much the same way as conventional watercolor, working primarily from light to dark, adding darker and darker details as I proceeded." The mass of the trees to the left is painted directly over the sky. The dark tones of the house are added and touches of detail begin to appear, like the shapes of the bricks and the texture of the foreground. The posts in the foreground are painted with masking fluid, which will later be peeled off to reveal the white paper beneath. Aside from the posts, the artist pays no attention to other light areas which may be covered up at this stage, but which can be re-established by touches of opaque color later on.

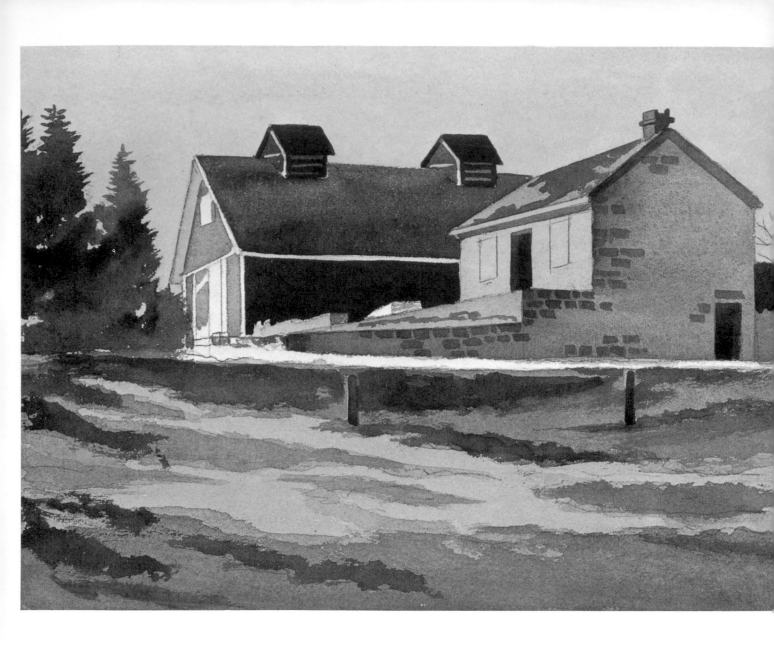

Abandoned Farm by John Rogers: Step Three

Now still more detail is added as the foreground tones are deepened, strengthened, and more clearly defined. Further architectural detail is added to the house. Note, in particular, the refinement of the architectural details that protrude from the rooftops. However, at this stage, the artist is still working mainly with flat shapes and flat color areas. The painting is not yet fully three dimensional.

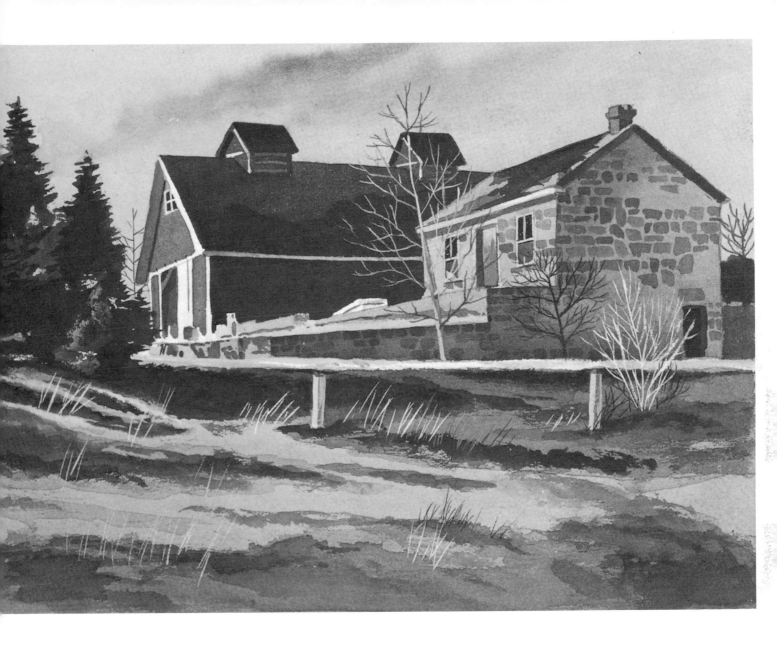

Abandoned Farm by John Rogers: Step Four

Now the painting really springs into three dimensions. The tones of the trees to the left are deepened and enriched. More complex tones are added to the rooftops; the foreground tones are deepened and made more precise. The shadow planes of the architecture are established in more final form. Details of windows and stonework are added, with opaque touches for the light foliage in the foreground, the scrubby trees in the middle distance, and the strips of light on the architecture. A wet-in-wet tone is also added to enliven the sky.

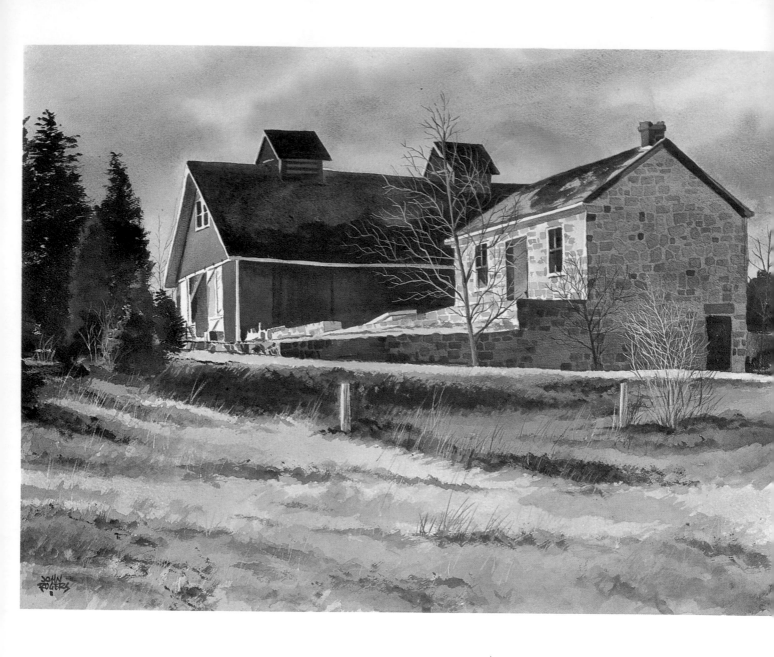

Abandoned Farm by John Rogers: Step Five

The final painting is mainly transparent, with touches of opaque color added for crisp detail in the foreground foliage and in the architecture. The sky is painted wet-in-wet and the color has tended to settle into the texture of the paper, which lends it a lively, granular quality. The foreground runs the full gamut of textured effects from fluid paint to drybrush. The deep tones of the architecture demonstrate the unique capacity of acrylic to produce dark washes—built up by a series of light washes—which are both deep and transparent. Abandoned Farm is on a 20"x28" sheet of watercolor paper.

DEMONSTRATION 4:
PAINTING ON WET PAPER

Dried Flower Still Life by Arthur J. Barbour: Step One

A full sheet, 22"x30", of rough Arches watercolor paper is soaked in a tub of water for about twenty minutes, then taped to the drawing board and allowed to dry for several hours. After the paper is "stretched" in this way, the entire composition is lightly drawn in pencil; the lines are faintly visible here. Barbour selects a palette of burnt sienna, raw sienna, raw umber, cobalt blue, Hooker's green, cadmium red light, cadmium yellow, thalo crimson, and black India ink. The lower portion of the picture is wetted down with clear water, using a natural sponge. Various grays (mixed

with raw sienna, burnt sienna, and cobalt blue) are introduced into the wet paper, and these colors soften and diffuse. When these tones are settled into the moist paper, India ink is mixed with the pigment and added with a small brush to retain or sharpen edges here and there. The area is allowed to dry and the process is repeated several times until the full color density is developed. The little saffron flower in the center is also painted wet-in-wet—with cadmium yellow, Hooker's green, burnt sienna, and cadmium red light, with touches of black India ink.

139

Dried Flower Still Life by Arthur J. Barbour: Step Two

The top flower head is painted by the same wet-in-wet method, and then Barbour attacks the cockscombs. Cadmium red light is introduced into the moist paper, and thalo crimson is fed into the cadmium red. A mixture of black India ink and thalo crimson is added for the darker tones. A natural sponge is used for strippling, along with brush and ink, on the now semi-wet areas to complete the ragged, soft feeling of the cockscombs.

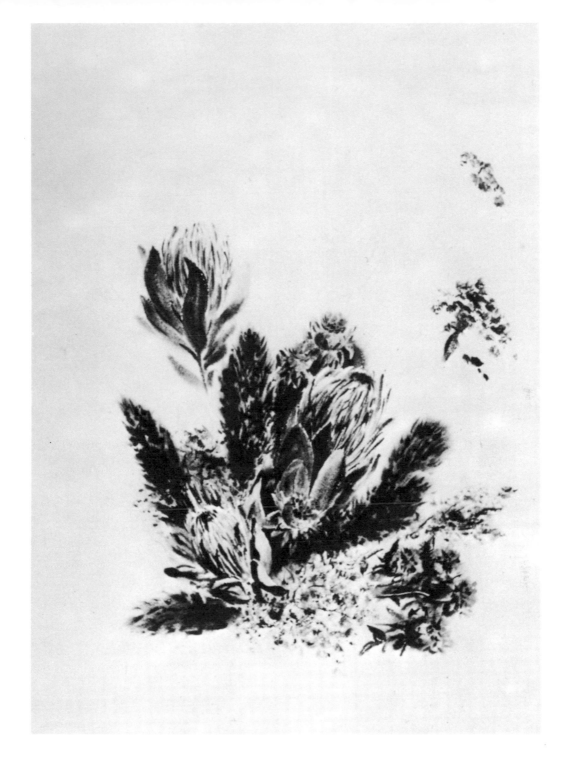

Dried Flower Still Life by Arthur J. Barbour: Step Three

The remaining cockscombs are completed as described in step two. Surprisingly, this wealth of detail has been painted entirely wet-in-wet. By flooding the paper with clear water and carefully observing drying time, the artist has judged when to introduce his colors on the painting surface. In the beginning, color is introduced onto a fairly wet surface, and is inclined to spread. As the surface begins to dry, more color is introduced, and it is more inclined to stay put. In a more advanced stage of drying, the paper receives more precise notes that define edges and details.

Although the wetness of the paper softens every touch of the brush and gives a faintly blurred quality to each stroke, the flowers are rendered with great accuracy and completeness. The function of the wet paper technique, here, is to integrate the texture of the painting without destroying detail. This extraordinary control is rare in a painting executed by the wet paper method. Acrylic makes this control possible because the paper can be allowed to dry, and can then be rewetted and repainted many times without dissolving underlying layers of paint.

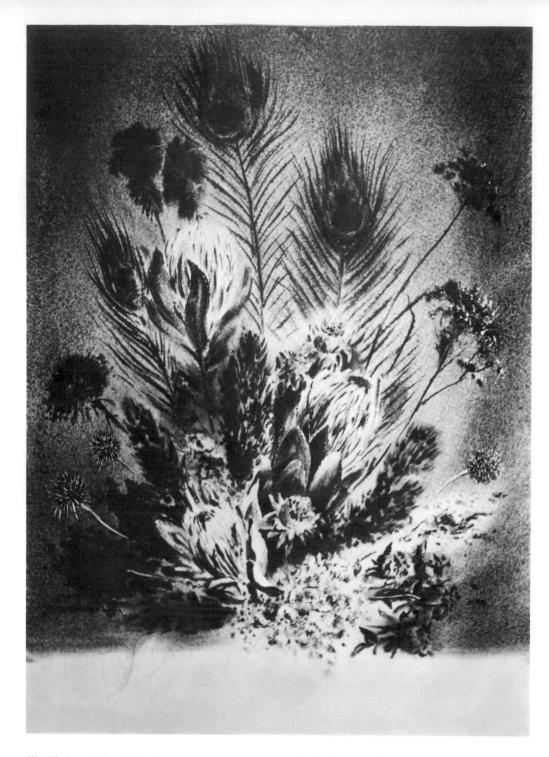

Dried Flower Still Life by Arthur J. Barbour: Step Four

A sponge dipped in burnt sienna is used for stippling in the weeds—Queen Anne's lace. Now, when all the details are dry, the paper is again flooded with clear water and a mixture of raw sienna and water covers it entirely, except for important light areas of the design. Into this wet background, raw umber, raw sienna, and cobalt blue are flooded to create the final tone. As the wet background color settles into the texture of the paper and forms a granular effect, the rest of the still life is painted in with brush, sponge, ink, and color—the strokes blurring only slightly because the background wash is now almost set.

Dried Flower Still Life by Arthur J. Barbour: **Step Five**

When the paper is completely dry once again, the lower part of the picture is wetted down and flooded with colors in the same way as the background. As the pigment begins to settle and the paper becomes semi-wet, leaves and shadows are added to strengthen the design; the colors are supported with black India ink. A knife blade is used to scrape out a jagged white weed stem, which is then lightly tinted. A touch of opaque color is added to the feather tops. Dried Flower Still Life is on 300 lb. rough Arches paper, 29½"x21½". (Collection Mr. and Mrs. Robert Wullen; photographs courtesy Special Papers, Inc.)

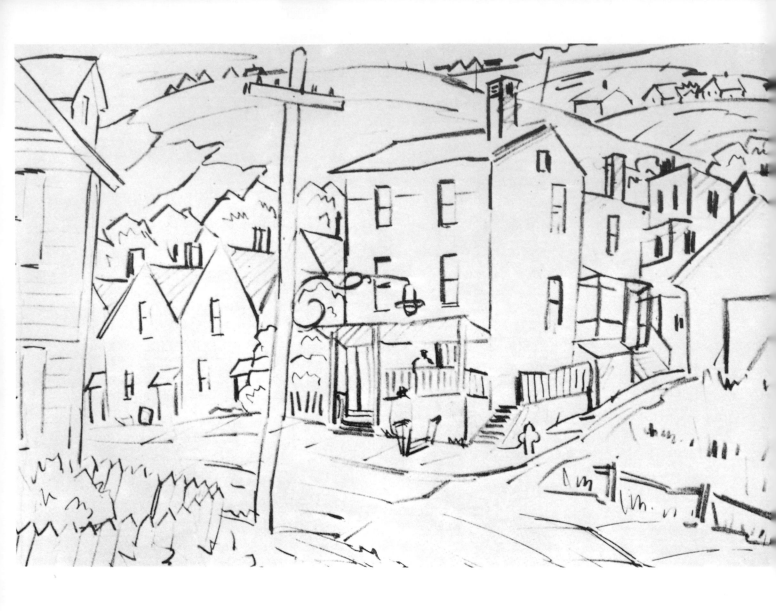

DEMONSTRATION 5: OPAQUE COLOR

The White House by Henry Gasser: Step One

The elaborate composition is roughly indicated with a charcoal pencil. Because there are so many architectural elements, the artist includes a fair amount of detail in this preliminary drawing on the painting surface. Although the lines are free and sketchy, Gasser makes certain that every window is in place, that the buildings are in correct perspective, and that even cast shadows (like that of the central figure) are placed where they'll appear in the final painting. Note the compositional importance of the telephone pole to the left of the center of the pictorial design. Gasser isn't concerned about the possibility that these dark lines will dominate the final painting, since there will be enough opaque tones to obliterate the charcoal lines when the picture is completed.

144

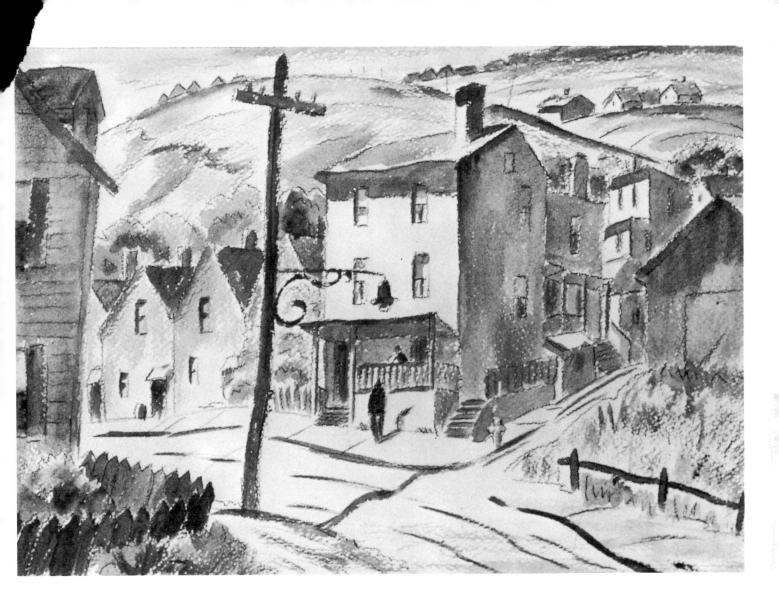

The White House by Henry Gasser: Step Two

Over the charcoal line drawing, the artist paints a monochrome wash of bluish gray to indicate areas of light, halftone, and shadow. The wash is acrylic diluted to the consistency of transparent watercolor. At this stage, the artist doesn't focus on color or texture, but only on form. His idea is to establish the three dimensional shapes of the buildings, as revealed by the pattern of light and shade. Notice that the wash is applied quite roughly, with flecks of white paper striking through and establishing a lively, informal texture throughout the picture. Like the charcoal lines, this will also disappear as the paint is built up more opaquely in later stages.

145

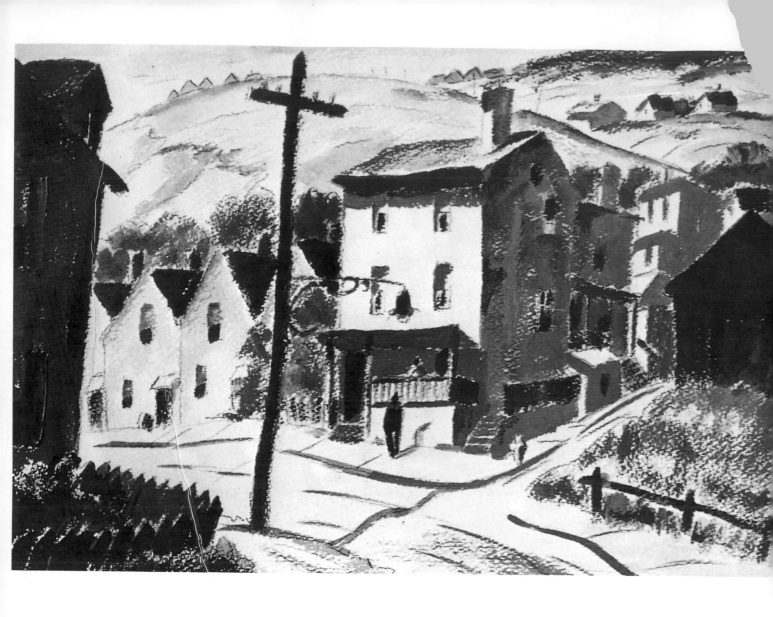

The White House by Henry Gasser: Step Three

Now Gasser begins to apply opaque paint and the dark areas receive their full color. The picture ceases to be a transparent watercolor, and begins to take on the full weight and depth of an oil painting. The color is applied roughly with bold brushwork, and it is diluted with much less water than the original washes. Note how the heavy texture of the paint on the shadow side of the house already begins to take on the feel of the crumbling wall itself. The combination of thick paint and rough paper gives much of the painting a drybrush quality. The full tonal range of the painting is established here, from the darkest darks to the sunstruck lights. There's still no detail; the windows, for example, are just dabs of color, and nearly all the charcoal lines have disappeared under the heavy paint.

146

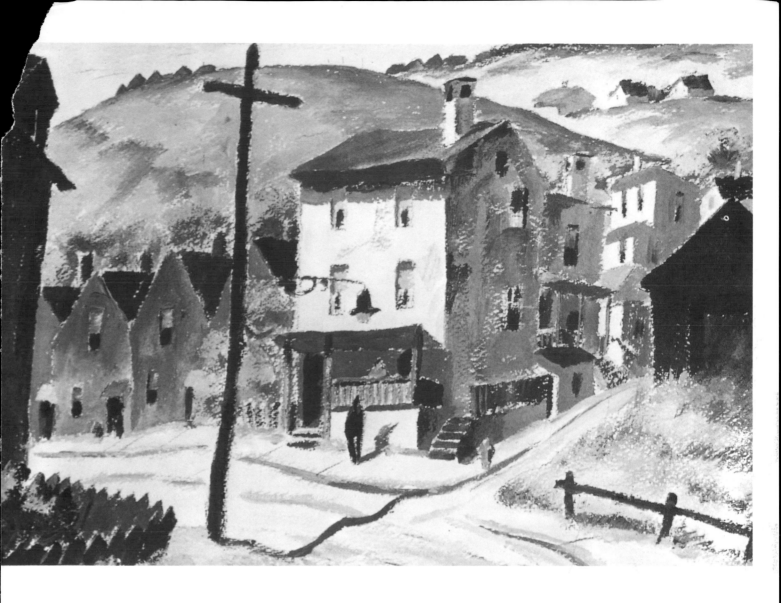

The White House by Henry Gasser: Step Four

Now the entire painting surface is covered with opaque and semi-opaque color, still applied in a rough manner, with no emphasis on detail. Having established the full range of tone in the preceding stage, concentrating on the darkest darks and the lightest lights, Gasser now focuses on the various middle tones, such as the row of houses to the left. The middle tones of the distant hills are also further developed, as is the weedy patch of land to the extreme right foreground. The artist still makes no attempt to sharpen edges or refine detail. The picture is kept in a rough state, retaining the spontaneity of the artist's first impressions. The refinement of shapes and textures is left for the very end in order not to lose the initial vitality of the brushwork.

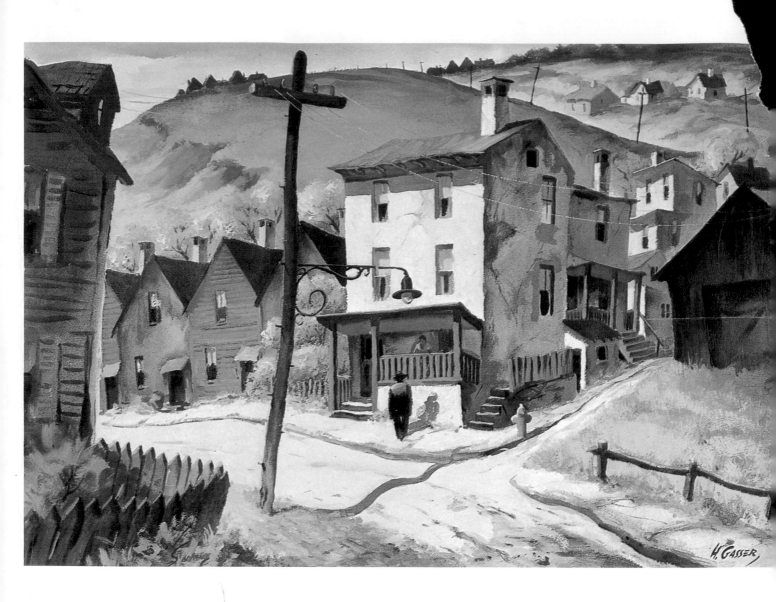

The White House by Henry Gasser: Step Five

Now Gasser pulls the entire painting together. The shapes of all the buildings are sharpened and detail is introduced in windows, fences, porches, doorways, and foliage. All the original rough strokes are still there, but they've been overlaid with more precise strokes to indicate edges of light and dark, cracks in masonry, window shades, mullions, and all the tiny touches that give reality to the picture. Certain areas have been built up in an impasto technique to give them even further texture. Note the heavy drybrush texture of the weedy patch in the lower right hand corner, where the paint has been applied thickly. In general, the light areas tend to be thicker and more opaque than the shadow areas, which are treated more transparently. The telephone wires, by the way, are scratched in with a decisive stroke of a razor blade. The White House is on cold pressed watercolor paper, glued to a 20"x28" board.